IMAGES
of America

BEAUFORT

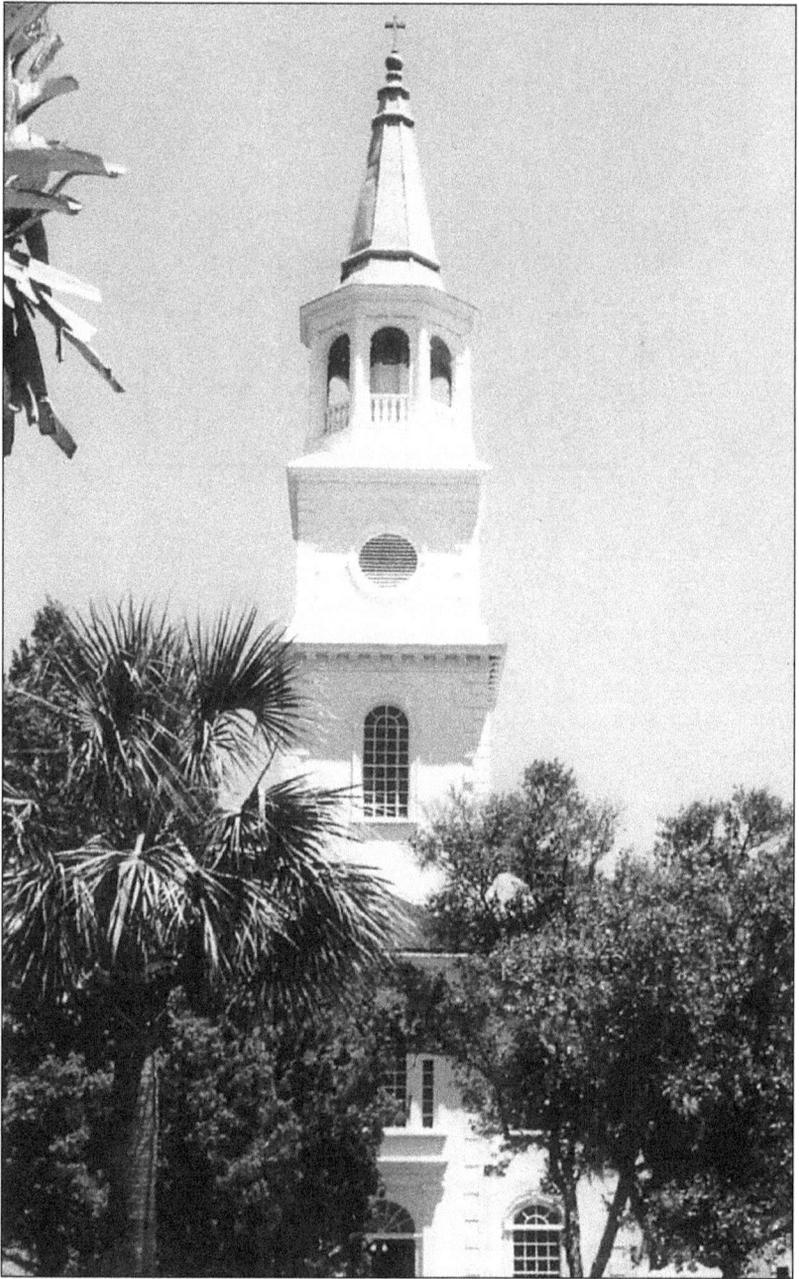

The Parish of St. Helena was organized in 1712 and the church built by 1724. The next year, the Rev. Lewis Jones arrived from England as pastor. During his term, Capt. John Bull gave a gift of communion silver in memory of his bride who disappeared during the Yemassee Indian War. Among old gravestones are those of two British officers killed in the Revolutionary War battle of Port Royal. Two Confederate generals are also interred here: Lt. Gen. Richard Anderson and Brig. Gen. Stephen Elliott. In 1823, Rev. Joseph Walker became rector. In 1861, he and the congregation fled before the Civil War. Five years later, he found the church had been stripped of it furnishings, used as a hospital, and tombstones dragged inside for operating tables. After heavy restoration in 2000, it is a vital and active parish today.

2

IMAGES
of America

BEAUFORT

Polly Wylly Cooper
Betty Wylly Collins

ARCADIA
PUBLISHING

Copyright © 2003 by Polly Wylly Cooper and Betty Wylly Collins
ISBN 978-1-5316-1030-2

Published by Arcadia Publishing
Charleston, South Carolina

Library of Congress Catalog Card Number: 2003102692

For all general information contact Arcadia Publishing at:
Telephone 843-853-2070
Fax 843-853-0044
E-mail sales@arcadiapublishing.com
For customer service and orders:
Toll-Free 1-888-313-2665

Visit us on the Internet at www.arcadiapublishing.com

This book is dedicated to the children of Beaufort in hopes that they will grow to appreciate how special this area is; that they will never forget their religious and cultural heritage; that they will stand firm against the destruction of historic houses for parking lots and protect the majestic old trees, the health of the river, and the fragile ecosystem.

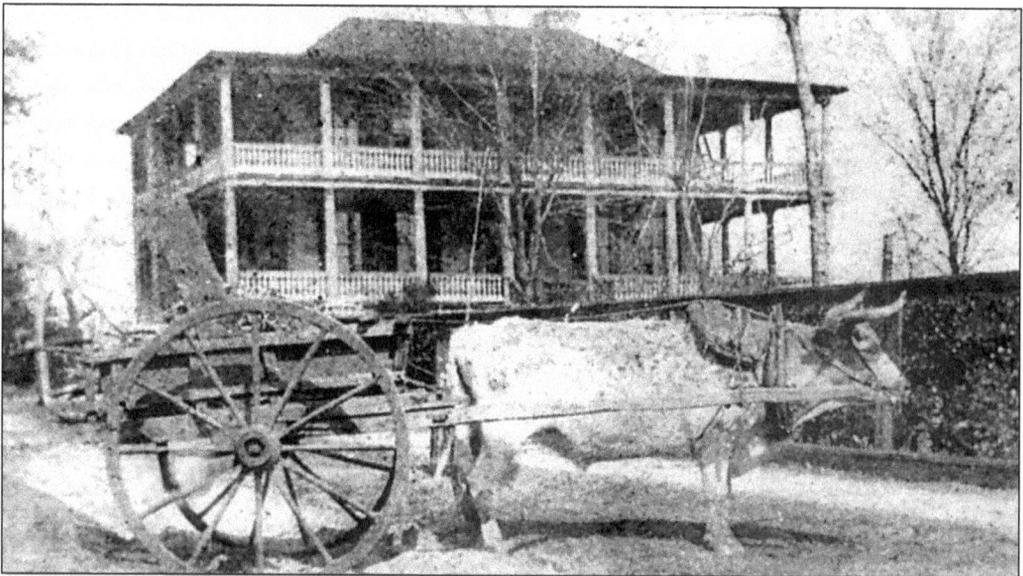

This c. 1840 home at 411 Bayard Street was built by Rev. Thomas E. Ledbetter, who came to Beaufort to teach Christianity to slaves on the islands. After the Civil War, Neils Christensen Sr. and his wife, Abbie, lived here. He served in the war and was later superintendent of the National Cemetery. She started a Montessori school in the house. The well-known founder of the Red Cross, Clara Barton, visited here. Today, it is the home of Wyatt and Sally Pringle.

CONTENTS

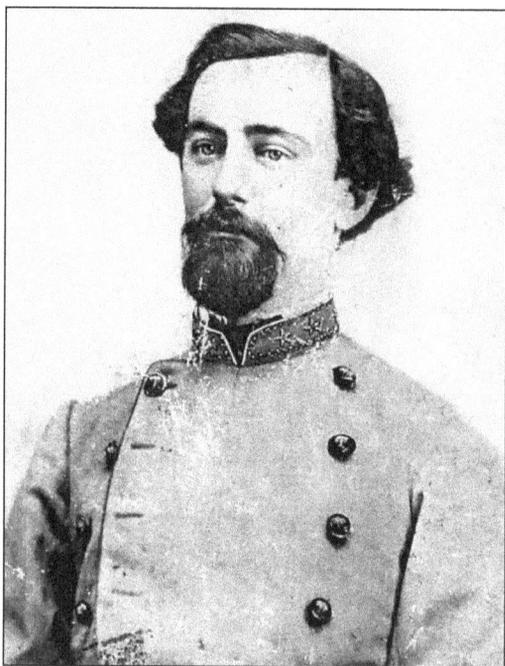

Gen. Stephen Elliott Jr., son of an Episcopal minister, commanded the Beaufort Volunteer Artillery. He was wounded during a Union attack at Port Royal. After capturing the steamer USS George Washington in 1863, he took command of Fort Sumter. Sent to Virginia as commander of the Holcombe Legion, he was made brigadier general. Returning home to recuperate, he led a brigade opposing William Sherman's invasion of South Carolina and surrendered in April 1865. (Courtesy of Historic Beaufort Foundation.)

ACKNOWLEDGMENTS

This book belongs to the people of Beaufort who provided their treasured photographs—our windows to the past—and shared their memories with us. We had the pleasure of putting it all together.

We would like to thank the following: Polly Brooks, Julian Cooper, Tim Cooper, Jim Collins, Jeanne Aimar, Bitty Brant, Mary Ann Blake, Biz Campbell, Alma Cappelmann , Marguerite Broz, Ned and Janet Brown, Henry Chambers, Sally Chaplin, Paula Harrell, Dick Deal, Marvin Dukes, Ron and Natalie Daise, Carol Christensen Eve, Duncan Fordham, Molly Gray, Hastings and Nancy Greene, William Green, Patsy Hand, John Parker, Geni Flowers, Mae Mendoza, Russell and Kitty Harley, Dee Hryharrow, Mary and Vicki Jenkins, Ann and Bill Kennedy, Beth Kennedy, Bill Rauch, Mike Taylor, Harriet Keyserling, Elly Levin, Grace Cordial, Bobbi and Merrill Levy, Mills and Julia Kinghorn, Renee and Julian Levin, Ann Marshall, Claude McLeod, Bill and Kathy Sammons, Nancy and Bill Rhett, Mary Patrick, Louis Pinckney, Chloe Pinckney, Madeleine Pollitzer, Wyatt and Sally Pringle, Gaillard Pinckney, Margaret Rodgers, Dr. Lawrence Rowland, Willie and Wanda Scheper, Ruth and Gerhard Spieler, Stephen Wise, Marjorie Trask, Reeve Sams, Jean Kearns, Hope Cappelmann, Grace White, Sharon Stewart, Bob Sofaly, Jim Cato, Bob Hartzog, Nevy Clark, Jack Miller, Lucille Culp, Nan Hall, Jim Knight, Rev. Alex McBride, and Rev. Frank F. Limehouse III.

INTRODUCTION

Beaufort is a special town of friendly people, with a population of 12,950, many artists, a tight grip on preservation, a vibrant waterfront, classic architecture, military presence, and many retirees. Vast expanses of water and marsh grass cover the area of 70 large and medium islands and approximately 200 small ones.

Native Americans lived in the Beaufort area continually for 4,000 years before the first European settler arrived to stake claims to the land. The first European explorer, Spaniard Pedro de Quexos, sailed into the area in 1525 and called it Santa Elena.

The French named the area Port Royal. In 1562, Jean Ribaut from France built Charlesfort on Parris Island and established a French Huguenot colony. It was the first Protestant colony in the new world. This attempt at colonization failed because of a lack of supplies from France. Jean Ribaut went back to France to solicit assistance, became involved in matters there, and never returned. The colonists built a ship and sailed for home.

Spain coveted this area of North America, and Port Royal in particular, because it was such a strategic location in the new world. Dr. Lawrence S. Rowland explains in his book, *The History of Beaufort County, S.C.*, that it was the deepest and most accessible harbor on the southeast coast of North America and on the route of the galleons transporting gold to Spain.

In 1566, Pedro Menendez de Aviles founded Spanish La Florida's northernmost colony, also known as Santa Elena, near the location of Charlesfort. The colony served as the capital of Spanish La Florida. The Spaniards stayed 21 years. When Sir Francis Drake attacked St. Augustine in Florida, the Spaniards removed their forces from Port Royal.

The saltwater was alive with crabs, shrimp, fish, oysters, and alligators. The forest sheltered deer, bear, mink, wild turkeys, raccoons, and possums. It was a land of abundance. The influx of explorers and settlers caused displacement and tension, which would later erupt into bloodshed.

The town of Beaufort was established in 1711 by the British Lords Proprietors. Thomas Nairne was an Indian trader who worked to placate difficulties in Indian relations with his long-range policies. The settlers desired harmony. Nairne and others met with the Yemassee Indians to negotiate deep into the night. Many were relaxing and beginning to feel optimistic. Towards morning and without warning, a band of war-painted Yemassees leapt upon the settlers and slaughtered Nairne and other white settlers. One wounded settler escaped and sounded the alarm in Beaufort. Because of his warning, many still in Beaufort were able to escape to Charleston in a smuggler's boat. The Royal Governor of South Carolina responded with the militia and in just two military actions ran the Yemassees down to Florida, where they sought refuge with the Spanish. The war went on for many years, after which the settlers came back into town to rebuild.

Around the same time in North Carolina, tension was rising between the Tuscarora Indians and settlers. Men between the ages of 15 and 60 were drafted by Gov. Edward Hyde. Col. John Barnwell of Beaufort went to North Carolina in 1711, becoming known as "Tuscarora Jack" because of his fearless fights with the Indians. He is buried under St. Helena's Church today with an epitaph to the left of the entrance.

Plantation owner John Bull and his British bride had just been married. Unaware of danger, Mr. Bull left for Charles Town. Returning a few days later, he was aghast at the hideous carnage rotting in the sun. His slaves had been slain and scalped. The ashes of his lovely home were still glowing. His livestock had been shot. One can imagine his fury upon finding one satin slipper near the river. There was no trace of his wife. He became a man full of gnawing bitterness and grief. St. Helena's Episcopal Church still uses the silver service that he gave in his wife's memory in 1734.

By 1727, rice was the major cash crop with indigo also an important crop. Immense wealth was amassed and stately homes were built. The demand for slave labor was great and Charleston was the port for the African slave trade in South Carolina. Shipbuilding thrived in Port Royal and contributed to the thriving economy in the Port Royal Sound area.

By 1775, the colonists felt the need to shrug off the heavy yoke of England's control, especially taxation and stamp duties. The Boston Tea Party proclaimed resistance to the archaic rulings of King George III and the Tories in Parliament. By 1776, it was clear that the Americans would accept nothing less than independence.

Beaufort was active during the Revolution. Francis Marion, known as the "Swamp Fox" and stationed near Sheldon, was in charge of the American revolutionary forces for a time. The Beaufort district suffered much hardship. Loyalists and American patriots burned each other's houses and crops. By the end of the war, criminals were threatening travelers and social instability was the rule of the day. Recovery was tedious and long.

People began growing an exciting new crop from the Bahamas. Long Staple Sea Island cotton was desirable and expensive. Its long silky fibers were made into fine fabrics, such as linen, which were much sought after in the European market. Cotton was "king" from 1790 to 1860. Many of the elegant dwellings in the historic district today were built during those halcyon years.

Soon, the War Between the States was looming. In South Carolina, the white population wanted separation from the Union for economic, political, and cultural reasons. The abolitionist fervor of the Northern states and the restrictive tariffs and laws were critical threats to the economy. Brothers would take opposite sides and spill family blood.

On Craven and Church Streets, in Secession House, a group gathered to discuss leaving the Union. Robert Barnwell Rhett led the movement for Secession in 1860. When South Carolina

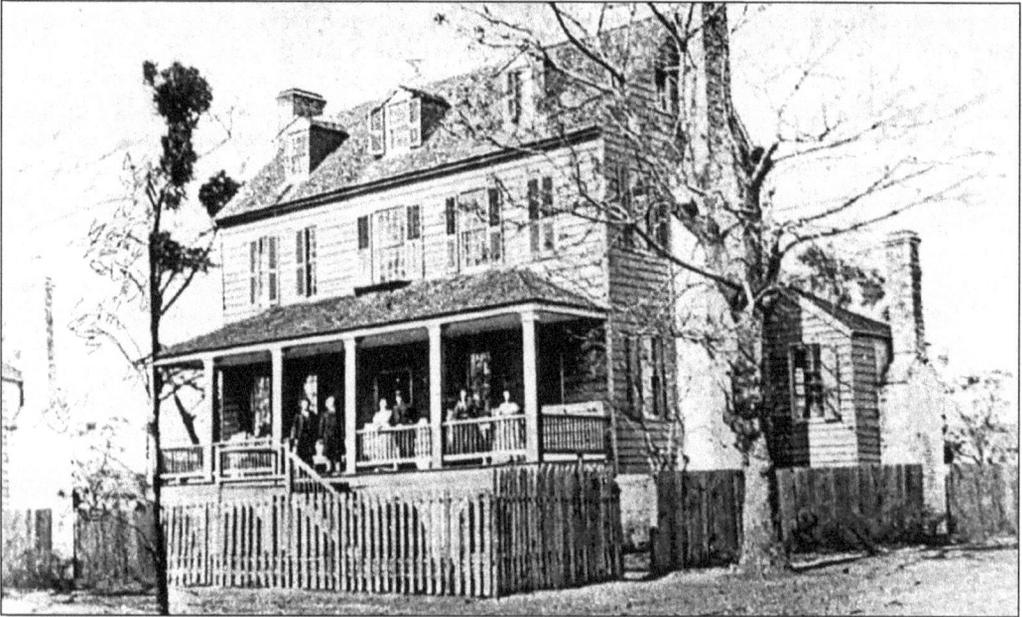

The deTreville house, c. 1790, was first occupied by Rev. James Graham's family. The J.T. Bakers were the next owners and fled inland when Union soldiers occupied the city in 1861. Gideonite abolitionist missionaries from Boston (pictured here) took it over in 1863, hence the name Mission House. Subsequent owners were Francis Shaw, George Whipple, Joseph Collins, Winchell French, and Rachel Mather, founder of Mather School. In 1907, Joseph Claghorn Jr. bought it; he sold it to Ruth Claghorn Saffold and her husband B. Ellis deTreville in 1927. Today it is the home of their daughter, Ruth deTreville, and her husband, Gerhard Spieler.

seceded from the Union, Beaufort was drawn into the Civil War. Plantation owners fled in fear following the Battle of Port Royal in November of 1861 when the Union army occupied Beaufort County. Later, they found their land confiscated, homes occupied, slaves freed, and the military ruling. Few ever recovered their ancestral lands. None recovered the tremendous wealth lost with the emancipation of the slaves.

Six miles from Beaufort on St. Helena Island is Penn Center, founded by abolitionists in 1862 as the first school for freed slaves. Its mission is to preserve the history of the Sea Islands and the Gullah language and culture which originated with the interaction of slaves and their white overseers in the early 18th century. It was here that Dr. Martin Luther King Jr. and his Southern Christian Leadership Conference planned the 1963 March on Washington. Penn Center, on 50 acres of the campus of Penn School, was designated a National Historic Landmark in 1974.

In 1870, phosphate beds were discovered throughout Beaufort County. New money was generated by this large industry. In 1889, a navy yard was established in Port Royal Sound, which could receive large battleships in 1892. This harbor was closer to Chattanooga, Omaha, St. Louis, and Kansas City than was New York harbor.

By the 1890s, produce farming bolstered the economy. Farms on Port Royal Island, St. Helena Island, Cane Island, Cat Island, and Distant Island grew fresh produce. Familiar names in the trade were Trask, Sanders, McLeod, Bellamy, Gray, and others. Vegetables became the main cash crop on the Sea Islands.

A wicked hurricane in 1893 surged across the Sea Islands. The tidal wave, high winds, and flooding waters drowned many and ruined the phosphate mining industry by destroying the equipment. With this loss and an additional tax levied on the phosphate rock by Gov. "Pitchfork" Ben Tillman, the industry was doomed. Agricultural farming, timber, and seafood were the economic mainstays of Beaufort County until the modern development of Hilton

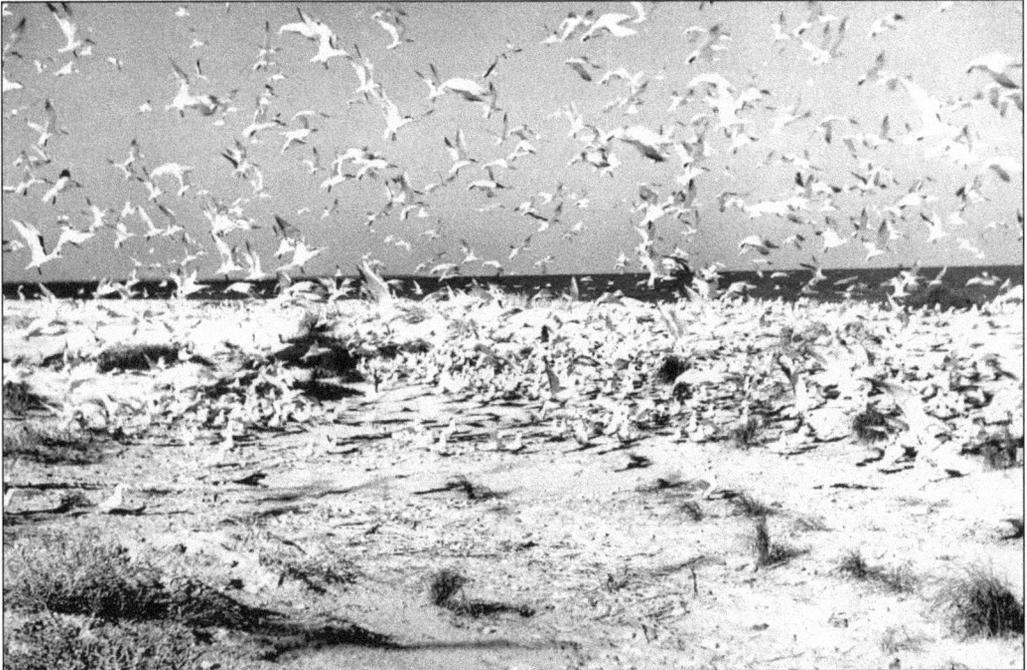

Egg Bank, a small island in St. Helena Sound off Harbor Island, was known as "Bird Cage" in colonial times. In the 1860s, when interest in phosphate mining was revived, two companies were formed: the Charleston S.C. Mining and Manufacturing Co. and the Wando Fertilizer Co. Their mining boats were careful not to run aground here. It was a natural nesting beach for seabirds. As beaches change with wind, time, and tide, so did this one. It is practically submerged today.

9

Head Island. This popular resort has attracted many year-round residents, bringing an economy to Beaufort and many sections of the county.

In his excellent book *Doctor K*, Dr. Herbert Keyserling describes Bay Street in the early 1900s. He narrates a westward walk on Bay Street passing "MacDonald-Wilkins cotton gin and warehouse, Peoples Bank, Ohlandts' Grocery, Wall Motor Co., and Danners' Warehouse. Crossing Scott Street were Macdonald-Wilkins grocery and hardware, Abe Rudowitz's cobbler shop, and DeTrevilles' Drug Store. Across the alley were Nick Pannanedes's fruit stand in front of Ari Coclin's restaurant, Lengnick's Department Store, Riverview Hotel and Alston's Grocery. Across West Street and the alley leading to the ferry dock was Bristol and Hall Jewelers, Wallace and Danner's department store, and Luther's Pharmacy. Across the alley stood Kinghorn Brothers' grocery and insurance with the Masonic Lodge upstairs. Ye Olde Fashion Shoppe, Seeley's Singer Sewing Machine shop, Mr. Gage's bicycle shop, the old Custom House containing Thomas and Thomas law firm. Across the alley leading to the Waterhouse cotton gin and dock were the Beaufort Bank, Dr. Foster's office and Dr. Elliott's office."

The U.S. Marine Corps Recruit Depot was established in 1915 with a vital Women's Training Battalion added in 1948. The Marine Corps Air Station is on U.S. Highway 21. Today, tourism provides a cash flow to the area of $767 million yearly.

Film crews have used the area as settings for the movies *Forrest Gump*, *The Prince of Tides*, *GI Jane*, *The Big Chill*, *The Great Santini*, and more. Hunting Island, with 5,000 acres of unspoiled beach, wildlife habitats, and its famous lighthouse is nearby. Because of the early Federal occupation of Beaufort during the Civil War, the historic district is well preserved and legally protected. The county has a vital Open Land Trust founded by visionaries Marguerite Broz, Betty Waskiewicz, and John Trask.

Beaufort is the second-oldest city in South Carolina after Charleston and was voted one of the top 12 distinctive destinations by the National Trust for Historic Preservation. The entire historic district is a National Historic Landmark, a coveted title and source of strong local pride. Residents who have contributed to this rich and remarkable history are the focus of *Images of America: Beaufort*. Within these pages, they are captured at work and at play, in times of solitude and times of celebration. These treasured photographs provide readers with a glimpse of the town's past through the eyes of the men and women who are proud to call Beaufort home.

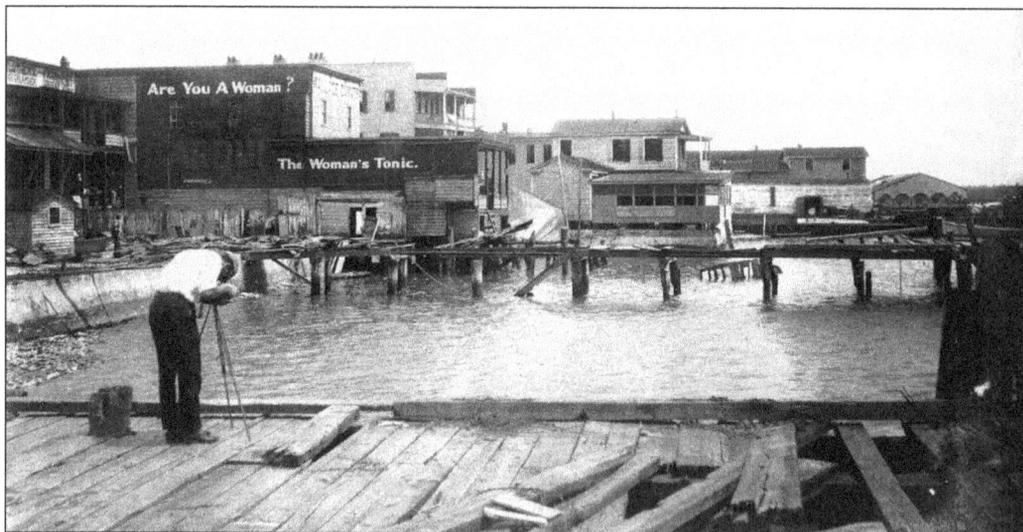

An early view of the waterfront shows a photographer under the hood of his camera capturing a morning scene.

One

MEMORABLE
BEAUFORT TOWN

Edward Wesley Bailey, six years old, observed the New York funeral procession of Abraham Lincoln. He was descended from Methodist ministers John and Charles Wesley. Later, as a druggist in Beaufort, Dr. Bailey often took medicines in his "kicker," a small boat, to the poor on the islands. He drove a Hupmobile with his dog, Jack, on the running board. When he died in 1928, pallbearers refused to put their old friend into the hearse. They carried the coffin three blocks to the Catholic cemetery at Old St. Peters on Carteret Street.

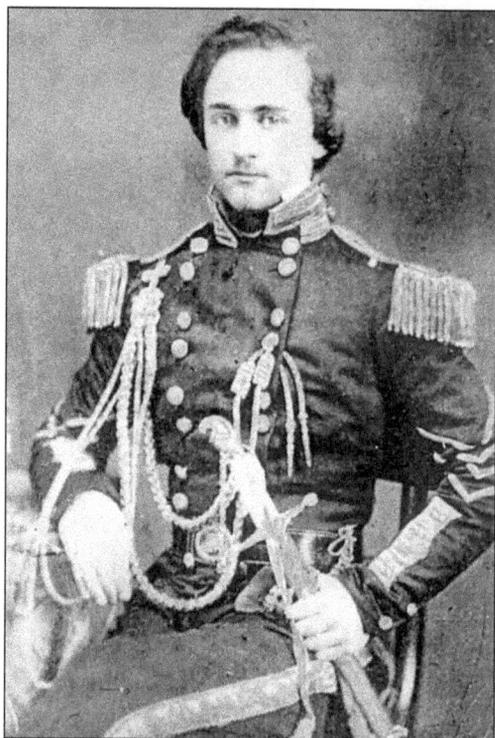

Lt. Col. Robert deTreville, C.S.A., born in 1833, was married to Eliza Glover. He practiced law with his father in Charleston until the start of war in 1861. After a short time with the Washington Light Infantry, he commanded First S.C. Infantry (Regulars). During an attack on Averysboro, North Carolina in 1865, he was killed. Four of his brothers, who also wore the Confederate gray, survived the war. His name and those of other brave men who died in the war are inscribed on a tablet at St. Helena's Church under the words "In Memory Of Our Honored Dead of St. Helena Parish."

The archives of the First African Baptist Church of Beaufort state that the church began in 1863 with 134 members. Constructed entirely by hand without nails, this bastion is located on New and King Streets and stands as a faithful witness to salvation. Small prayer houses, such as the one on the left (now gone) enabled slaves to worship while avoiding strict regulations imposed upon large gatherings by plantation owners. Most of these houses had fallen into disrepair by the late 1960s.

Charlie "Doc" Luther was a pharmacist-mate in the Spanish-American War. In 1906, he borrowed $4,000 from his aunt and bought Elliott's Pharmacy and changed the name to Luther's Pharmacy. Called the "poor man's doctor," he treated gout, snake bites, and "crumblin' of the bones," and he sold "Wahoo Tonic," a popular alcoholic cure-all. He sold the drugstore to his nephew, Dr. Julius Long, in 1941.

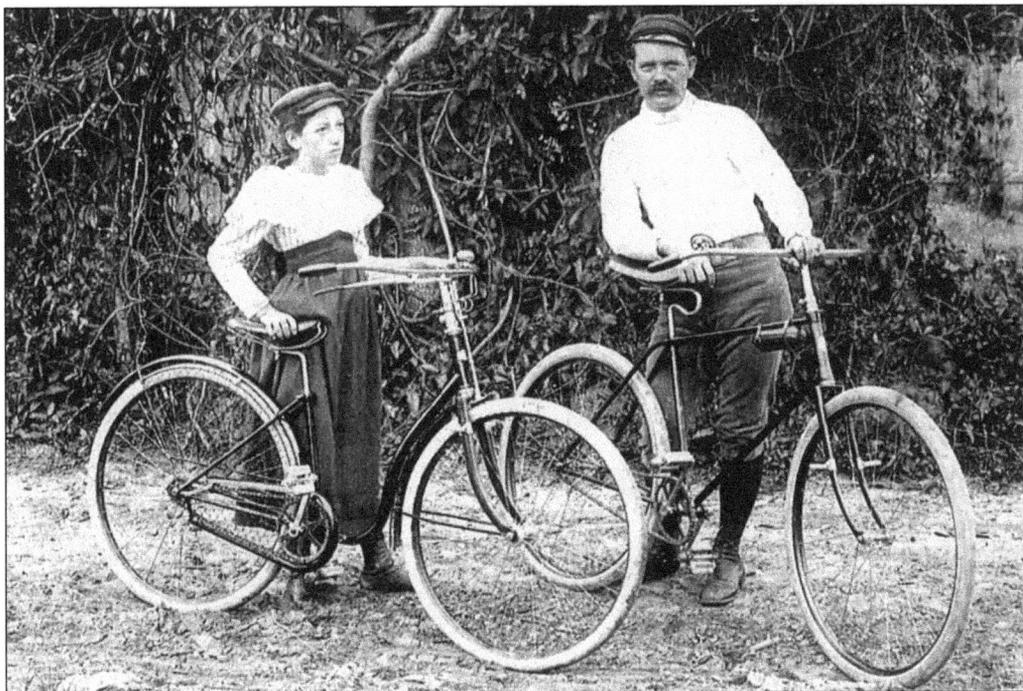

Elizabeth Crofut (Waterhouse) and her father, George A. Crofut, enjoy a morning on their bicycles. Mr. Crofut was in the phosphate business on Lady's Island and later the captain of the *Clivedon* and other steamships. Elizabeth grew up to be an acclaimed musician.

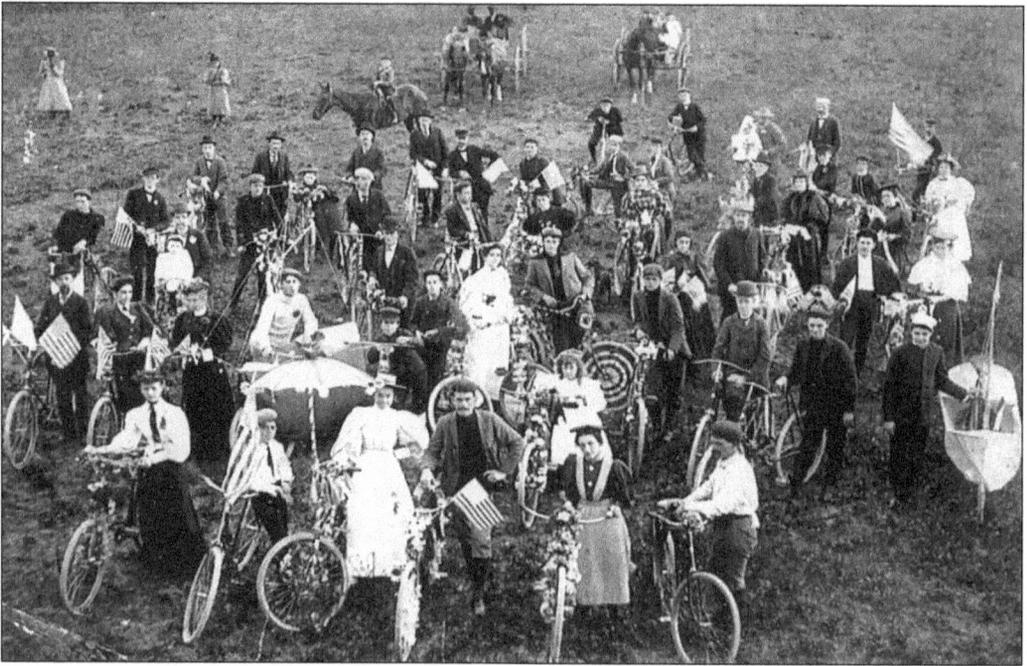

The Bicycle Club of Beaufort, followed by some horse-drawn carriages, is gathered for a Sunday outing and picnic. The photo was taken at the south end of Bay Street in the early 1900s. George Crofut and his daughter, Elizabeth, are in the forefront of this photo.

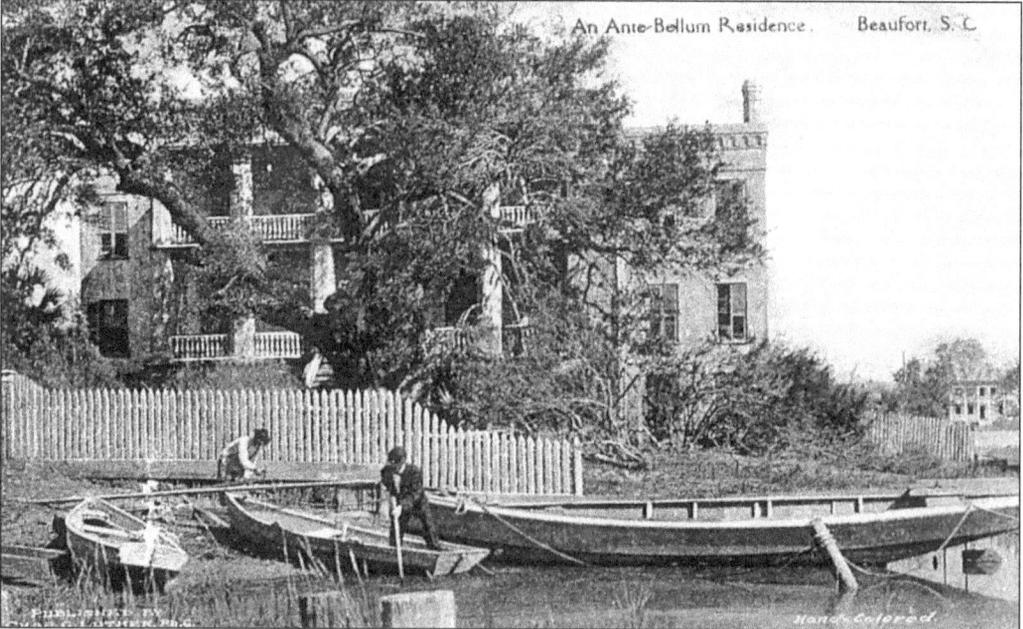

An Ante-Bellum Residence. Beaufort, S. C.

The Joseph Johnson House, "The Castle," c. 1850, has a view from the porches of the Beaufort River and marshes. This view is protected by the City of Beaufort. The house was a hospital during the Civil War with a morgue in an out-building. The Howard Danners, descendants of Dr. Johnson, lived here for most of the 20th century. Today it is the home of Mayor Bill Rauch and his wife, Sarah Sanford.

14

Thomas Talbird, born in 1855, graduated from Washington and Lee University and was an attorney, probate judge, and senator. He was a member of St. Peter's Catholic Church and married Josephine Jeanne Canton, who came to Beaufort from France as a governess. They had two girls: Thérèse (Sams) and Christine (Jenkins). Jeanne died in childbirth during the hurricane of 1893, with a tide cresting eight feet above normal. Warehouses of Sea Island cotton were destroyed. Phosphate mining was wiped out. Rice farming ended because the fields were flooded with salt water.

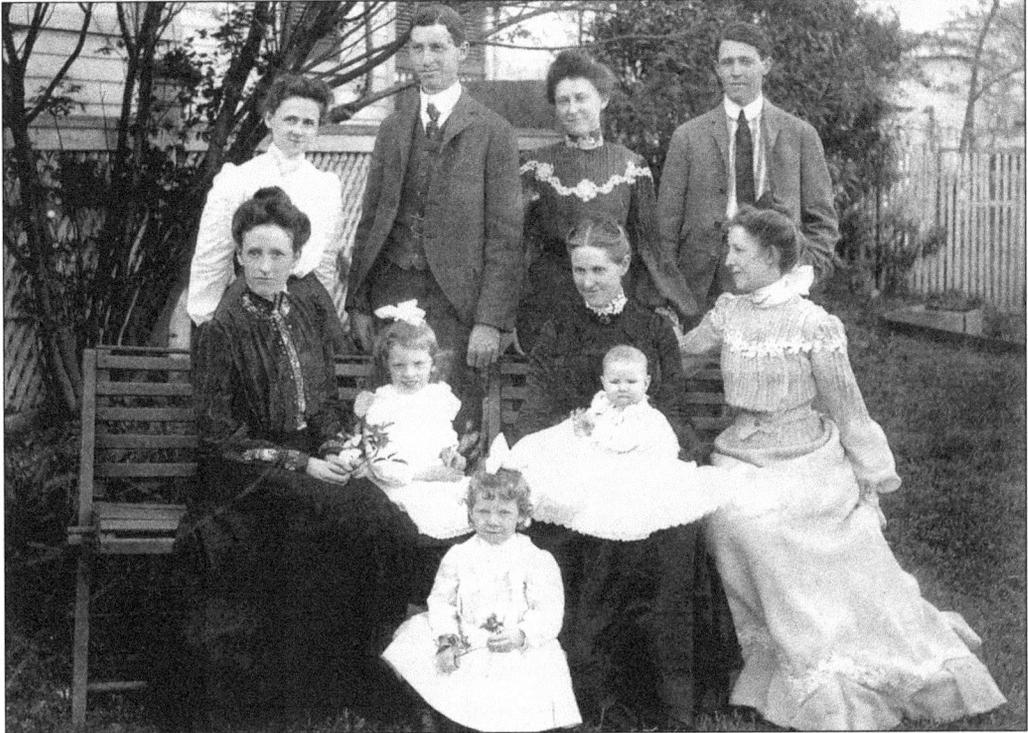

This Waterhouse family photo was taken in their backyard on Bay Street in 1899. Pictured from left to right are (front) Jean Waterhouse; (on laps) Isabelle Richmond Waterhouse, and Elizabeth Goethe Sanders (Rowland); (middle row) Adelaide Waterhouse (Sanders), Harriet Parmelee Waterhouse, and Mary Elizabeth Waterhouse; (back row) Isabelle Richmond Waterhouse, William Parmelee Waterhouse, Jane Waterhouse (Bray), and George Waterhouse.

Olive Rentz (1829–1911) spent her childhood in Savannah living with the Andersons, who owned a drugstore on Henry and Anderson Streets. She married William Franklin Cummings from Scotland who had five brothers, four of whom were flag bearers in the Battle of Gettysburg. She was the grandmother of Christian Isaiah "Christy" Cummings, Ruby Cummings (Danner), and Lily May Cummings, all of whom grew up in Beaufort.

Thérèse Talbird (Sams) (left) and Jean Hay (Jordan) were picnicking on Buzzard Island in the early 1900s. Thérèse's husband, Toland, worked with the Peoples Bank and Jean's husband, Bill, was a haberdasher on Broughton Street in Savannah. Jean's dad, Dr. Hay, was the quarantine officer on Buzzard Island.

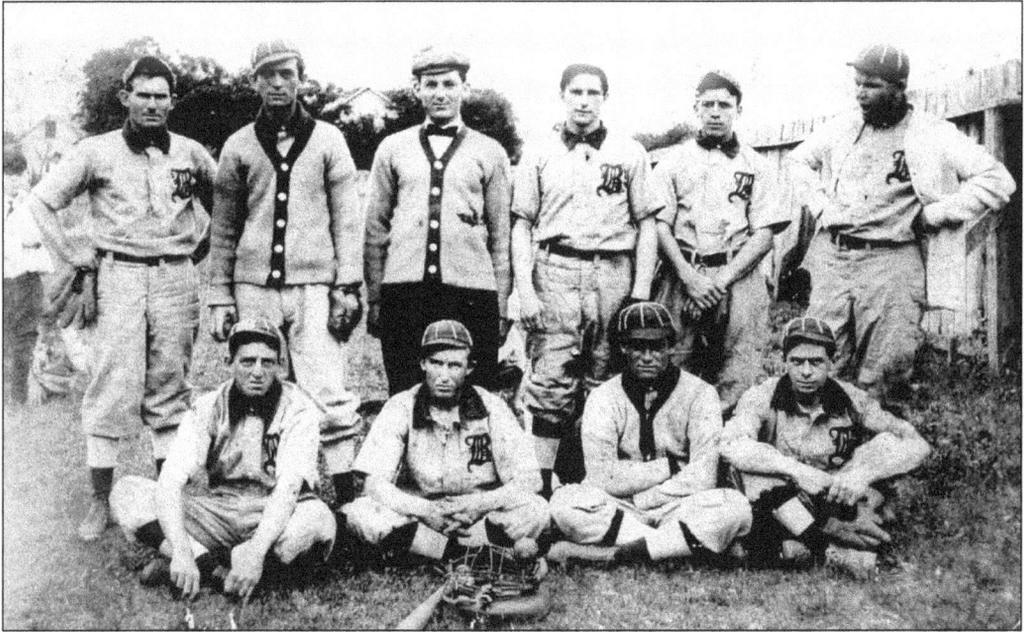

The faint handwriting on the back of this old photo identifies, in no particular order, players on the baseball team as Howard Burns, Burt Rodgers, Alex Levin, Robe (illegible), Burmiaster (illegible), Jim Odell, Hickory Hutchins, Lollie Bond, Eddie Bero, and Charles Luther.

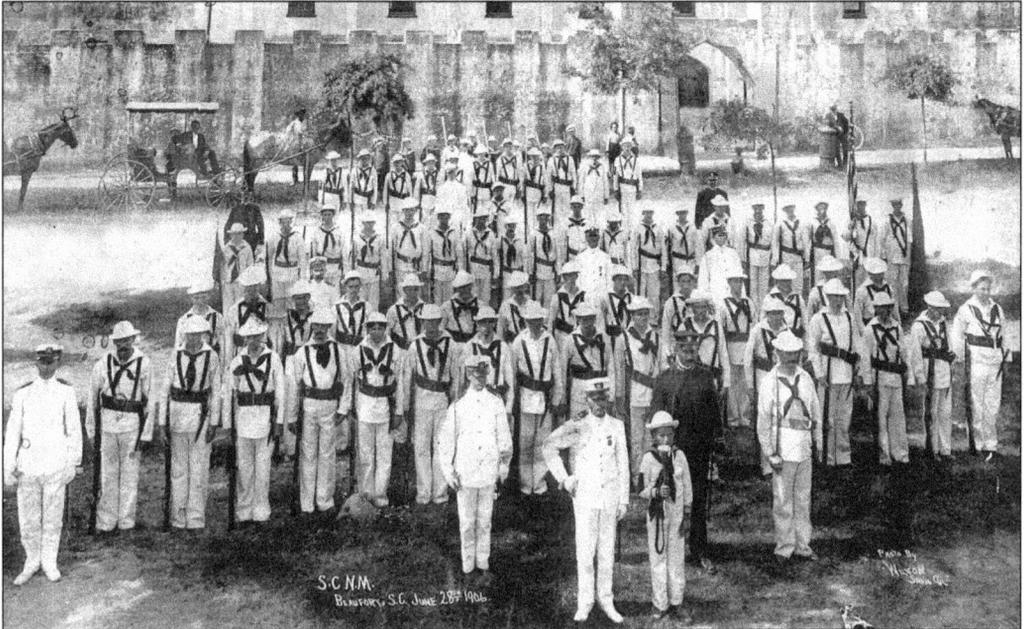

The Arsenal, a masonry building with lancet arch windows, is of Gothic Revival architecture. It was originally built on the site of the first courthouse, and rebuilt in 1852. In 1775, the Beaufort Volunteer Artillery was organized here as the fifth military unit in the United States. The image shows the Beaufort Volunteer Artillery, which served as naval militia in the Spanish American War. Today, the Arsenal houses Historic Beaufort Foundation and the Beaufort Museum. (Courtesy USMC Photo, Parris Island Museum.)

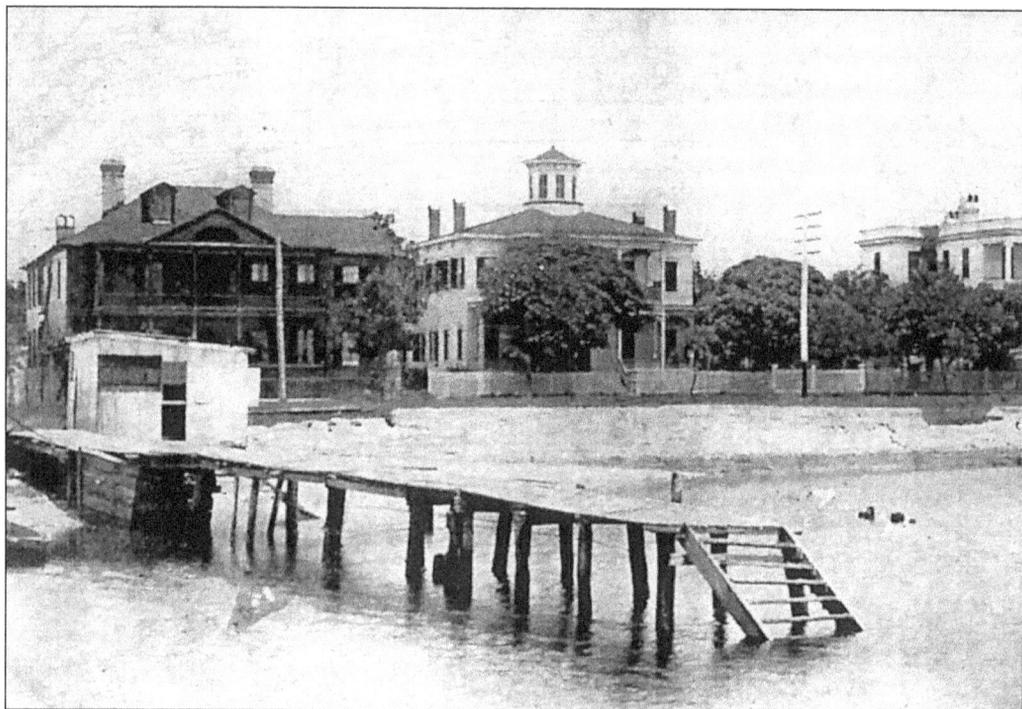

Ferries were the only way to reach Lady's Island or St. Helena, and this early 1900s image shows the landing at the end of Carteret Street. Capt. Willie Roberts ran the *White Hall Ferry*. According to the keen recollections of Mills Kinghorn, Captain Roberts owned two 30-foot boats. Each towed a barge capable of carrying three autos or horses and wagons. The new bridge built in 1927 ended the need for a ferry. Captain Roberts lived in the house later converted to the Beaufort Yacht Club. In the distance, from left to right, are the Bellamy House, the James Thomas House, and the George Waterhouse House.

The Beaufort National Cemetery was established in 1863 by President Lincoln as the final resting place for soldiers who died in the Civil War. Along with thousands of Union soldiers, a small number of Confederate soldiers are interred here. Neils Christensen Sr., superintendent of the cemetery, landscaped it and laid out the roads. He was married to Alma Holmes of Beaufort. Neils Christensen Jr. later became a senator who served Beaufort County in the General Assembly from 1906 to 1926. Here, the United Daughters of the Confederacy remember their lost loved ones. (Courtesy USMC Photo, Parris Island Museum.)

18

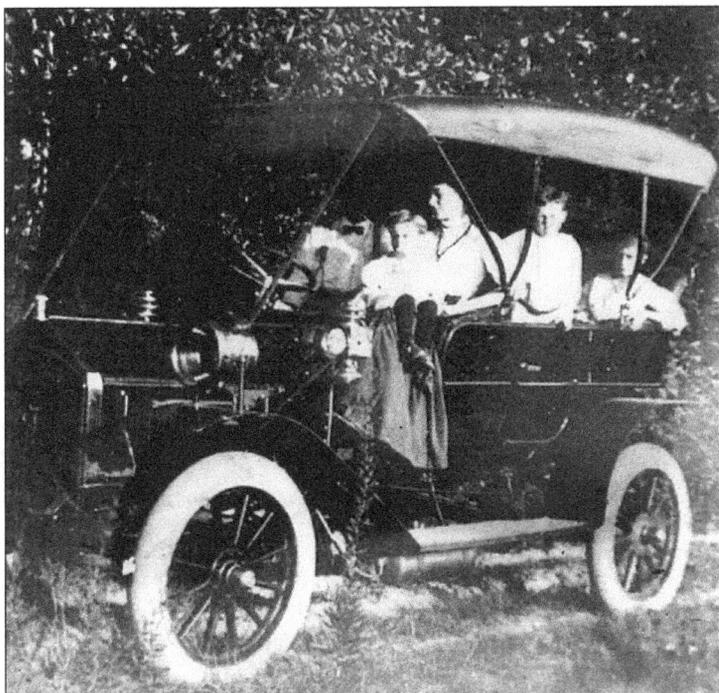

Family legend has it that C.E. McLeod Sr., in his 1910 Model 10 Buick with brass radiator, made the first motorized road trip from Beaufort to Savannah in 1908. Wearing a bow tie, Mr. McLeod is behind the wheel. His wife, Hope Chandler McLeod, holds her daughter, Marjorie McLeod (Fordham). The two sons are Claude (standing) and Hardee.

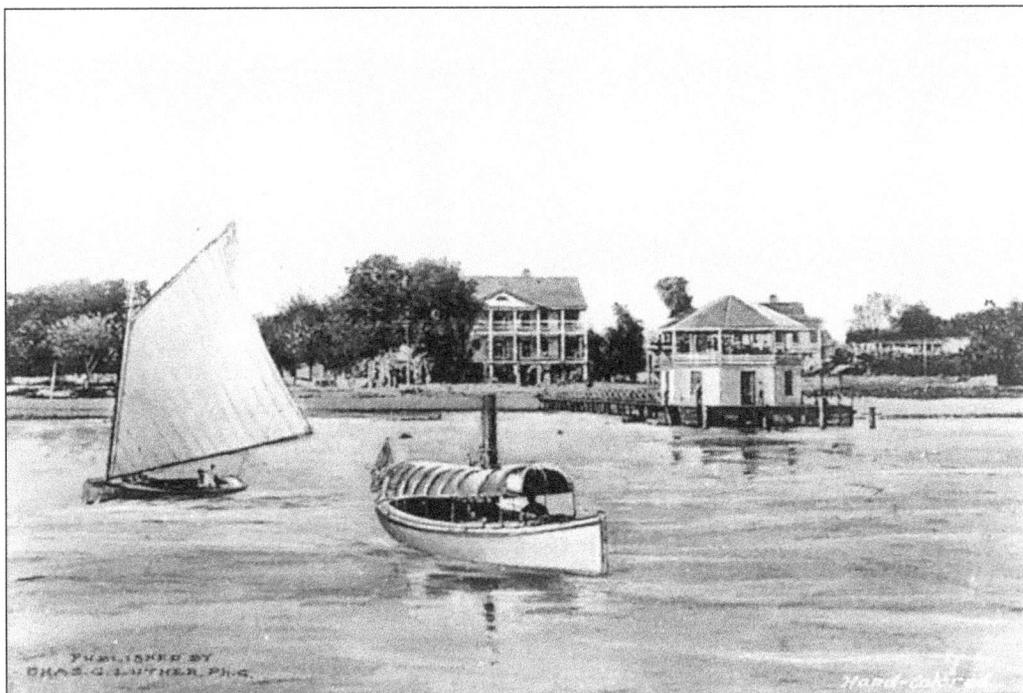

The Sea Island Hotel on Bay Street was the hub of social life from early 1900s to 1924. Mrs. Alice O'Dell became proprietor. Her daughter, Maude, left for acting school in New York and became famous as Sister Bessie in *Tobacco Road*. The bathhouse, designed by Paul Brody, was the hang-out during the hot summers. Pictured are boats for guests—a gaff-rigged sailboat and a launch—with the bathhouse and hotel in the distance.

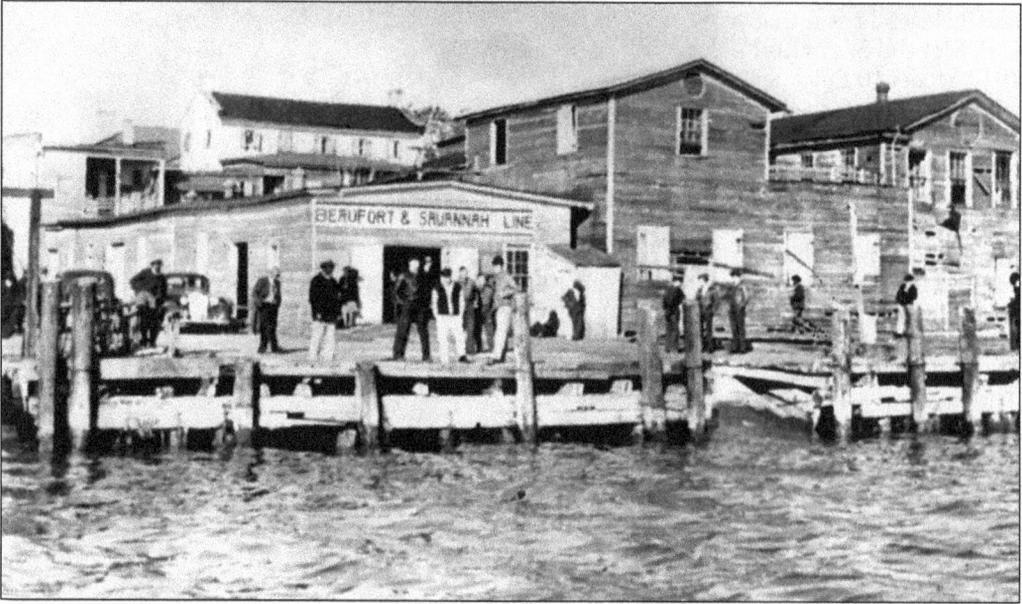

The Beaufort and Savannah Line docks bustled with passengers waiting for the steamboats. The pilings upon which the docks were built were covered with barnacles below the waterline, making ideal fishing conditions. While waiting, passengers often "bottom fished" with handlines baited with fiddler crabs and took home sheepshead and red or black drumfish for supper.

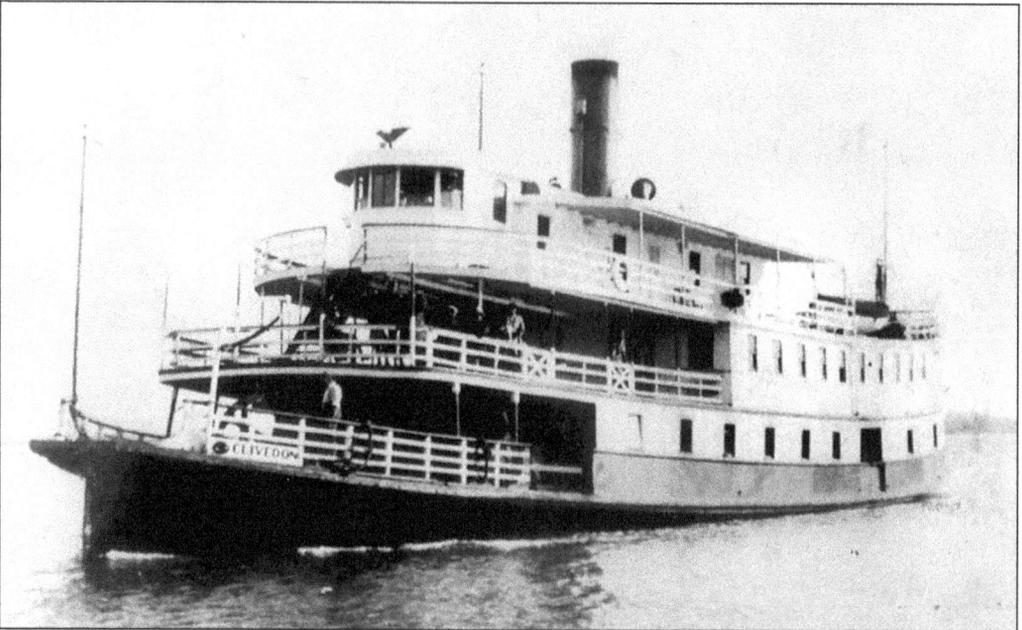

The *Clivedon* and the *Merchant* were steamboats of the Beaufort and Savannah line. Three round trips from Beaufort to Savannah were made each week, and on Sundays, the number of passengers was so large that both steamboats were used. The *Merchant* carried only white passengers and the *Clivedon* carried only black. By the end of World War II, both ships had been sold and departed the area.

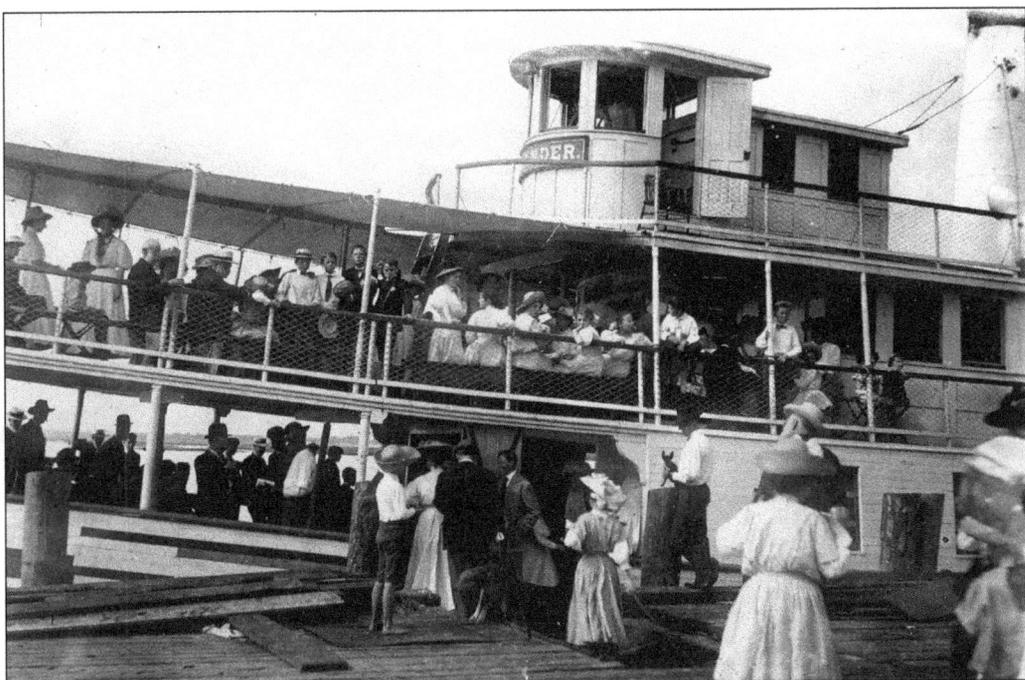

Longtime Beaufortonian Mills Kinghorn remembers the *Islander* as a river steamboat about 125 feet long with 2 decks. She ran from Charleston to Beaufort in the early 1920s and was used for special charter from Charleston to Savannah. The Baptists often engaged her for picnics to Bluffton. The *Hildegard* replaced her when the *Islander* left Beaufort.

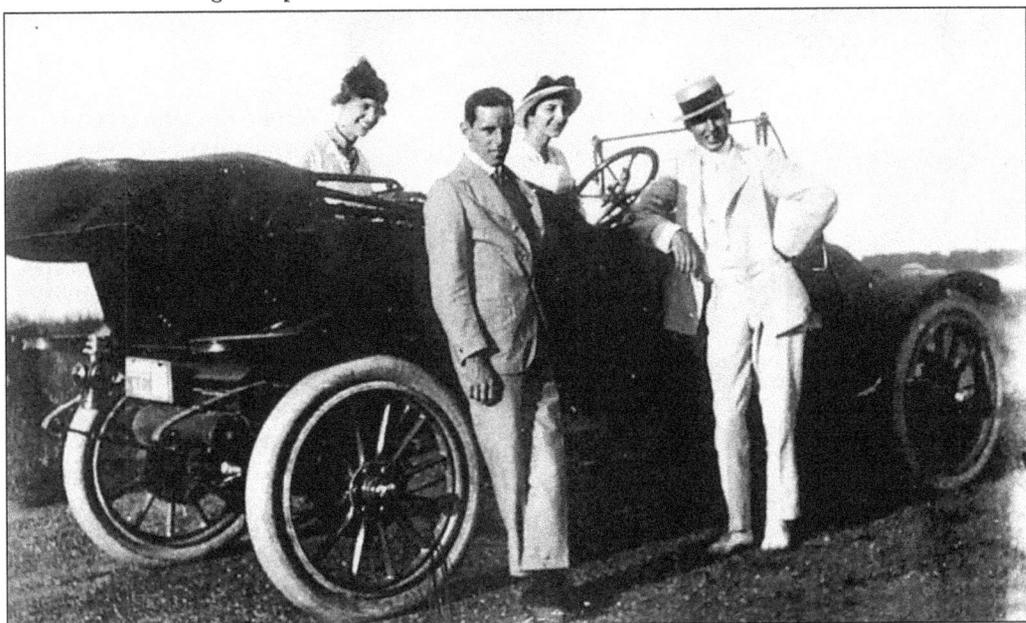

Properly attired in their linen suits and summer frocks, these two young couples went on a double date. Before going outdoors, girls always checked in the looking glass to make sure the petticoats were not showing. Pictured from left to right are Ruby Cummings and Howard Danner with Ruth Claghorn Saffold and Ellis deTreville.

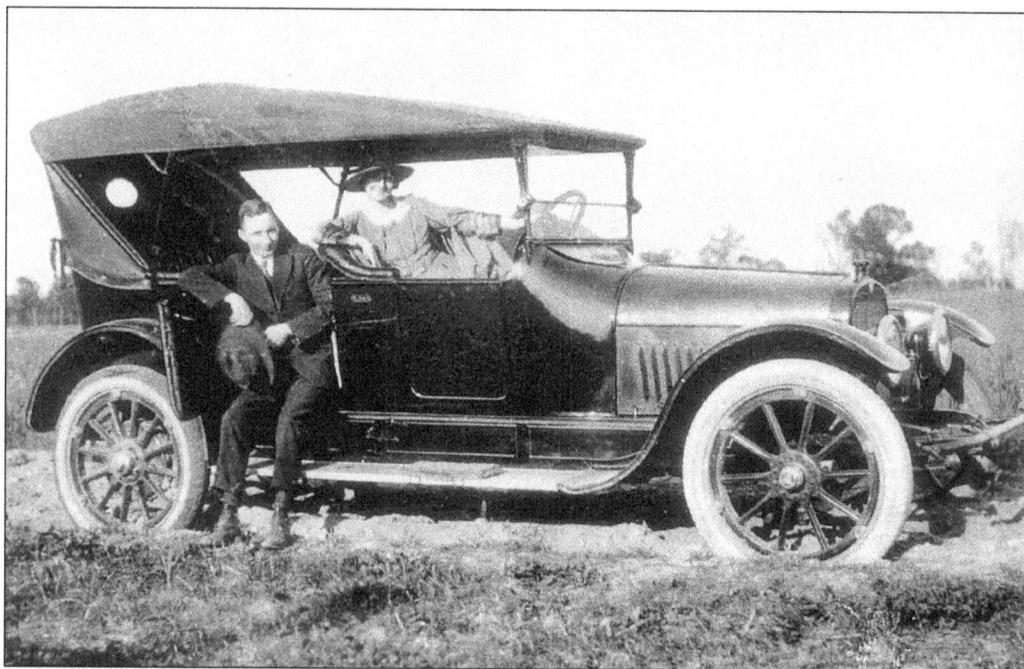

Resting in a field, Ruth Claghorn Saffold and Ellis deTreville, parents of Ruth (Spieler), had gone for a spin in his handsome Dodge touring car with a leather top. On pretty Sundays, Ellis delighted in taking his betrothed, Ruth, for a drive on Meridian Road. Back then, the road was hilly, making the ride more fun.

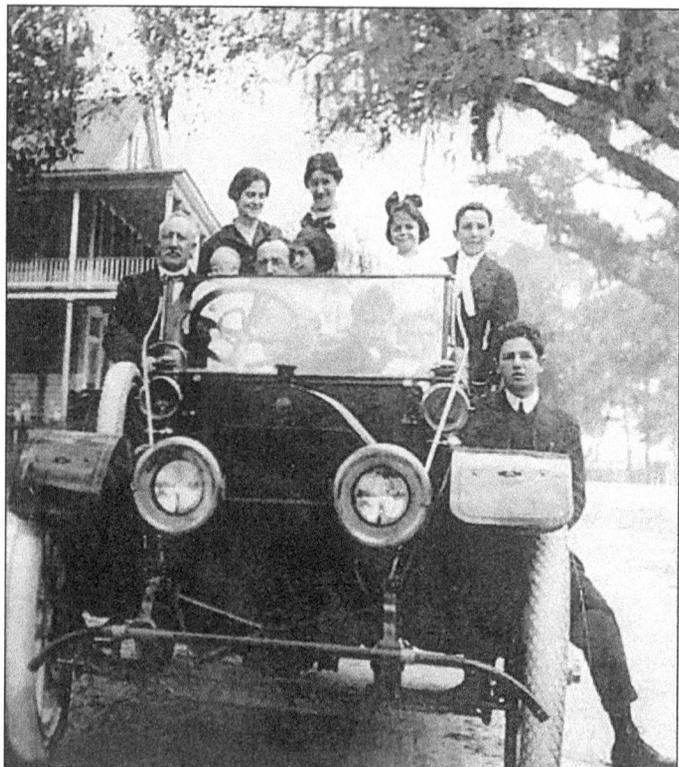

A jolly Keyserling family outing takes place in 1916. The car is probably a 1912 Chalmers. Pictured from left to right are (front row) Uncle Joe Keyserling, baby Herbert, William, Beth (Rosenfarb), Leon, and unidentified; (back row) Jeannie, Aunt Theresa, Rosalyn (Schreiber), and Leroy. Harold is on the running board. This was the era when songs such as "Pretty Baby," "Li'l Liza Jane," and "Yack Hula Hickey Dula" were popular and couples danced to "Oh, You Beautiful Doll," "Everybody's Doing It," and "Take Me Back to the Garden of Eden."

George and Elizabeth Waterhouse had three children: George Jr. (left), who graduated from Deerfield Academy and the University of North Carolina; Marguerite Lee (Herendeen) (Broz), who graduated from Hollins College and majored in sociology; and Mary Elinor (Hoyler), who graduated in music from Hollins. Mr. Waterhouse bought cotton from St. Helena Island and ginned it in his warehouse on the Beaufort River. Mrs. Waterhouse studied music at the New England Conservatory in Boston and for 25 years was organist and choir director at St. Helena's Church and a leading spirit in the Clover Club, a music and literary organization founded in 1891 by Mary E. Waterhouse, her sister-in-law.

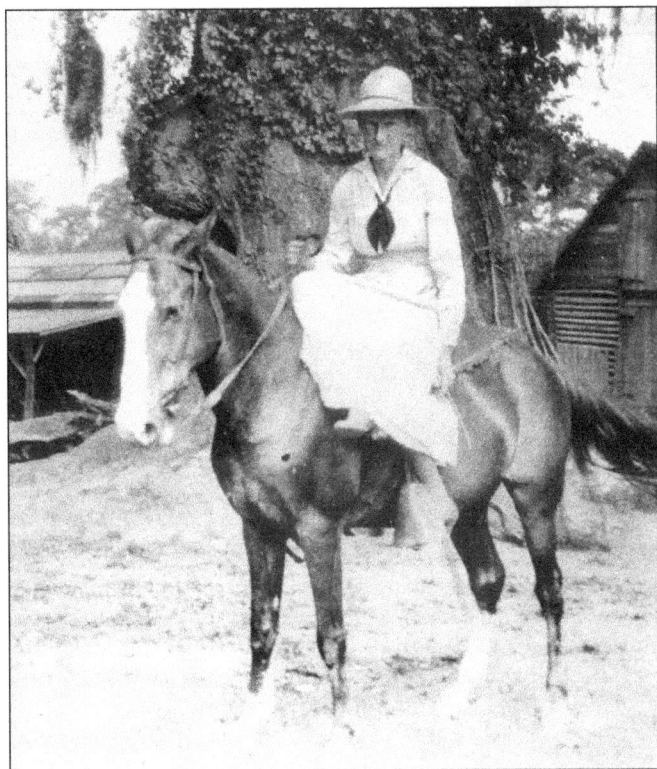

In 1918, Nellie Hazell Fripp rides sidesaddle on her Marsh Tacky "Dolly" at Old Oak Plantation in Burton, South Carolina. These small, rugged horses were brought here by the Spaniards in the 16th century. Until about 1968, they were raced on Hilton Head Island. Some still roam in the area on Horse Island. Mrs. Fripp belonged to the Beaufort Female Benevolent Society, Beaufort Historical Society, Stephen Elliott chapter of United Daughters of the Confederacy, and St. Helena's Church. She also was curator of the Beaufort Museum. (Courtesy of Lucille Culp.)

(*Above left*) In 1915, James Porcher Pinckney Jr., age 18, was courting Katherine Walpole, graduate of the Confederate Home in Charleston. Mr. William "King" Copp, owner of Spring Island is on the right. Katherine's first job was as a teacher on Spring Island. With gusto, young James often rowed his bateau across the Broad River to woo her. Because he uttered the bad words "aw shucks!" once within earshot of his father, the oars were locked up as punishment. (*Above right*) Love always finds a way, and as Katherine saw James pull up to the dock with two shovels in the oarlocks, she was evidently delighted and smitten by her resourceful suitor. James Pinckney (1897–1973) and Katherine Walpole (1896–1985) were married in 1918.

The *Amphitrite* was an iron-hulled, twin screw coastal defense monitor. Before the war with Spain, she patrolled the U.S. East Coast and Caribbean waters. During World War II, she guarded New York Harbor. Decommissioned in 1919 and sold to A.L.D. Bucksten of North Carolina, she was stripped of turrets and superstructure and towed to Beaufort to be used as a floating hotel. She was anchored in front of "Old Fort," Fort Frederick, for about two years. This photo, showing from left to right Miss Smoak, Miss Dantzler, and Miss Gourdin, was taken in 1942 by Gaillard Pinckney.

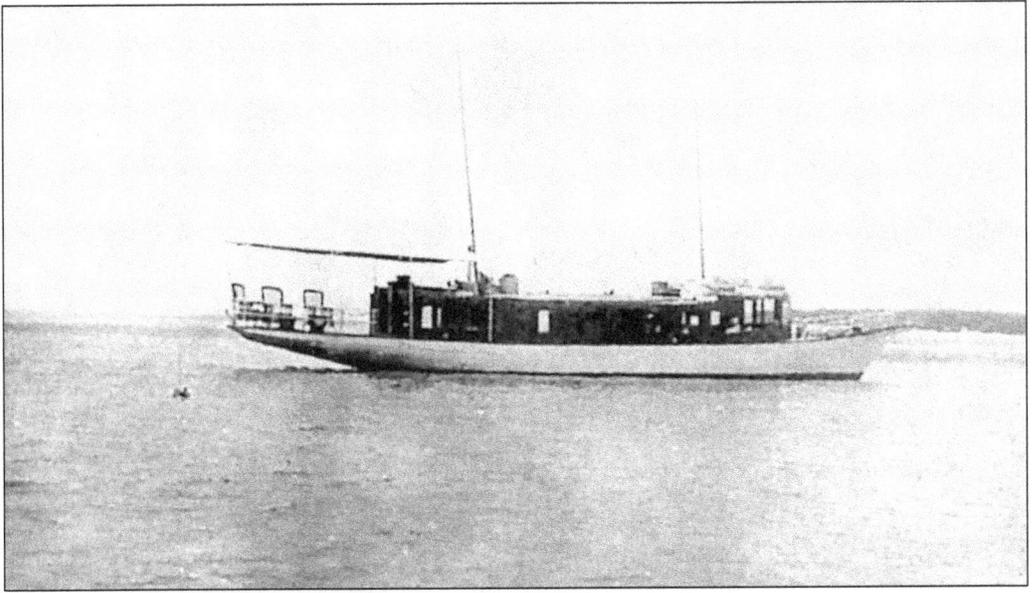

The *Zorayda*, approximately 50 feet long, was a recreational yacht owned by the McLeod family in the mid-1920s. It was frequently seen anchored in the Beaufort River and cruising around the islands with everyone having fun aboard.

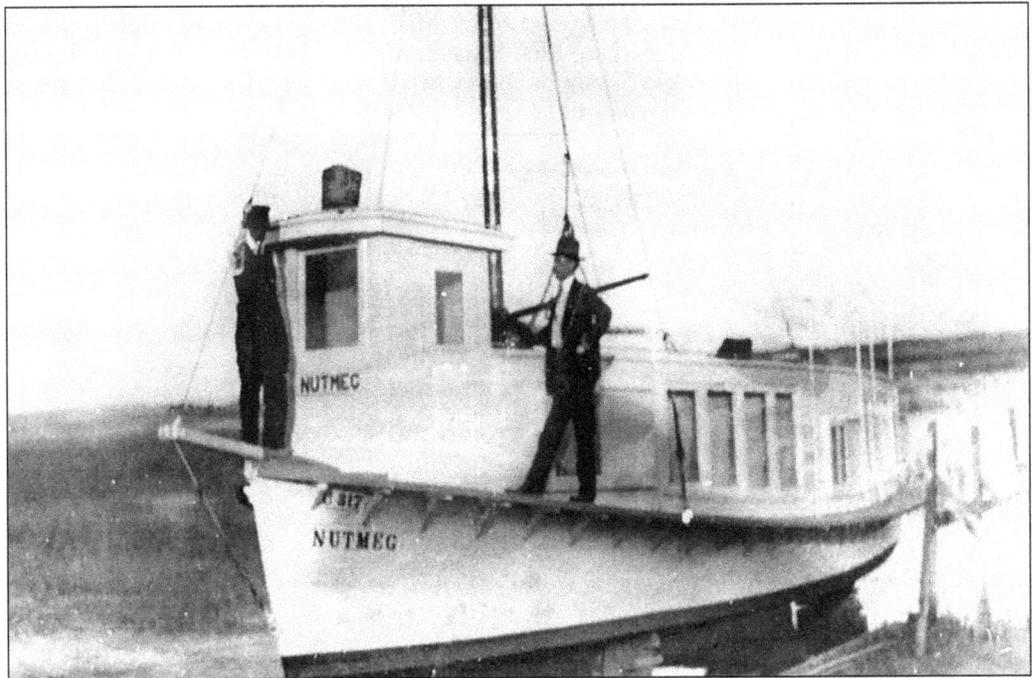

The *Nutmeg*, owned by Mr. F.W. Scheper, was broken up during the hurricane of 1940. In front of the pilot house stands "Mr. Willie," as he was known. His friend in the top-hat is not identified. The *Nutmeg* had a party deck at her stern. In the 1930s, Gilbert Parks, editor of *Liberty Magazine* and owner of Port Royal Hotel, started a nudist colony on Cat Island. Pleasure boats, listing to starboard or port with the weight of passengers all leaning over one side, often cruised slowly near the island in hopes of a glimpse of a bare derriere!

The Ladies Card Club takes a lawn break in 1920 at Mrs. Anderson's home. Faint names on the old photo, in no particular order, are Mrs. Schaub, Mrs. Daukmeyer, Mrs. Greisell, Mrs. Styrlauder, Mrs. Harzog, Mrs. Wicks, Mrs. Hammond, Mrs. Reiter, Mrs. Derr, Mrs. Heatherton, Mrs. Deck, Mrs. Bond, and Mrs. Anderson.

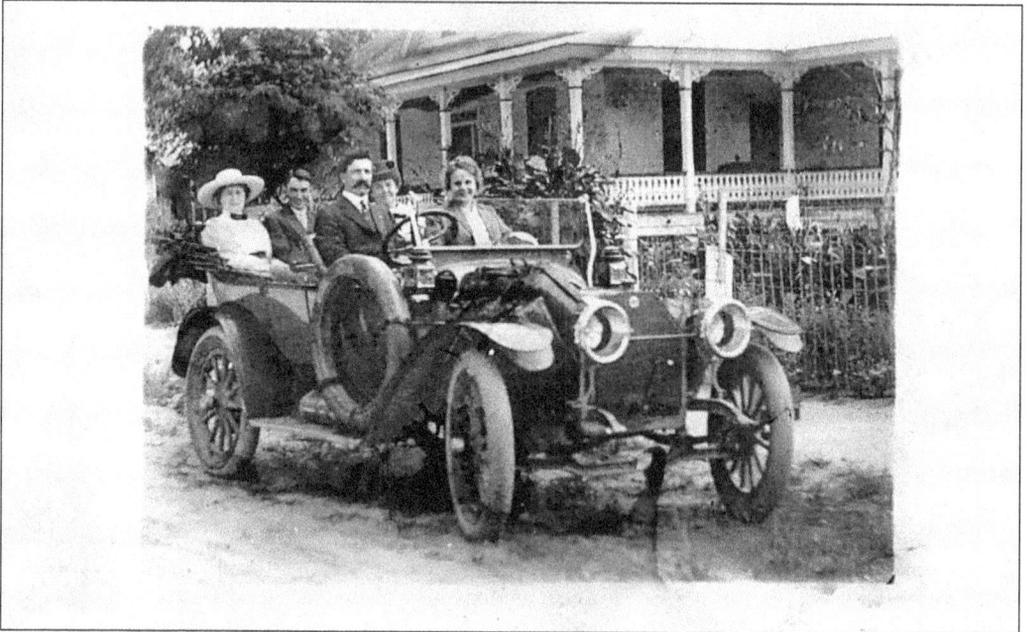

The Cummings family is off for a picnic in the country in their 1912 Overland with 30 horsepower. The top speed was 35 to 40 miles per hour depending on the wind and the number of big hats. A car like this cost $1,200 to $1,300 new.

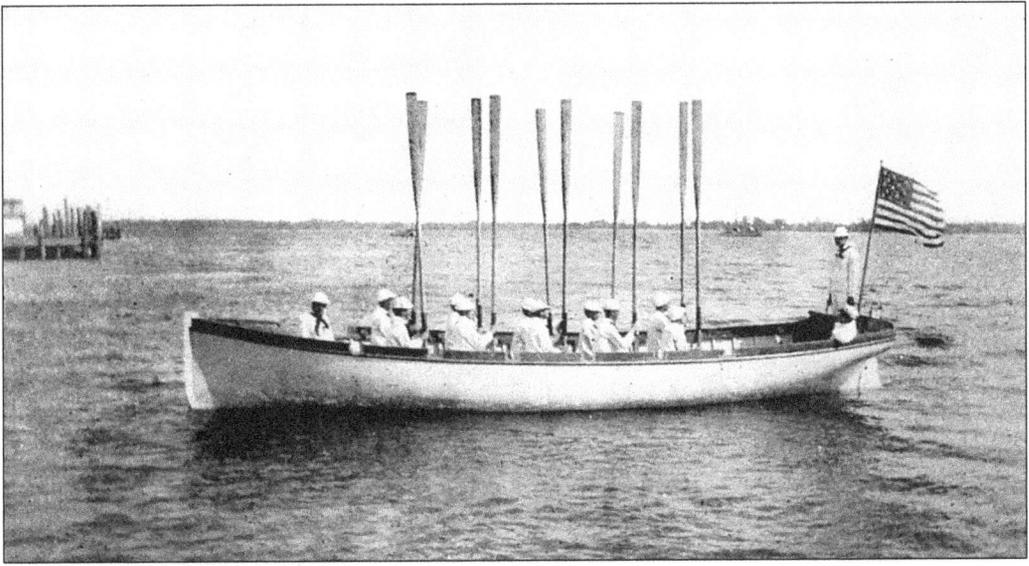

"Shoring the oars" in a naval salute, these sailors practice maneuvers in the Beaufort River in the early 1900s. (Courtesy USMC Photo, Parris Island Museum.)

This group had a "super peachy keen" time in the 1920s. On the front row, from left to right, are Dr. Sol McLendon, Verna Walsh, Julie Luther, and Peggy Mitchell. On the back row, from left to right, are Charles "Doc" Luther, Cliff Baxter, Hedda Morrall, Leamond Hall, and Johnnie Morrall.

Proud Papa Esau Levy holds bashful baby Beth (Kennedy) in front of their 1922 Model T Ford "Tin Lizzie." Mr. Levy managed a cotton gin on the Macdonald-Wilkins wharf until he owned a plumbing company. He was married to Bertha "Birdye" Lipsitz and they had one more child, Merrill, who lives today with his wife, Bobbie, on the Isle of Hope in Savannah. From left to right are Frances (Siegel), Rehette (Stein), Beth (Kennedy), Esau Levy, Bertram "Bookum" Levy, and Mimi (Greenfield).

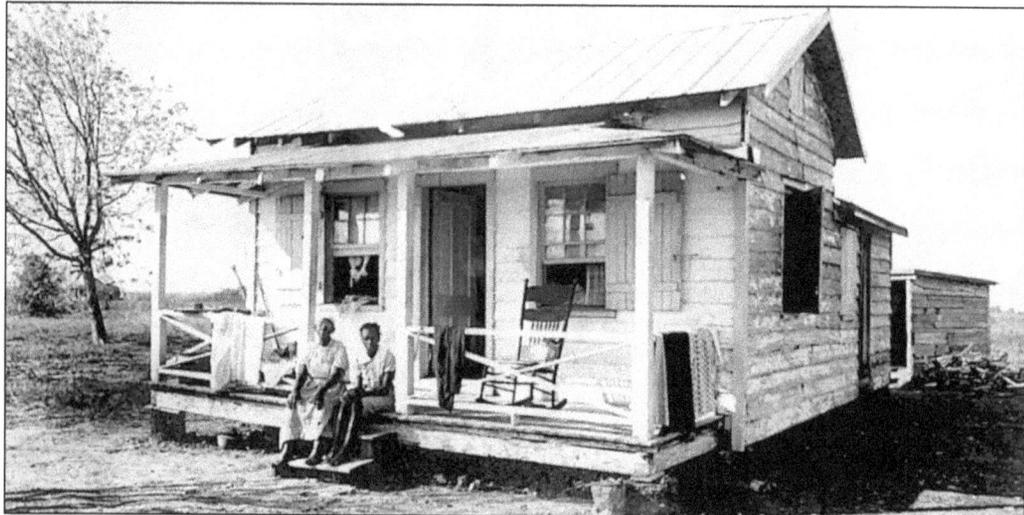

With gumbo simmering on the wood stove, cornbread baking, rugs beaten and airing, it's time-out for a "chaw" of tobacco on the stoop. This old cottage on St. Helena has a tin roof, wooden shutters, and a privy. Rocking on the porch while watching chickens and their "beeplings" scratch in the dirt is a tranquil way of life, which, without a doubt, contributed to many living ten decades.

28

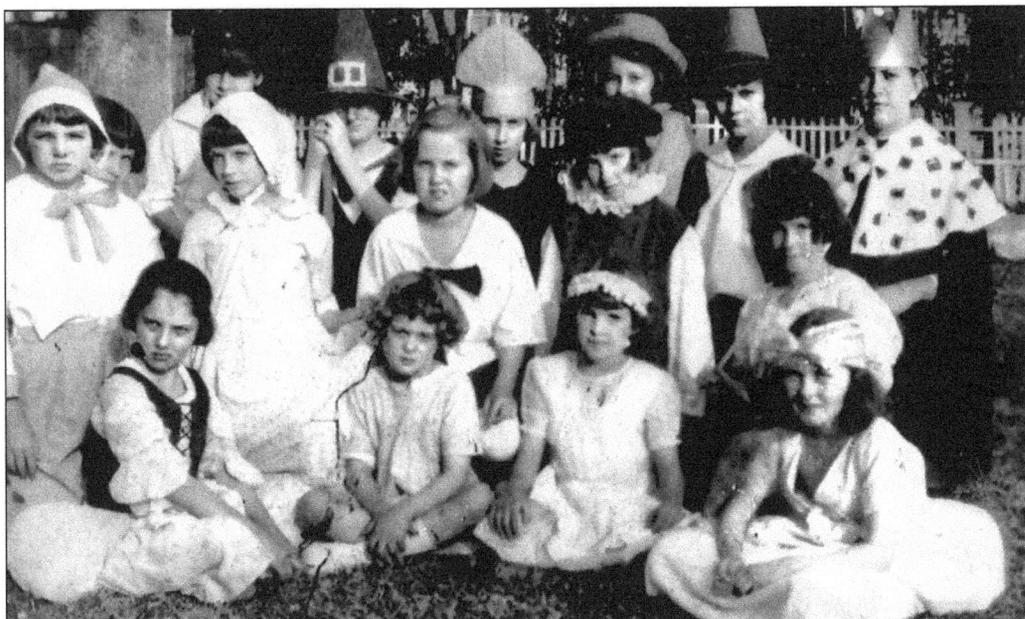

Pictured here is a dress-up party in 1920 at Mrs. Bolger's Dance School at the Visitors' House owned by the Knights of Columbus. From left to right are (front row) Lena Getz, Peggy Pollitzer, Jane Tucker, and Mary Bailey; (middle row) Martha "Marfee" Outlaw, Marjorie "Mac" McLeod, Rosalyn Keyserling, Catherine O'Brien, Ramelle Smith, and Elise Ohlandt; (back row) Helen Frances Raney, Margaret Sams, Lena Schein, Louise Sparks, Julia Stevenson, and Marguerite O'Brien.

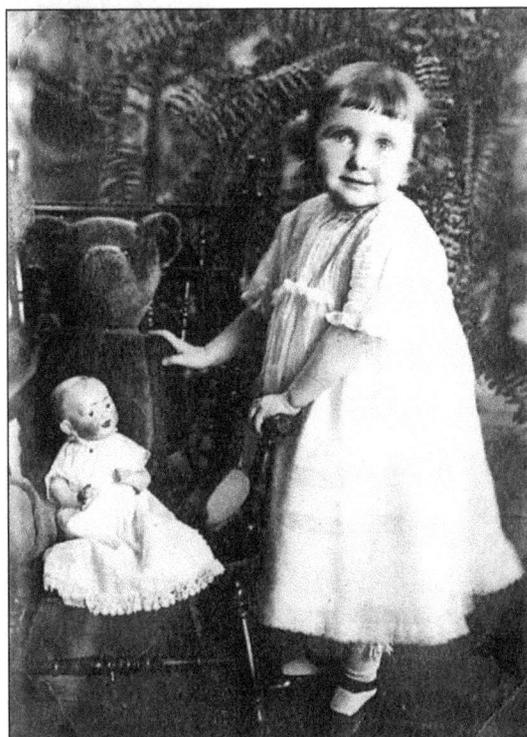

In 1922, four-year-old Mary Bailey (Jenkins) plays with her dolly "Jimma" and "Teddy Bay" on the porch of 906 Carteret Street where Kinghorn Insurance Co. is today. The lacy dresses were sewn by Mrs. Eva Rowell, whose grandfather was a signer of the Articles of Secession. Mary is the daughter of Mary Ferguson and Edward Wesley Bailey. The popular mantra of that year was "Every day in every way, I'm getting better and better."

How could any lassie refuse a proposal from this lanky, handsome Casanova on a romantic beach? This young man is hoping for a "yes" and permission to speak with her parents for their blessing. Perhaps he didn't realize that this was the year, 1922, that the Episcopal bishops voted to eliminate "obey" from the marriage vows!

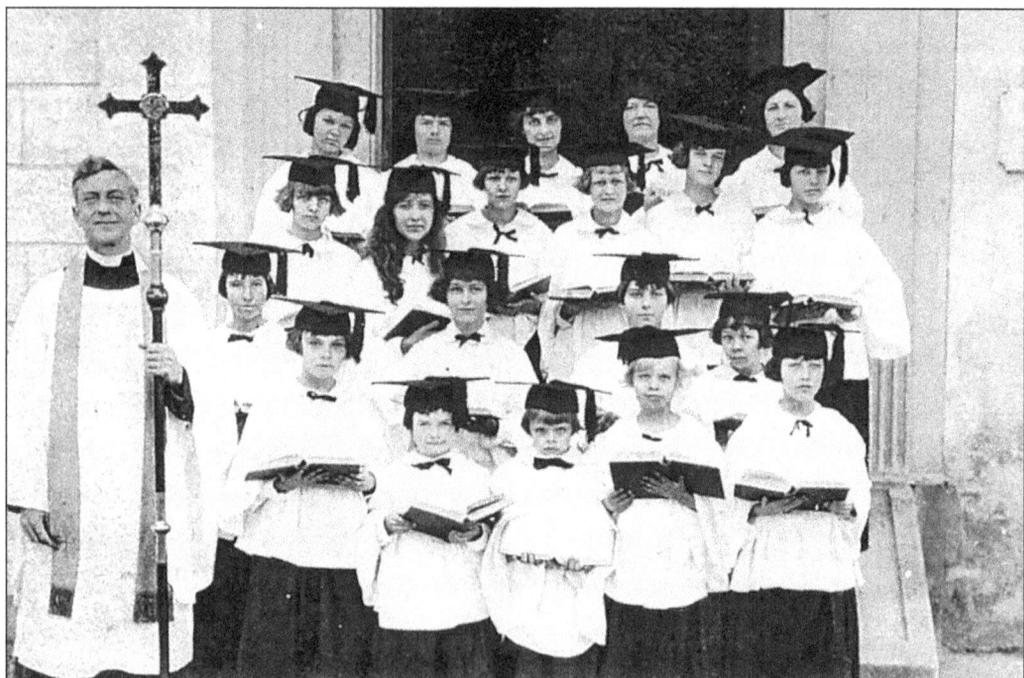

St. Helena's Junior Choir is vested for a service. Rev. R. Maynard Marshall is holding the Cross. On the top row, far right, is Mrs. Ruth deTreville, who organized the choir in 1920. Mrs. Marshall is next to her. Harriet Marshall is second from left, fourth row back. Roger Pinckney (absent) was crucifer. Mrs. deTreville was a fine musician and author. She wrote *Cornelius of Beaufort*, *Captain Claghorn of the Chatham Artillery*, and *Music With Color Harmony*.

30

Beth Levy (Kennedy) is shown in this photo on Bay Street with Schein's Department Store in the background. Her bonnet was stitched by her mother, Bertha "Birdye" Lipsitz Levy, who sewed all of her clothes. Beth was voted "best dressed" one year at Beaufort Elementary School. She and her childhood sweetheart, William Kennedy, eloped and they had a happy marriage of 58 years.

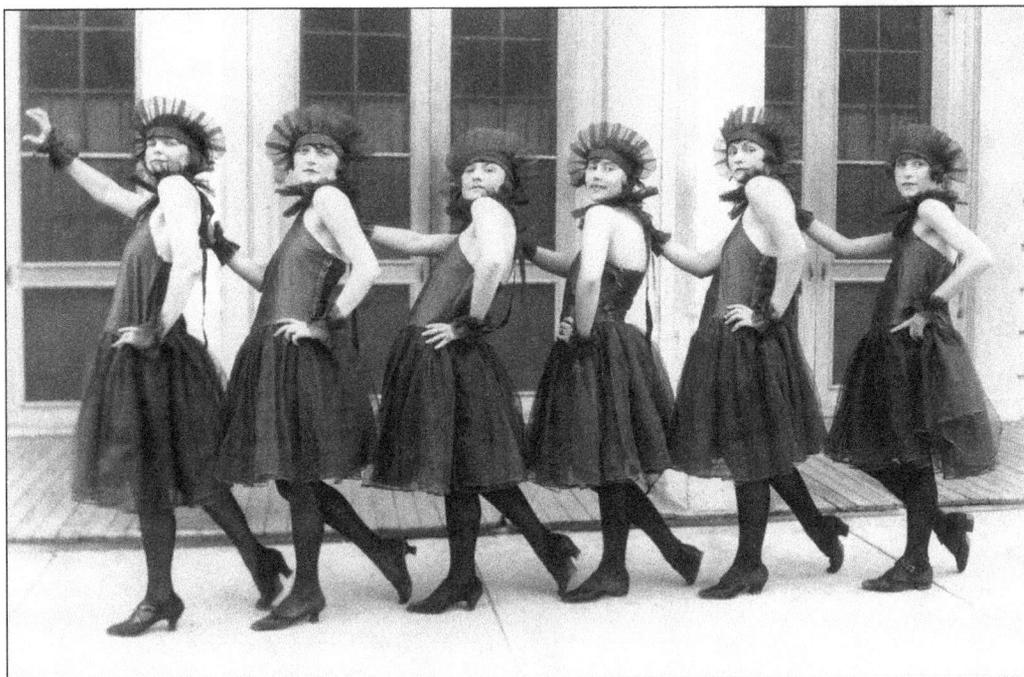

In 1926, these girls participated in their school assembly skit at Beaufort High School. From left to right are Florence Tucker, Mary Butler, Fanny Seay de Graffenreid, Angie Luther, Lucile Kershaw, and Florence Walpole.

Four generations of the Cummings family are pictured on the steps of the Barnwell-Gough House at 705 Washington Street. Ruby Cummings Danner is in the dark skirt with Howard Ellis Danner Jr.; from left to right on the back row are Lilly Leaphart Cummings, Ruby Ellis, "Dee" Danner Hryharrow, and Eliza Hays Leaphart.

Gus Raney invited some pals to his sixth birthday party at the Raney home at 1401 North Street in 1927. Pictured from left to right are (front row) Paul Schwartz, Mary Lengnick, Hardee McLeod, Gus Raney, Marie Scheper, Helen Frances Raney, Marjorie McLeod, Henry Scheper, Alfred Lengnick, and Jack Pollitzer;(back row) Lewis Lengnick, Hal Pollitzer, Marion Lengnick, Claude McLeod, Sidney Smith, Billy Steinmeyer, Virginia Pollitzer, and Lee Scheper.

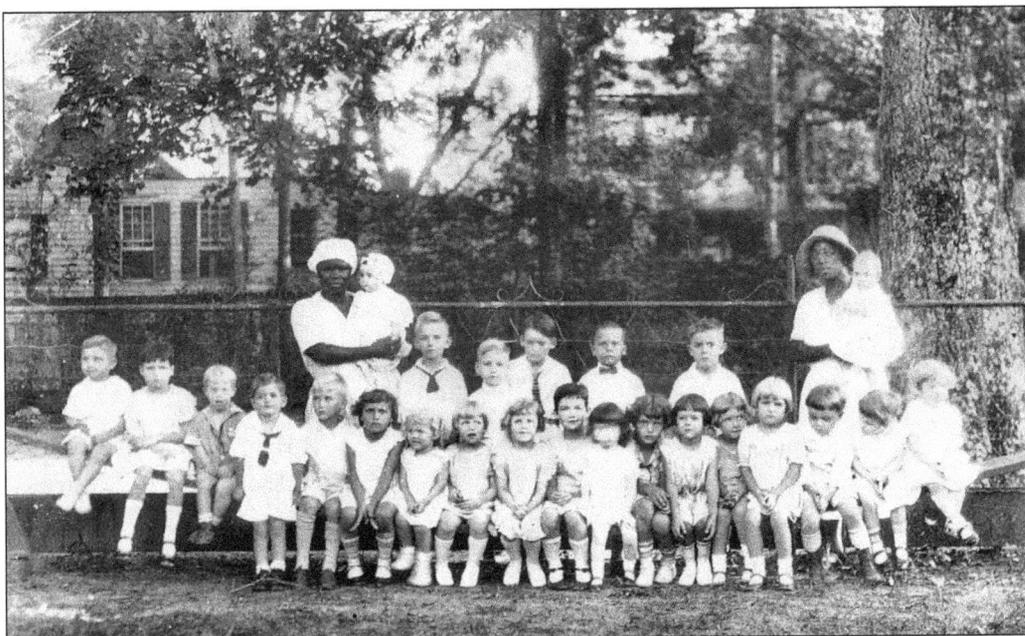

On their porches or lawns, many homes often had joggling boards—a long flexible plank between two supports on which nurses "joggled" babies or young romantics "joggled" while looking at the stars. Some "joggled" after supper to improve digestion. Here is a birthday party with children on the joggling board for a photo. Among the children on the front row are Harold Fripp, Edison Marshall Jr., Laurie Attaway, Inez Morrall, ? Parker, Reeve Sams, and Elizabeth Knott. Nurse Doris is holding baby Ruth deTreville, back row, left, and Nursie on the right is holding Nancy Marshall, daughter of Edison and Agnes Marshall. Between the nurses, from left to right, are unidentified, Ellis deTreville Jr., Clifford Baxter, ? Stokes, and Alfred Rhett.

Kate Gleason, philanthropist and benefactor from Rochester, New York, came to Beaufort in the 1920s. As owner and builder of the Gold Eagle Tavern, she added its most distinctive feature—a tower reminiscent of a Norman castle. Miss Gleason invented and patented a machine part that standardized the gears in all cars and gave the land for the Beaufort Memorial Hospital and the adjoining Kate Gleason Park. She also built Colony Gardens, an apartment complex on Lady's Island. Miss Gleason owned Dataw Island and gave it to her good friend, Mrs. Richard (Libby) Rowland. It has since been developed by Alcoa Corp. (Courtesy of Lucille Culp.)

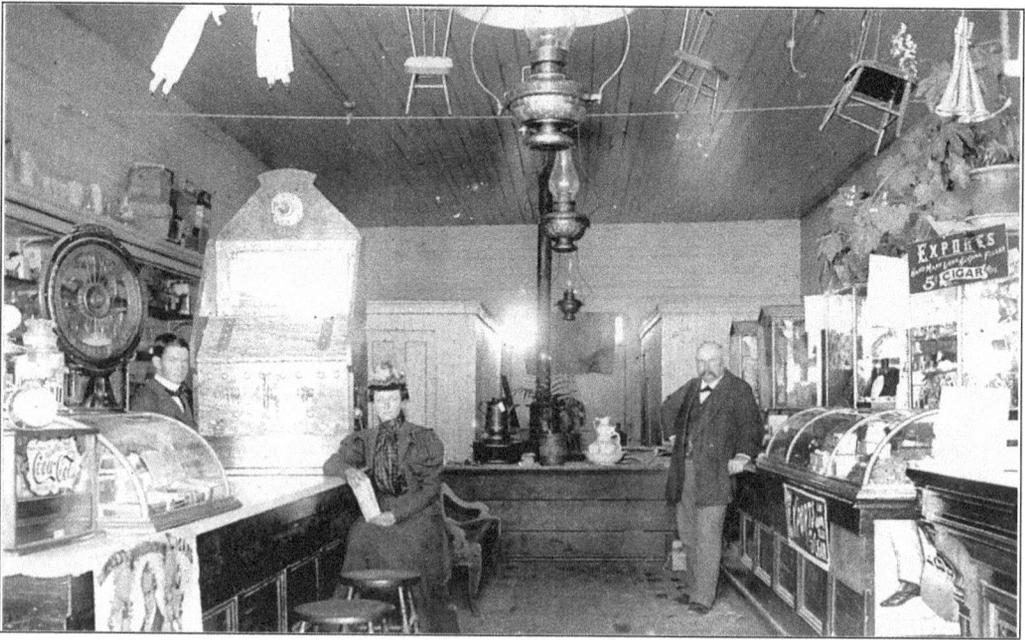

Mary and Edward Bailey are pictured inside their store, which closed in 1932. Behind the counter is Dr. Bailey's nephew. Bailey's store was on Bay Street and faced the alley leading to the Savannah and Beaufort Line docks. It sold school books, castor oil, shrimp nets, jaw breakers, licorice, cigars, charcoal tablets for "windy bowels," and Carter's Little Liver Pills. Note the stick-backed chairs for sale, hanging from the ceiling.

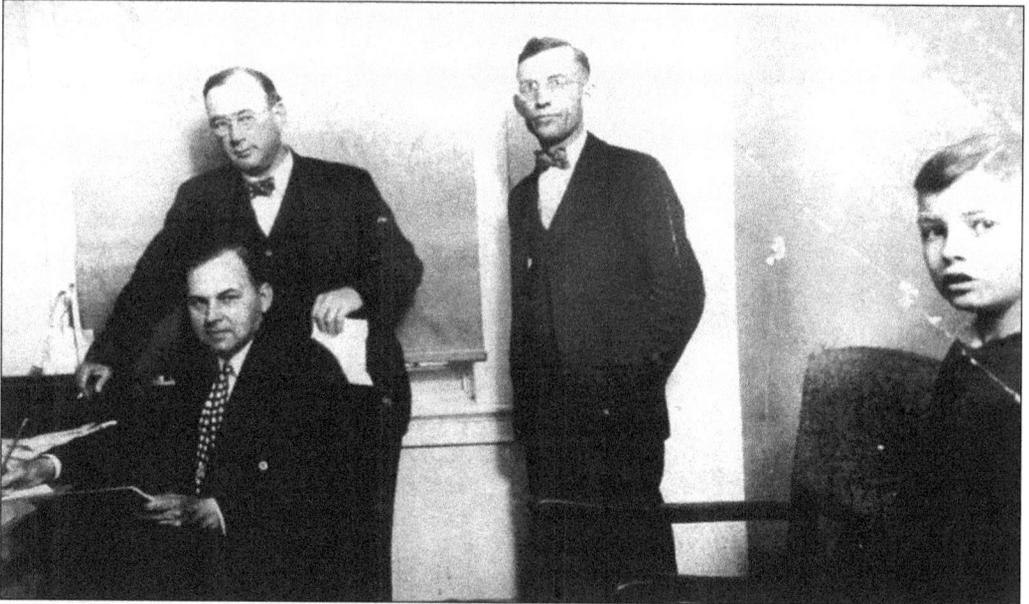

The Peoples Bank opened in 1903 on Carteret and Bay Streets. It was closed for two days during the Depression, and this photo was taken at the re-opening. With banks folding everywhere, it was good news when Kate Gleason, entrepreneur and engineer from Rochester, New York, living in Beaufort, made a hefty deposit making the bank solvent again. From left to right are F.W. Scheper Jr., Hal Pollitzer, Jasper Woods Sr., and Jack Woods Jr.

34

Two

THE BEST OF TIMES

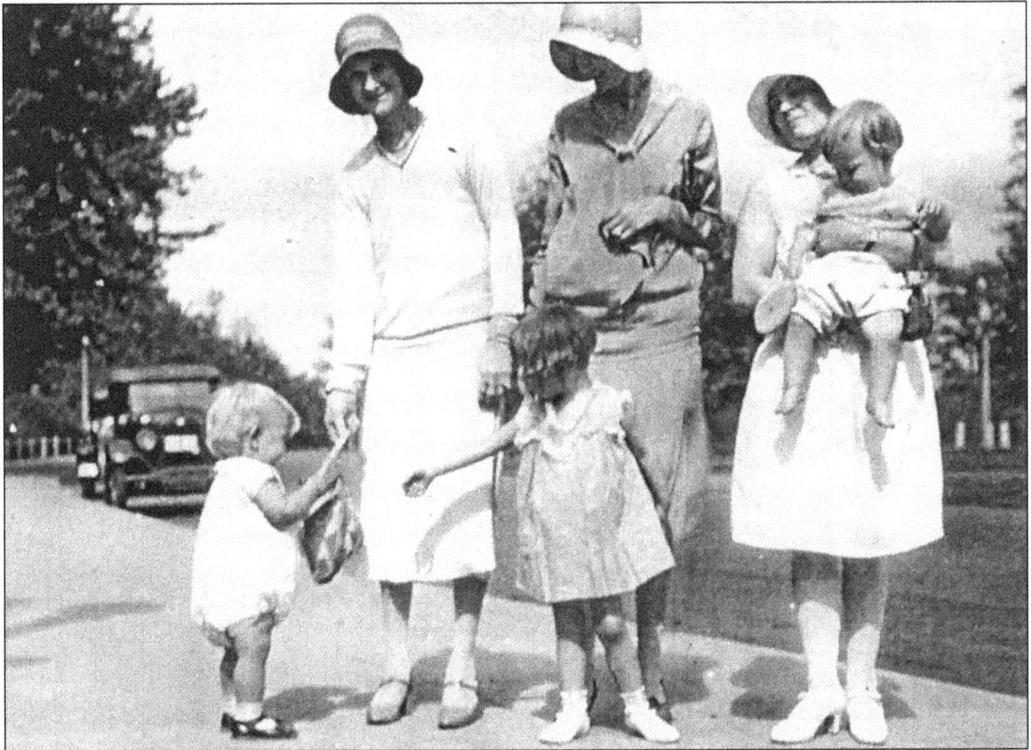

Wee Bobby (left) stands next to his mother, Janette Patterson Hartzog, and friends shopping in Savannah. Bob was later to have a 28-year career in the U.S. Air Force. Etiquette of the time dictated that white shoes nor trousers were to be worn after Labor Day. Nor should the color of the pocket handkerchief be the same as the necktie. Popular songs that year were "All Of Me," "Dancing In The Dark," "River Stay Away From My Door," and "When I Take My Sugar To Tea."

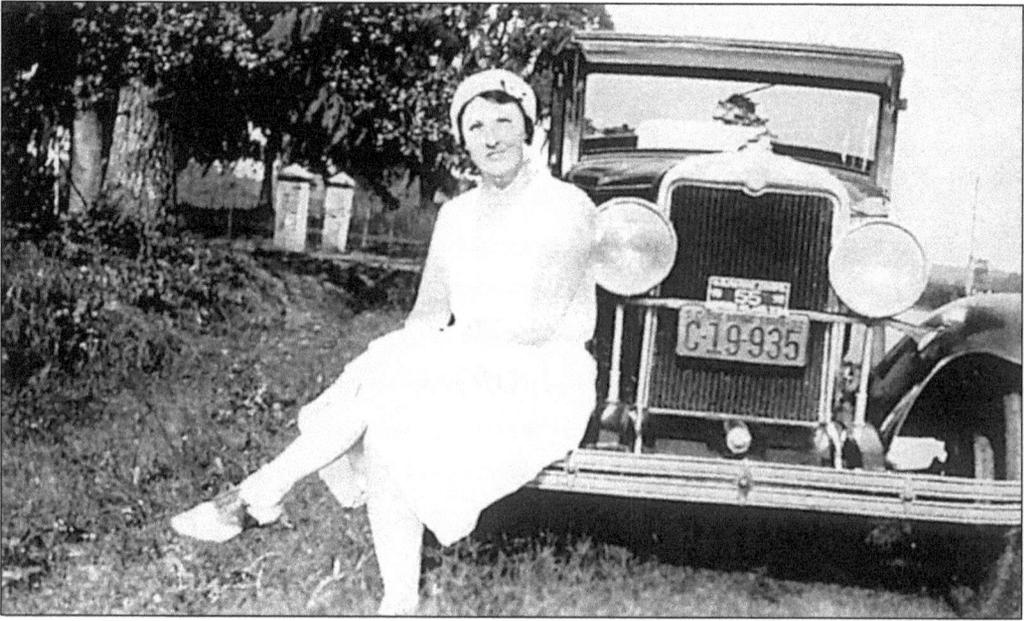

In 1932, Veltide Bell Greene was head nurse at Parris Island infirmary. She was married to George NewPort Greene, who died in 1918 in the Charleston flu epidemic. She is sitting on a 1925 or 1926 Chevrolet, which has a six-cylinder engine and a top speed of 60 miles per hour. At the time, a new car like this cost between $475 and $525.

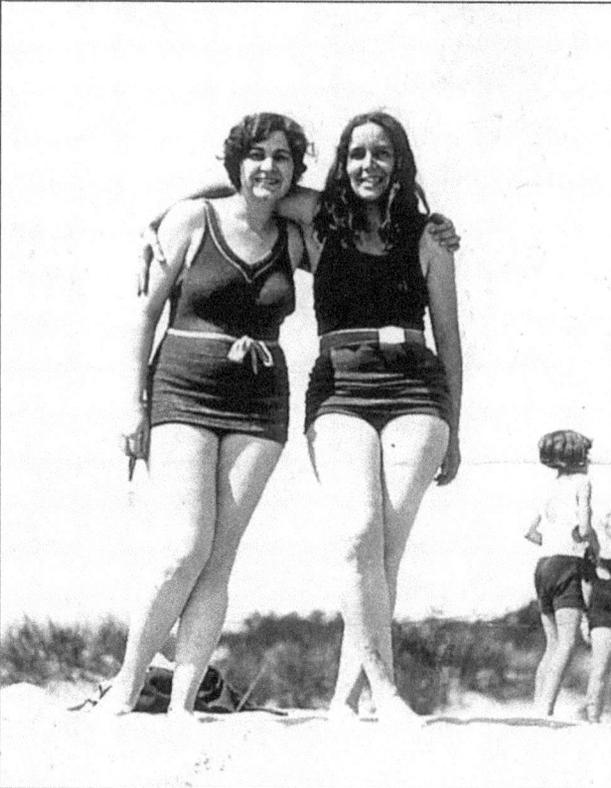

Mary von Kolnitz (Kellam) (left) and Helen von Kolnitz (Hyer), sisters from Charleston, removed their bathing caps for the camera. Mary and her daughter, Hope, were visiting from Baltimore. Helen was married to Edward Allen Hyer and the mother of Beaufortonian Jean Kearns. Helen was the second poet laureate of South Carolina, from 1974 to 1983, appointed by Governor West. Her most well-known book was *What the Wind Forgets, a Woman's Heart Remembers*.

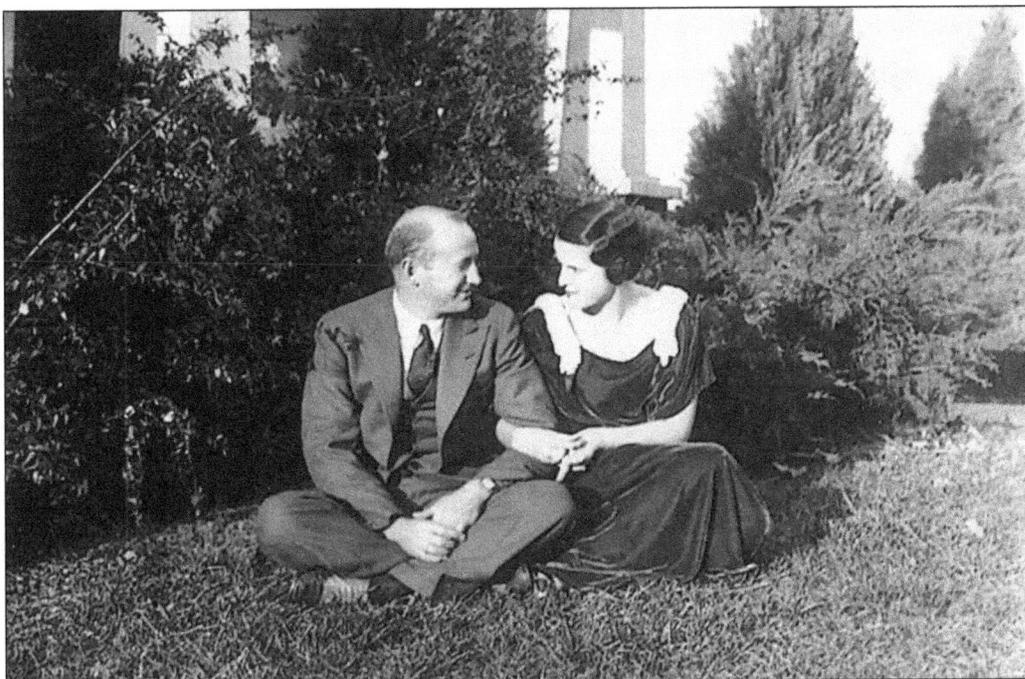

Coralee Kitchens and John Bull (pictured) had a double wedding with Angie Luther and Jack Sammons at St. Helena's Church in 1933. This had never happened here, so Rev. Maynard Marshall wrote Bishop Albert Sidney Thomas to learn how to perform the service without marrying the four of them to each other! This was the year of the shingle-bob hairdo and the popular songs "Did You Ever See A Dream Walking," "Easter Parade," "Inka Dinka Doo" and "Lazybones."

Tommy Martin, grandson of Eva Randall Rowell, dreams of winning sailing regattas when he is older. Here he sails a raft with a sail made from his granny's chicken feed croaker sack. He is the son of Chlotilde Rowell and Thomas Martin. Seeing this creation, armies of fiddler crabs scurried up the "pluff mud" to the safety of the spartina grass.

Jeanne Sams (Aimar) was a pupil at Beaufort Elementary School. In hopes that Miss Carson, her teacher, would send her home, little Jeanne drew fake chicken pox all over herself with a red pen. The trick rarely worked. Her great-great grandpa, Franklin Talbird, was a founder of St. Peter's Church and built the wall around it and the tabby seawall on Bay Street. Her best friends were Emma Frances Maddox (McGowan) (Mulligan), Betty Bostick (Haigh), and Esther Jenkins (Chiaviello).

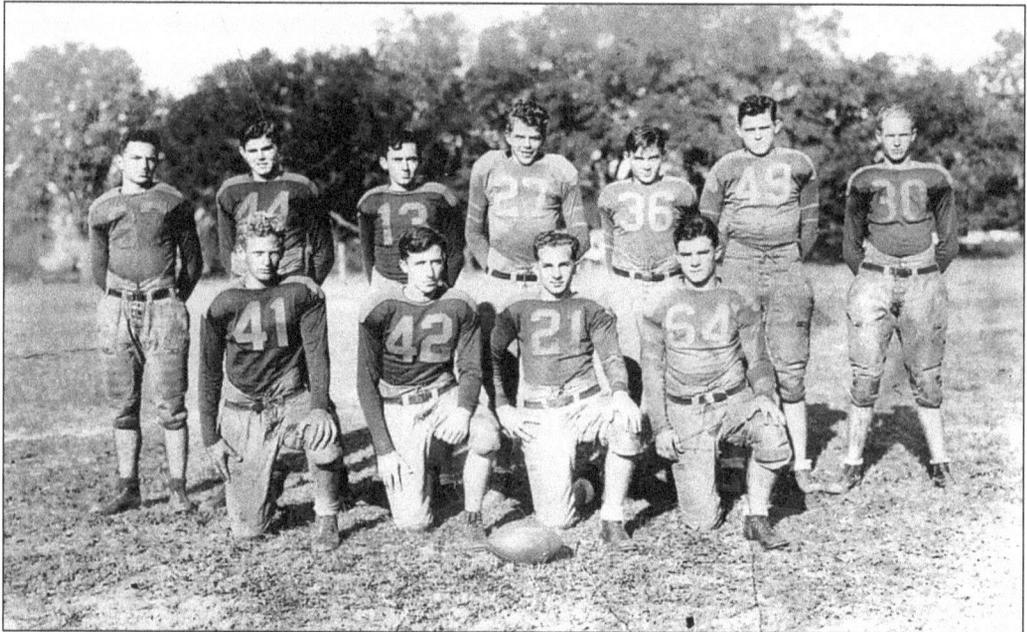

Members of the football team were regarded as heroes. Often their nickel for a "co-cola" in Luther's Pharmacy was waved away and the drink was on the house. In 1936, the Beaufort High School football team went to Great Falls, South Carolina and became state champs. Faint writing on the photo gives the following names in no particular order and omits one: Bert Levy, Tony Bishop, Andy Hinely, George Feltwell, J.M. Koth, Russell Bishop, George White, Connie Owens, Jim Collier, and Emerson Bazemore.

38

Paula Lengnick (Harrell), daughter of Georgie McTeer and Alfred Wood Lengnick, lived on Bay Street. The Sammons's house, now law offices of Jim Moss, is in the background. In those days, new mothers were told by their doctors to remain in bed two weeks after delivery. Friends bearing gifts filed in to admire and "coochie-coo" over the new bundle in the bassinet.

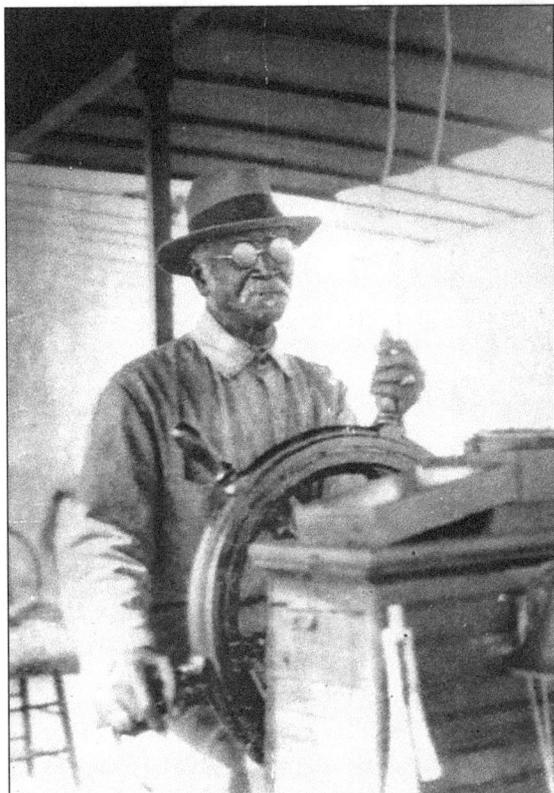

George Moody piloted the *Owanee*, a 60-foot houseboat owned by "Mr. Willie" Scheper. The *Owanee* sunk in the 1940s. After refloating her, the eight-cylinder gasoline Lathrop engine was replaced with a Caterpillar diesel. Often, Mr. Moody towed a string of sailboats to Savannah, Charleston, Rockville, and Wilmington, North Carolina for the regattas. The young sailors had fun jumping overboard and grabbing the stern of the last boat. Mr. Moody patiently cut the throttle and circled to retrieve the embarrassed swimmer who had slipped his grip. He never lost a swimmer.

This photo shows Willie Scheper III on his prize-winning bike with, from left to right, Henry Chambers, Toomer Aimar, Julian "Sweetroll" Schoenberg, Isabel Thomas (Davis), Bob Hartzog, and Isabel Glawson (Fulton). The house is the old Charlie Knott house at 401 King Street. Model boats, many built by Marion Jones, were sailed on the pond nearby, which was built by the WPA. Tub races with people sitting in galvanized washtubs, propelled with flailing arms, resulted in much "tumping over" and hilarity.

Pretty Mary Black (Vella) was valedictorian of her class at Beaufort High and May Queen at Columbia College. In the 1930s, her parents, Florine and Gordon Black, owned the 1907 Beaufort Inn, once a boarding house. She is in her plaid skirt and matching swing coat in front of the Sinclair Service Station. (Courtesy of Historic Beaufort Foundation.)

Four-year-old Toni Bell (McDaniel), daughter of Mary Bell (Jenkins) and H. P. Bell, was a runner-up in a beauty contest in 1939. She married Doug McDaniel, a retired colonel, and raised seven children. They live on Hermitage Road. Children amused themselves in those days in their backyards digging doodle bugs, conducting funerals for deceased insects, and scooping out holes in the dirt to make miniature reflecting lakes with broken glass bits.

This photo was taken after a traditional total immersion Black baptism in the Beaufort River off Bellamy Curve in 1939. For baptisms, candidates wore white while deacons and ministers dressed in black. It appears that the drenched little boy fell into the creek and is being escorted home for dry clothes. The dock in the distance belonged to Arthur Barnwell and was used by his caretakers, the DeCamps.

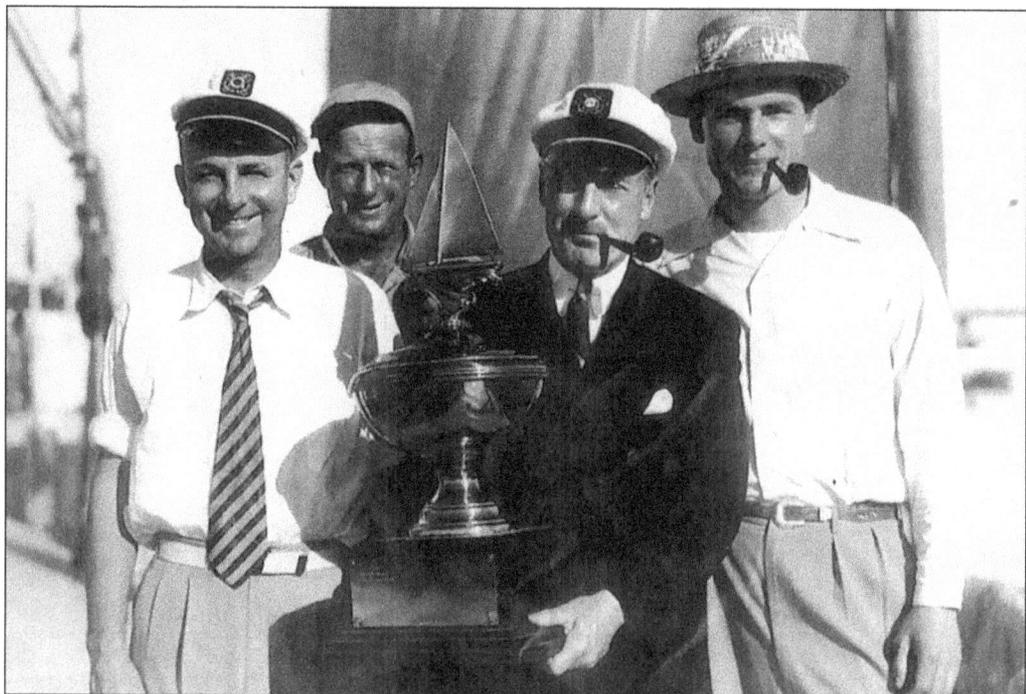

Raymond Demere (in the dark jacket) often towed a dozen or more Scow and Lark sailboats behind his power boat, the *Hoozier*, from Turner's Creek in Savannah to Beaufort for the races. Boat trailers did not exist then. Mr. Demere displays a trophy won by his crew aboard his large sailing yacht , *Ocean Queen*. From left to right are John Wylly, Millard Gale, Raymond Demere, and Bob Demere. F.W. "Mr. Willie" Scheper towed the Beaufort boats to Savannah for races.

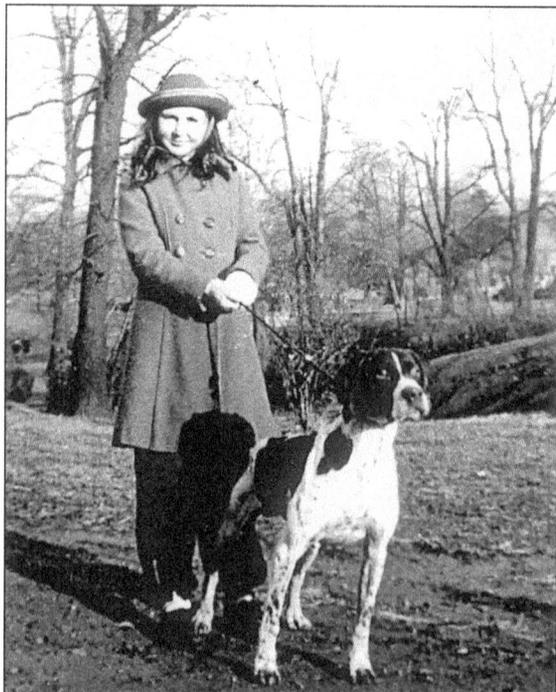

Ruth Saffold (deTreville) (Spieler) attended St. Agnes' Chapel School, a parish of Trinity Church in New York. W.W. Bellinger from Sheldon, South Carolina, was the vicar. Ruth is shown here with her pointer, "Gyp," going for a walk in Central Park. Today, she and her husband, Gerhard, live in the deTreville home on Greene and Carteret Streets in Beaufort.

Rehette Levy Stein and her brother Bertram "Bookum" Levy have a quick cuddle on the dock in the late 1930s. The Levy family home was on Craven and East Streets. Bookum worked with his father, Esau Levy, in the family plumbing business. Rehette married Luke Stein and moved to Savannah and lived on the Isle of Hope.

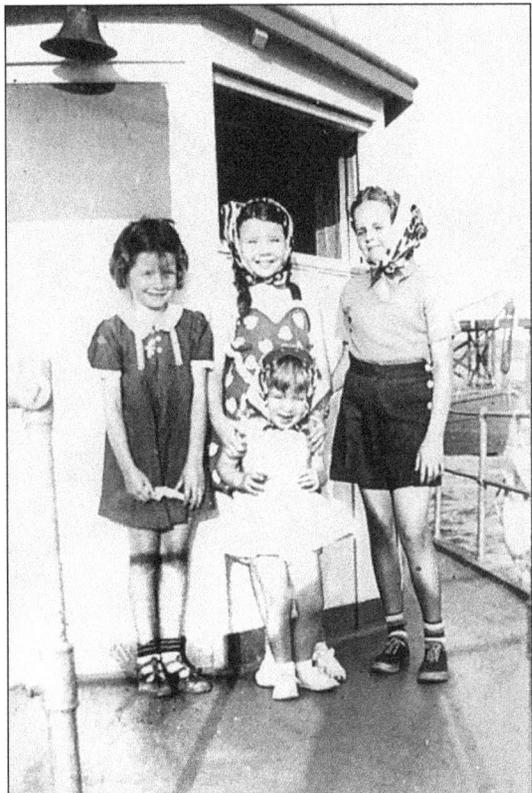

Aboard the *Owanee* are, from left to right, (in front) Sally McTeer (Chaplin); (back row) Georgie McTeer (Cooke), Mookie McTeer (Woods), and Margaret Scheper (Trask). The *Owanee* had a galley and slept 12, so families spent days camping aboard and "marooning" on the deserted islands. The Marscher family often went along and David Johnson was the cook.

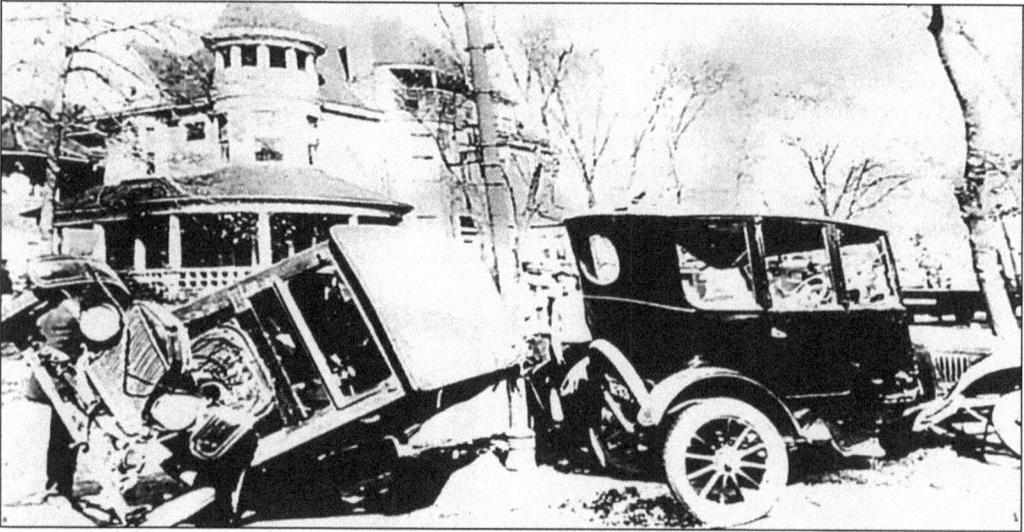

Unnamed and unannounced, the hurricane of 1940 caught the Lowcountry flat-footed and unprepared. Though not as deadly as the hurricane of 1893, it killed 13 Beaufort County residents, most of whom drowned in the wet fury. The Emil Lengnick house can be seen in the background.

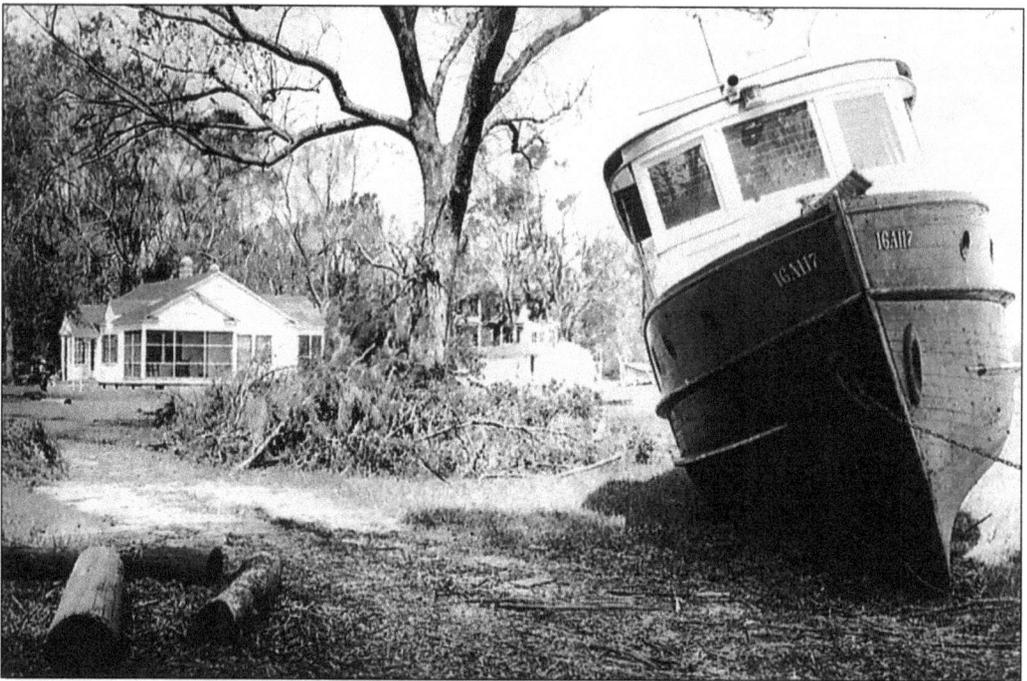

Mills, Albert, and J.B. Kinghorn inherited the *Lookout* after their dad died. The boat was battered during the 1940 hurricane. Previously owned by the telephone company, this 42-foot boat was used to service lines to St. Helena and Lady's Island. The boys often chugged to Fripp Inlet for weekends of fishing and partying. In the background, the house on the corner of Hamilton and Bayard Streets is still there. Jeanne and Charles Aimar's house was built where the tree is pictured.

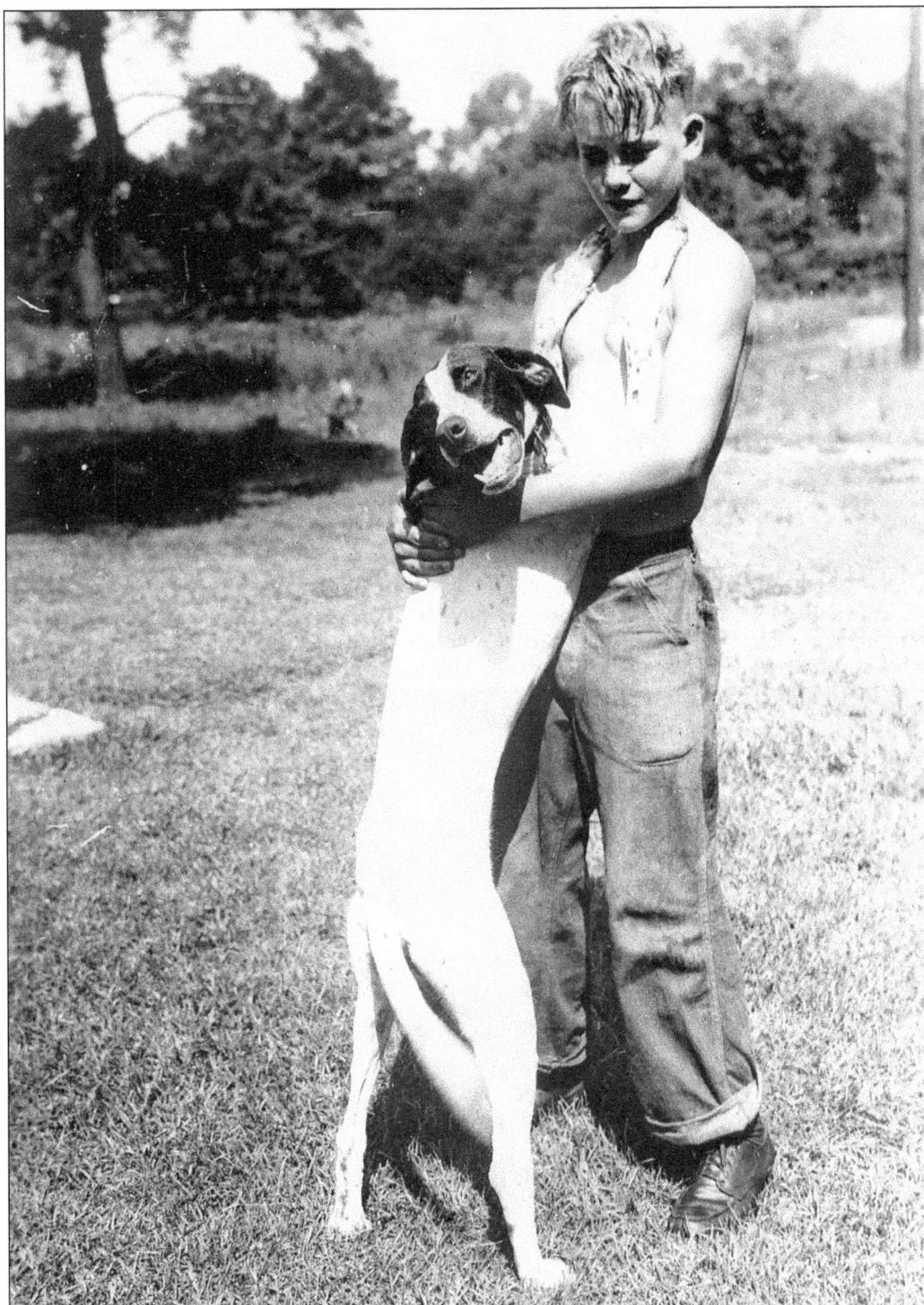

Young Louis Pinckney ruffles his Pointer, Jack, a keen birddog in the quail field. Louis was 14 when he got his first gun, a single shot 22. Louis went to Beaufort High School and has been in construction for 40 years.

Mary Mills Kinghorn is in her backyard in 1945 with Betty (Chamlee) (left) and Louise (Smithwick). Mrs. Kinghorn was a native of Sumter County and came to Beaufort as a school teacher. She married James Albert "Bert" Kinghorn, who was mayor of Beaufort during the years of World War I. He operated a mercantile business on Bay Street until his death in 1937.

Baby Louise (Smithwick) gurgles with glee to have her daddy, Mills Kinghorn, home on leave from the army. Louise was born in Orangeburg, as there was no hospital in Beaufort. In 1945, while on duty in the Phillipine Islands, Captain Kinghorn was subjected to hostile fire in the deactivation and removal of barricades and mines, enabling his division to attack the Japanese. He was awarded the prestigious Silver Star.

Ruby Ellis "Dee" Hryharrow majored in literature at the University of Richmond. She was a costume designer in New York and came back to Beaufort in 1944 to focus on raising her children and portrait painting. She married John Hryharrow of New Haven, Connecticut, who became a partner in the family store, Wallace and Danner. She is now in the real estate business.

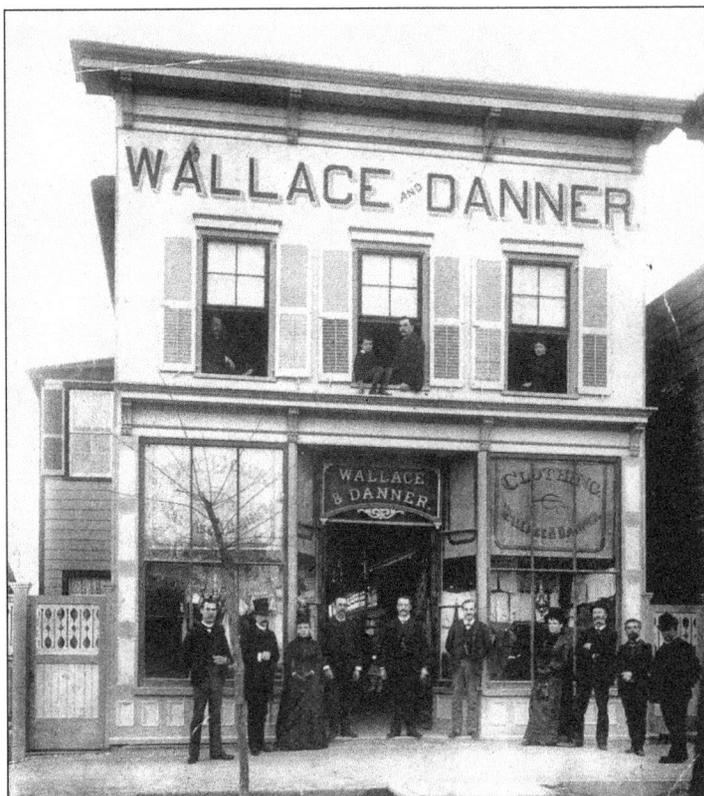

Wallace and Danner department store on Bay Street was started by William Porter Danner in 1876 and was a landmark on the street until it closed in 1970. Customers could buy dress goods, shoes, shoe polish, spats, hats, hat pins, suspenders, dickeys, petticoats, long underwear, corsets, and more. In the 1940s, the phone number of the store was "173."

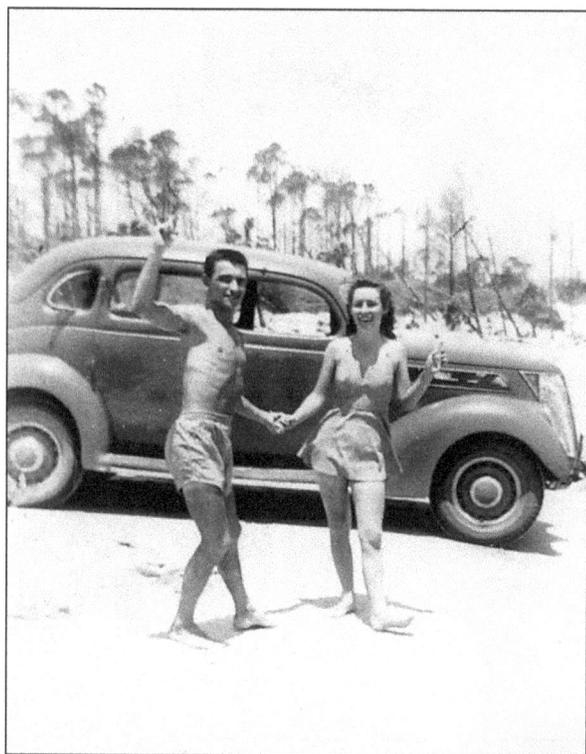

In 1941, Ryan Gunter and Carroll Christensen (Eve) kicked off their sandals and "jitterbugged" in the sand on Hunting Island. "Ain't She Sweet" was a popular song at the time and could have been playing on the car radio.

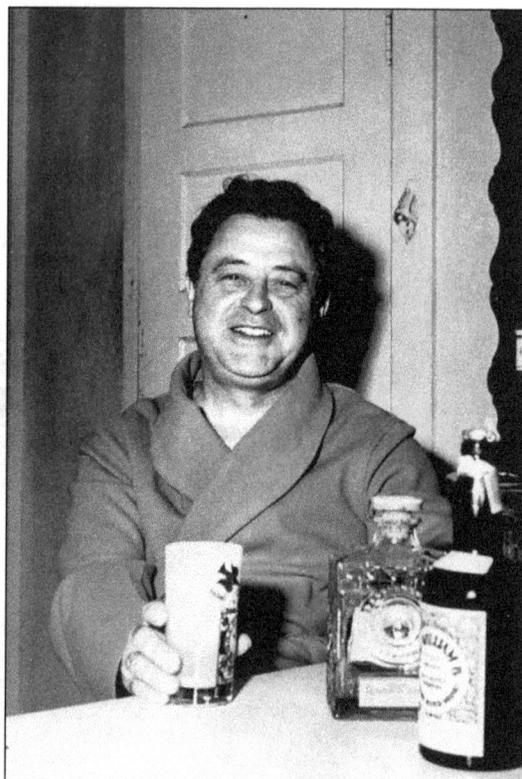

Sterling Harris started the Blue Channel Corporation, which was for many years the largest processor of blue crab in the world. In 1937, he hired a scientist who discovered an aluminum-sulfate dip that left the canned meat pearly white and kept its flavor. Prior to this, the market was limited to fresh crabs caught from the Chesapeake Bay because canned crabmeat was so unappealing.

Beaufortonian Chloe Martin (Pinckney) (right) poses with Anne Hetrick (Kennedy), who was visiting from Raleigh, North Carolina. The two were roommates at Winthrop College in Rock Hill, South Carolina. Anne's letters from a former suitor are featured in Larry King's new book, *Love Stories of World War II*. The wooden bateau, *Lulu*, obviously needs bailing and the barnacles scraped off its bottom.

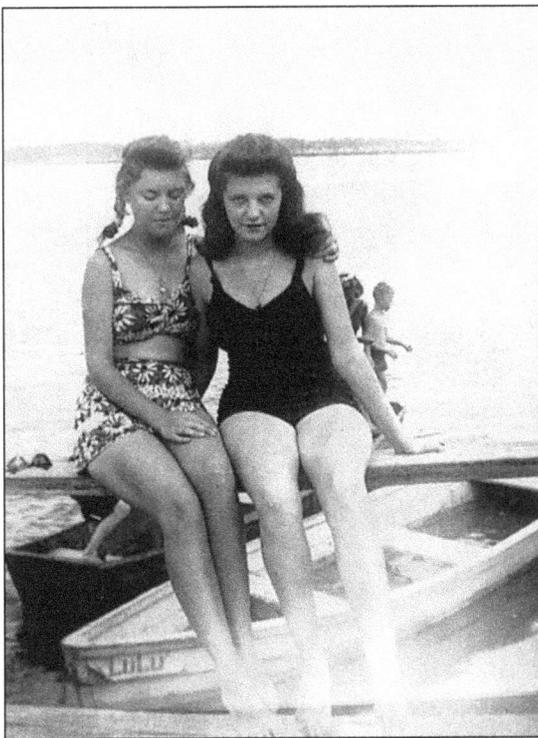

Julie Jernigan (Luther) waits for her ride to St. Helena's Church. She was born in the Jernigan-Long house at 12th Street and Parris Avenue in Port Royal. Her father, Julius, was the engineer for the Charleston and West Carolina Railroad. She and her husband, Charles, later lived at 1501 North Street.

49

Little Billy Sammons holds a nice string of fish caught with his grandpa "Doc" Luther and Leamond Hall in the Combahee River. Once, at St. Helena's Church helping his mother, Angie Luther (Sammons), with the altar flowers, Billy said upon seeing the large gravestones outside, "Mom, why do they put those heavy stones on those dead people? They can't get up!"

In 1941, Boy Scout Troup One prepared for an adventure to Boy Scout Camp Hononwah on Wadmalaw Island, Charleston County. Pictured from left to right are (sitting) Jennings Lyons and Eugene DeLoach; (standing, front row) Robert Black, Henry Chambers, Robert Hartzog, Charlie Brown, Fred Christensen, and Benjamin Chambers; (back row) Wyatt Pringle, Julian Schoenberg, and Miles Murdaugh.

Red Cross Ladies, from left to right are (front row) Mrs. Sam (Bessie) Levin, Mrs Somers (Katherine) Pringle, Mrs. Brady (Ouida) Shearhouse, unidentified, Thomas Taber (C.O. United States Naval Hospital), Mrs. John (Hedda) Morrall, Mrs. S.S. (Dreka) Stokes, Mrs. G.G. (Lenora) Dowling Sr., Mrs. John (Elizabeth) Parker Goldsboro, and Mrs. William (Margaret) Scheper; (back row) Mrs. John (Jane) Haskell and unidentified.

Mary Bell (Jenkins) is proud of her children. From left to right are Toni Bell (McDaniel), Paul Bell, and Richard Bell. This photo was taken in 1942 when the family lived at 906 Carteret Street. Little Vicki had not yet been born. Vicki was the first V.E. (victory over Europe) baby born in Beaufort County, hence her name. Mary was secretary at Blue Channel Corporation, the first company to can crabmeat successfully. It was on the tip of Port Royal and owned by Sterling and Edna Harris.

Childhood sweethearts Mary Moody and Billy Flowers were married in Allendale, South Carolina., and moved to Burton in 1944. He was a railroad agent with the Charleston and West Carolina Railroad and she worked with G.W. Trask and Sons, truck farmers. They had four children: Toni (Shiver), Patsy (Hand), Geni Flowers, and Bill Jr.

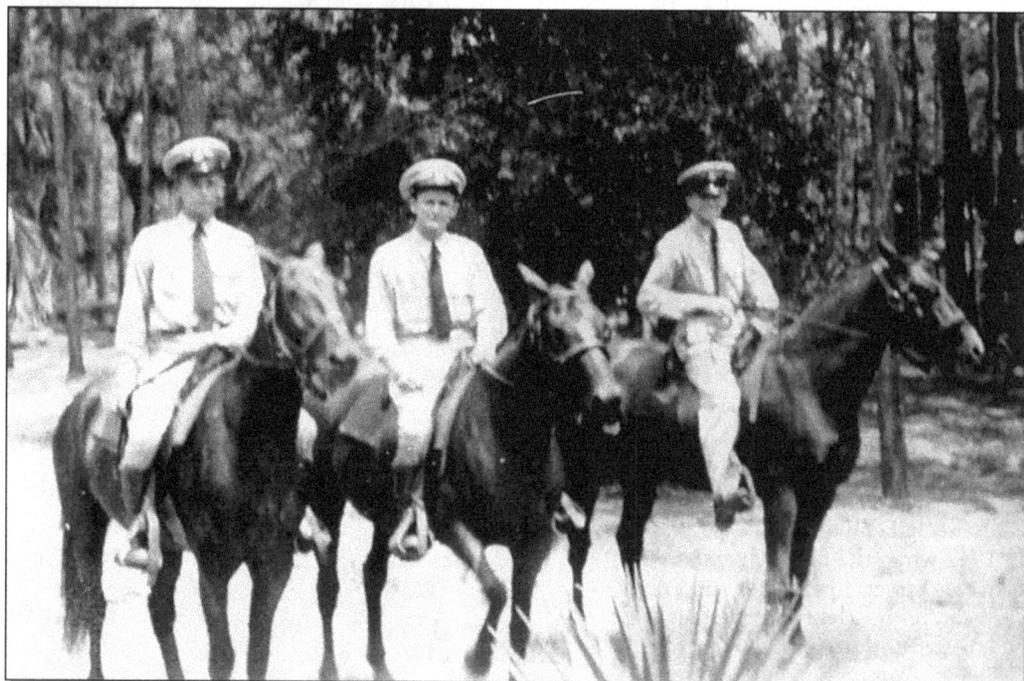

During World War II, protection of the U.S. borders was vital. Patrolling with dogs and on horseback were vigilantes, the unsung heroes of stateside duty. Ned Brown, photographer and storyteller, knew every tidal creek and backwater in Beaufort County. He joined the Coast Guard and led the mounted shore patrol. From left to right are unidentified, Randy Tiller, and Ned Brown. Paul Bazemore, not pictured, was also in the mounted patrol.

Charming Charmian Paul (Webb) climbs the ladder after a dip in Back Green Creek behind Tidalholm where *The Big Chill* was filmed. She and her husband, Charley, had four boys: Charles, an insurance broker with Kinghorn Insurance; Leith, who works in construction; Allen, pilot of the ferryboat to Daufuskie Island; and Paul, an anaestheologist at St. Joseph's Hospital in Savannah. Anne Hetrick is crabbing from the dock in the background.

Grace White, the first female lawyer in Beaufort County, graduated from George Washington University in Washington, D.C. with classmate J. William Fullbright. She became a probate court and tax attorney sharing an office with William Elliott. She later shared space with Dr. Sol Neidich and insurance agent Roy Attaway. In the early years of her career, clients often paid her with chickens, eggs, turnips, corn, cane syrup, or an apple pie. At the time of this photo, she had been in practice for seven years.

53

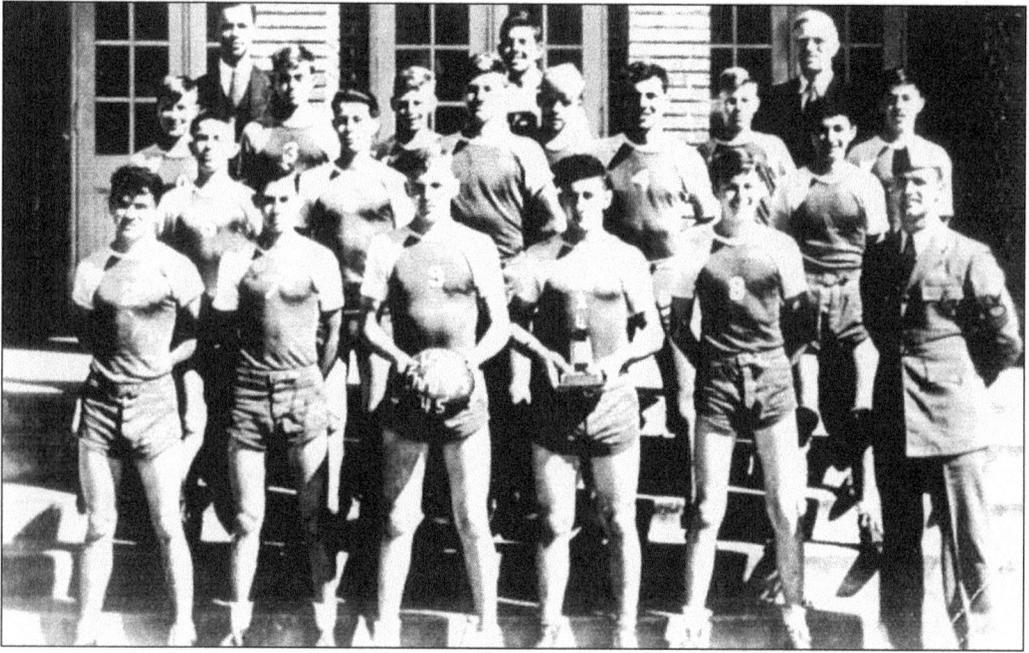

The Beaufort High School basketball team won the state championship in 1945. Pictured from left to right are (first row) John Rodgers, Willie Scheper, Charlie Brown, Harry Deloach, Henry Chambers, and Chief Warrant Officer Jack Russell; (second row) Red Cullom, Miles Murdaugh, Bill Marscher, Bill Danner, and Bob Volpe; (third row) Jim Till, Ben Chambers, Sonny Von Harten, Cleve Hutson, Brantley Harvey, and Vernon Merchant; (fourth row) Principal George Linder, Manager Al Purdy, and Superintendent O.K. McDaniel.

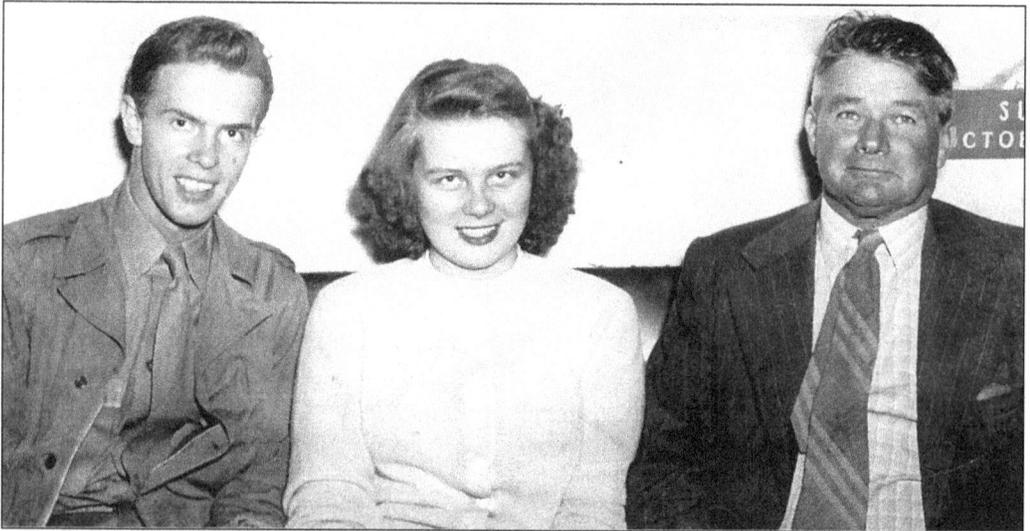

This 1946 photo shows Joe Simmons, photographer for *The Boot* newspaper on Parris Island, Ellen (Axmann), and her father Louis Fripp. Mr. Fripp worked on Parris Island in civil service for 42 years and was a skilled bricklayer. He laid walkways at the Sterling Harris home, Marshlands, on Pinckney and Federal Streets, which is the home of Helen and Brantley Harvey today. He repaired the brick wall surrounding St. Helena's Church and did brickwork for the Joab Dowlings, the Clayton Coolers, and others. Ellen grew up on Ribaut Road.

Photographer Lucille Hasell (Meredith) (Culp) ran Palmetto Studio on Bay Street from 1941 to 1981. Her second husband, Bill Culp, came to Beaufort from North Carolina to help build the Beaufort Hospital. Here she is in the dunes at Hunting Island. This glamorous photo hung in her waiting room. Once a marine said to her, "Wow! I'd like to meet this girl!" She had just finished a messy session in the darkroom and the marine didn't realize she was the same "fetching" girl in the picture!

Gaillard Pinckney, born in 1917, served in the National Guard. After discharge, he worked for his father at Pinckney Well Drilling and Pile Driving Co. in Beaufort. His grandfather, Roger Pinckney VIII, knowing it was a dangerous mission, volunteered as crew aboard the submarine *Hunley*. He was refused because there was a full crew of nine. It sank and drowned the crew after sinking the *Housatonic*, an 1800-ton sloop-of-war with 23 guns in Charleston Harbor. Young Gaillard heard this amazing bedtime story while sitting on his Grandpa's knee. This rakish photo was taken in 1946.

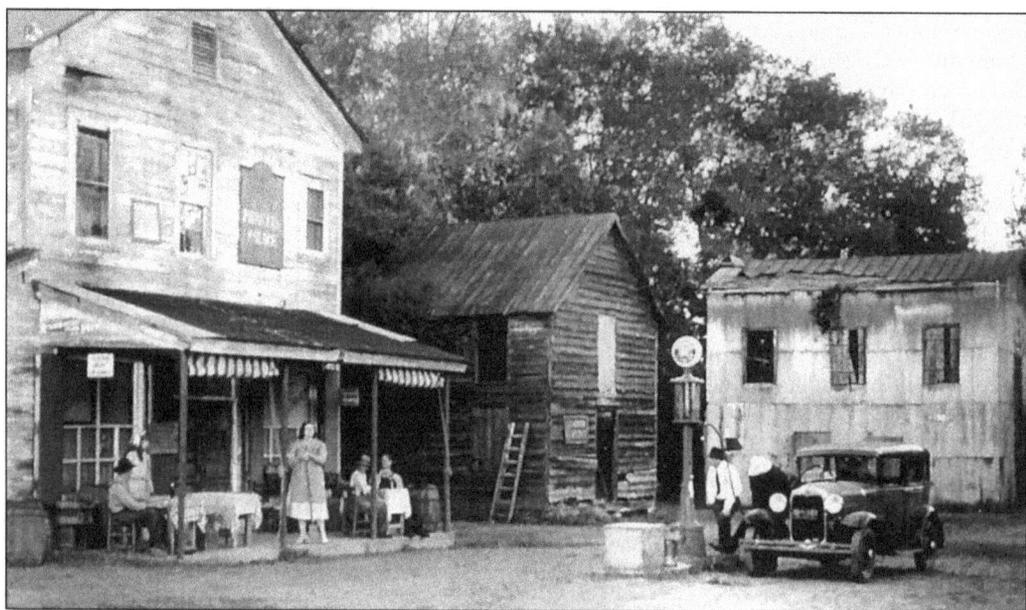

Film crews love the dilapidated buildings at the McLeod Farm at Seabrook left from a once-thriving truck farming era. The farm grew vegetables from 1884 to 1984. Wood packing sheds, two stores, and the white McLeod homestead cluster around the railroad line connecting Port Royal to the main lines in Yemassee. Four movies have been filmed at this rustic setting: *White Squall, Animal, Other Voices Other Rooms,* and *The Legend of Baggar Vance.*

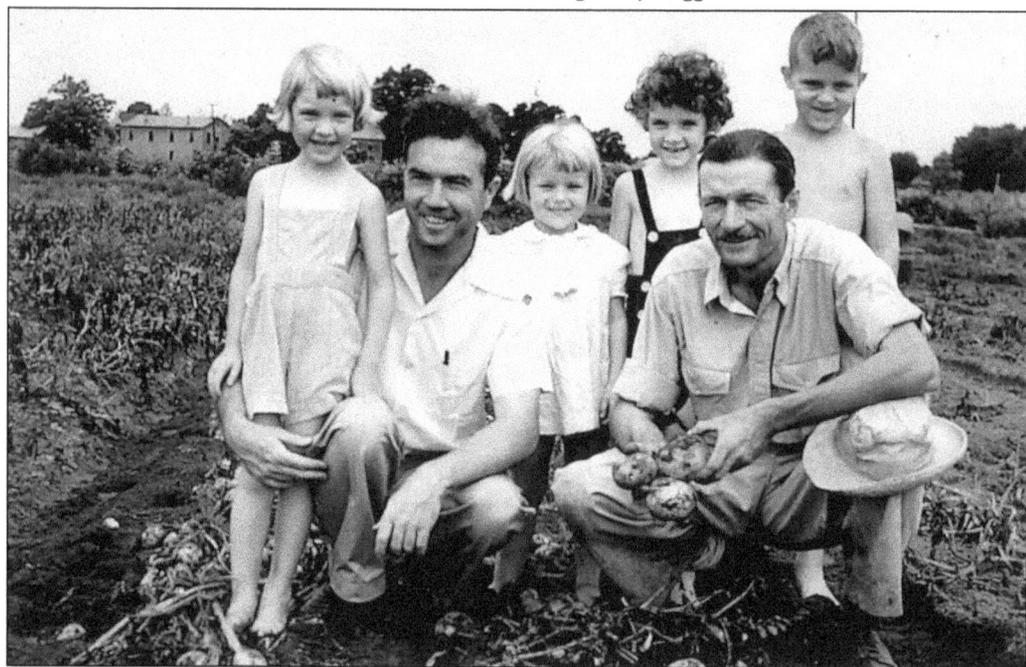

Beaufort's economy depended heavily on truck farming in those days. In the McLeod's potato field out in Seabrook are, from left to right, Caroline McLeod (Bowen), Hardee McLeod, Jay McLeod (Kidder), Hope McLeod (Cappelmann), George Ricker, and Claude McLeod. The success of truck farming was greatly aided by a growing season of approximately 300 days a year.

56

Each bunch of radishes had to be tediously tied with string. Note the coils of string in her lap. Radishes and other crops were shipped in refrigerated trucks as far away as Canada. Blocks of ice were placed into a cavity in the truck and a fan called a "putt putt" blew air over the ice, keeping the produce cool and fresh.

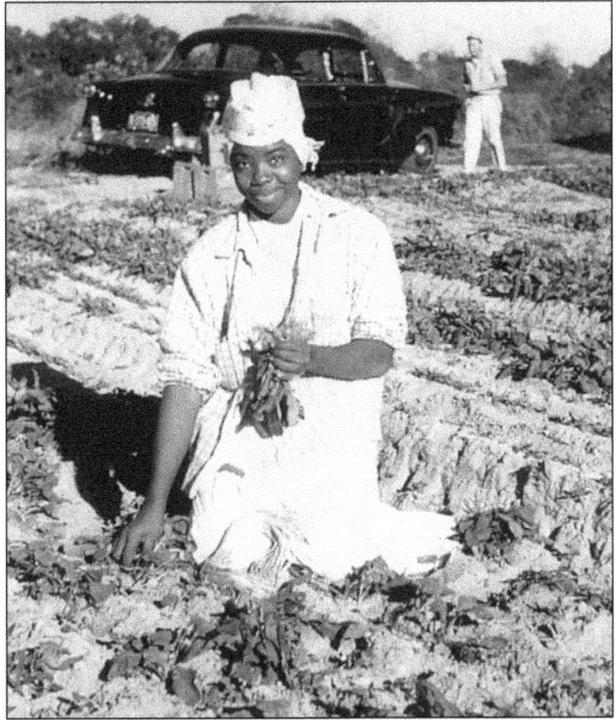

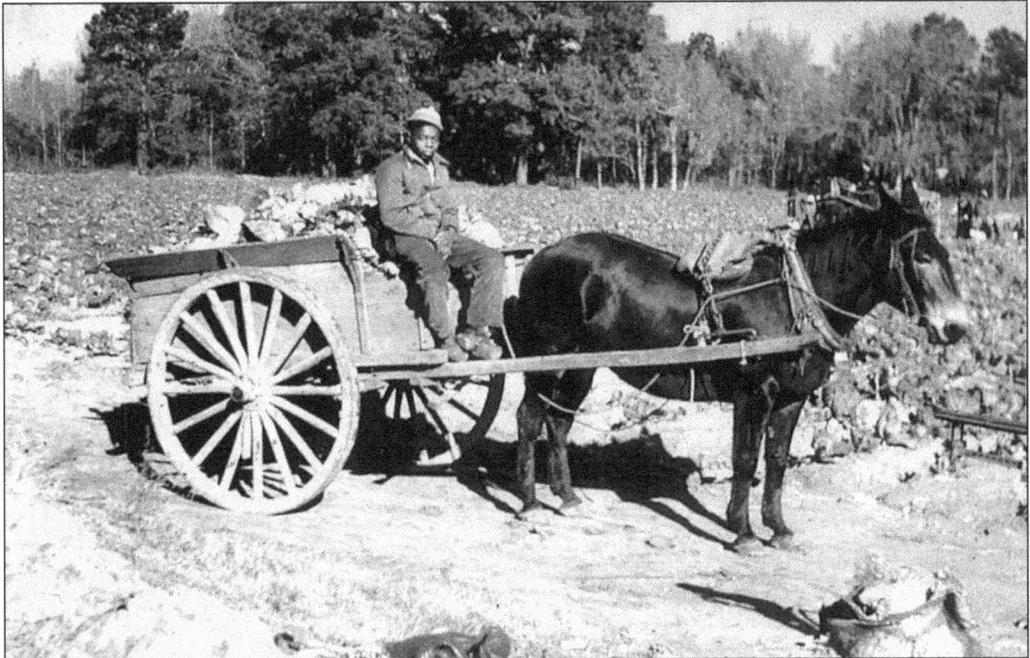

A sturdy mule hauls a load of cabbages from the field. Mules are better working animals than horses, because mules are more sure-footed and not as easily spooked. A smart mule can be trained to turn right or left by shouting "gee!" or "haw!" without tugging on the reins. Folks used to say "hot sun don't bother them mules none, 'cause them big floppy ears give 'um plenty o' shade!"

Barefooted in 1946 on their outgrown tricycles are Joe Bowers (left), whose dad worked on the McLeod farm, and Claude McLeod. Rufus Williams Jr. (standing) later graduated from Tuskegee Institute in Alabama where he earned his doctorate.

This photo was taken in 1949 in the Seabrook Store. Payday for farm workers was here every Friday. From left to right are Hardee McLeod, Jack Johnson, and Martin Johnson. Martin was convinced that when a locomotive rounded a bend, the caboose was traveling faster than the engine. It was always a topic of heated debate!

A big night on the town called for summer frocks to be starched and ironed. The McLeod farm supper was held at the Lobster House where the Comfort Inn is located today. From left to right are Maxine Dunnet, Jessie Parham (McLeod), Margaret (Johnson), Mary Bishop (O'Bryan), Troyce Bowers, Caroline Eve (McLeod), and Linda Powell McLeod

Back in the good old days in Seabrook, watermelons grew bigger, redder, sweeter, and juicier and they had more seeds for seed-spitting contests. With juice running down their chests and cheeks packed with seeds, these boys pucker up at close range in boyish delight. A splash in the pond to wash off the sticky juice was necessary before going home for supper.

This four-foot diamondback rattlesnake was spotted in the dunes on Pritchard Island and killed. Nancy Ricker (Rhett) (left) appears worried that the snake might not be totally dead as she and Jay McLeod (Kidder) hold it up for the camera. South Carolina has nine poisonous snakes with four known to be deadly: the Eastern diamondback rattler, canebrake rattler, timber rattler, and the cottonmouth moccasin.

Tired and happy, these first cousins, George Ricker (right) and Claude McLeod Sr, hadn't used a razor or soap in a week after "marooning" on Fripp Island in 1948. Families often took tents and supplies to last a week or two and camped on the islands. There was plenty to do—fishing, swimming, collecting shells, star gazing, telling ghost stories, setting up campfires, and building drip castles.

These huge drumfish make noise under water like a bass drum. The roe is a delicacy. In the late 1800s, many boats anchored at the fishing drops The Rocks and Hole-in-the-Wall. Often rods bent with the weight of these heavy fish, causing backlashes, collisions, capsizing, whooping, and hollering! William Kennedy (left), head of mechanical and electrical trades on Parris Island, and Beau Sam McGowan, operator of the Esso Station in 1947, grimace under the weight of their catch.

Pictured on Parris Island in 1945, Hastings Greene is a retired FBI special agent today. He and his wife, Nancy, special agent with S.C. Law Enforcement, live on Pleasant Point Plantation. He is the son of Sgt. Maj. William H. Greene, USMC (during World War II) and Elizabeth Greene, head librarian at the U.S. Naval Hospital from 1949 to 1969.

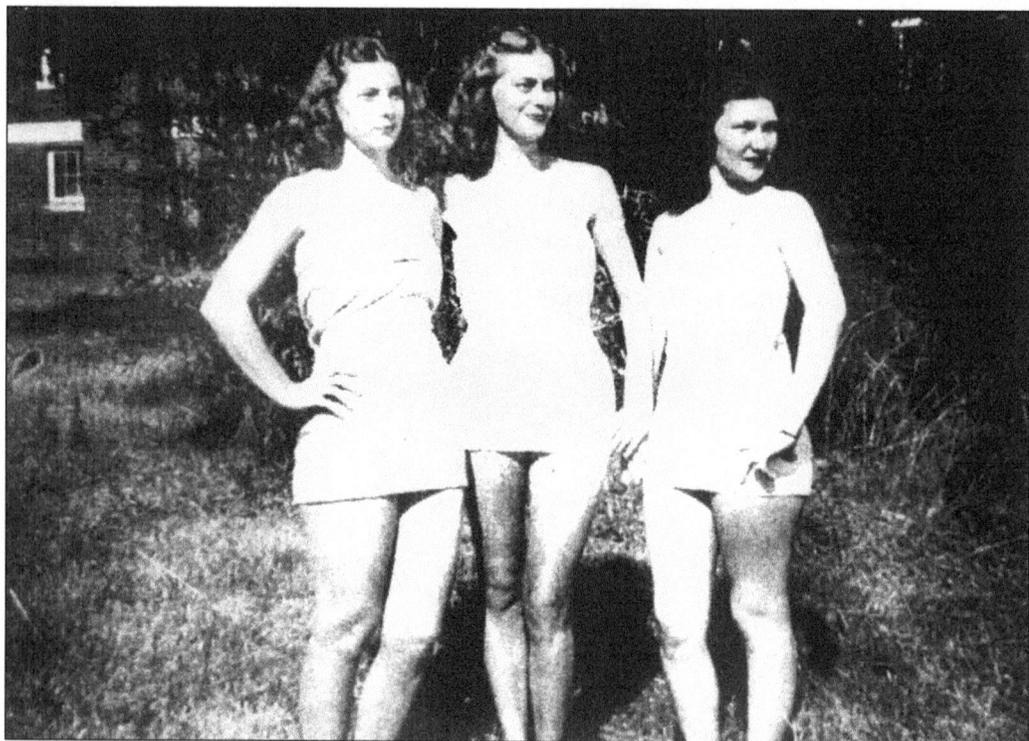

From left to right, Deena Watts, Nookie Von Harten (Neely), and Miriam Theus strike fetching poses on the campus of Limestone College in Gaffney, South Carolina. Nooke was from Beaufort and her two friends were from Georgetown, South Carolina.

Julie Mueller, daughter of Charleen and Jim Mueller, rides her wooden horse in the backyard of the Robert Means house (*c.* 1790) in 1948. Charles "Doc" Luther, owner of Luther's Pharmacy, bought this house and Cuthbert House next door around 1940. Julie's father, Jim, was with the marines at Pearl Harbor on December 7, 1941, and also stationed at Iwo Jima.

Enjoying a "ladies day" on Pritchards Island in 1949 included, from left to right, Lilla Long (Hutchinson), Anne Hinely (Long) (Marshall), and Dana (Hinely). Anne Hinely placed third in a bathing beauty contest at Tybee Island, Georgia, in 1937.

Pictured in a roadside alehouse after a deer hunt on Fripp Island, old friends shared a savory stew called "burgoo," stogies, and a cold Brown Forman "Bottoms Up" hooch, just to restore the tissues. The pick-up trucks parked outside also had wild turkeys piled in the backs for Sunday dinner. From left to right are John Bull, I.S.K. Reeves, Charlie "Doc" Luther, unidentified, Dick Horne, and Jack Sammons.

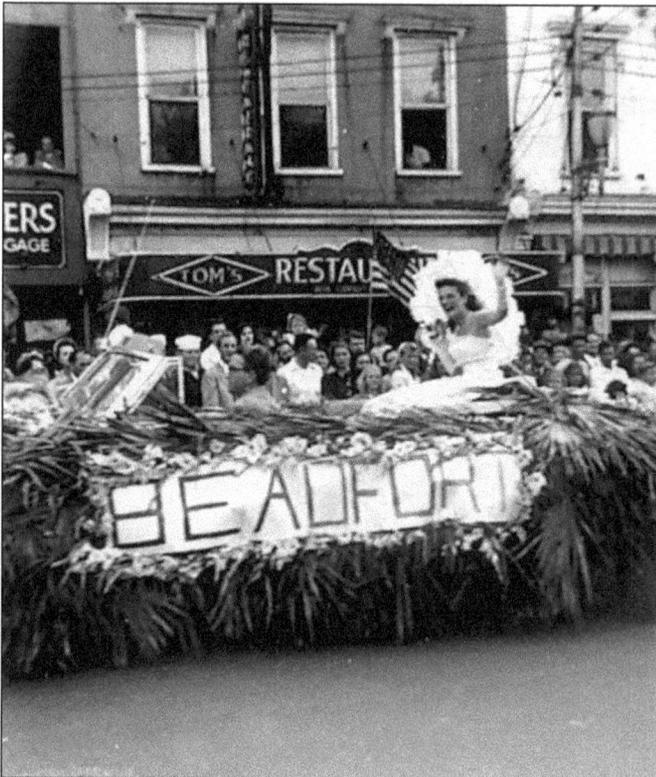

Eighteen-year-old Miss Gara Black, daughter of Mr. and Mrs. J. Gary Black of Beaufort, was chosen to represent Beaufort in the Charleston Azalea Festival. Miss Black was selected by the Beaufort Rotary and Lions Clubs and the Junior Chamber of Commerce. She attended the University of South Carolina in Columbia. Mr. Black was the author of My Friend The Gullah.

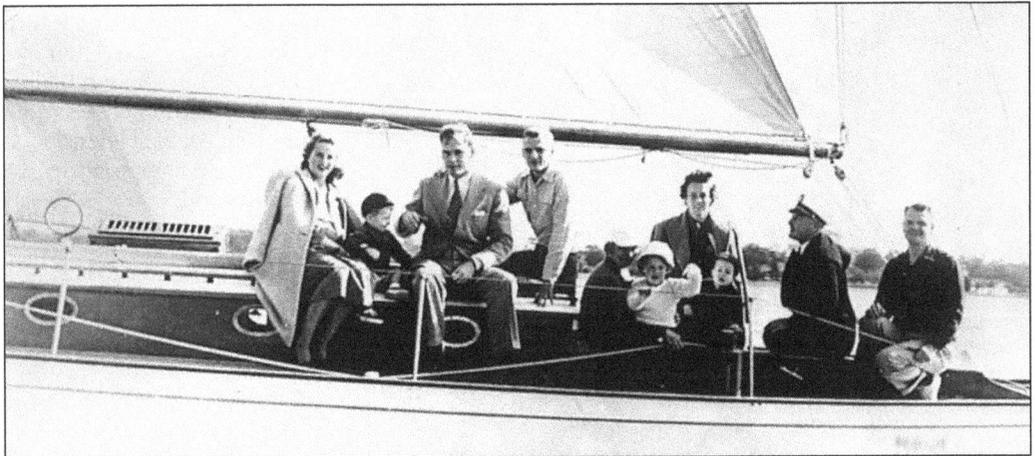

Aboard *Ocean Queen* in 1949 is the Demere family from Savannah. From left to right are Mary, Rob Jr., Bobbie, Charlie, Josephine ("Jo Jo"), Mike, Addie, Scott, Big Raymond, and Raymond Jr. During regatta season, Mr. Demere towed a string of little sailboats behind his power boat, *Hoosier*, to the town hosting the races. Nash McIntosh's chapter in *Sailing Savannah 1996*, reports that Ed Turner, aboard the *Merry Jean* schooner, carried the whole Penguin fleet lashed to her deck. Tommy Johnson aboard *Bounty* and Olin McIntosh Sr. skippering *Hobo* also towed Isle of Hope boats to the races.

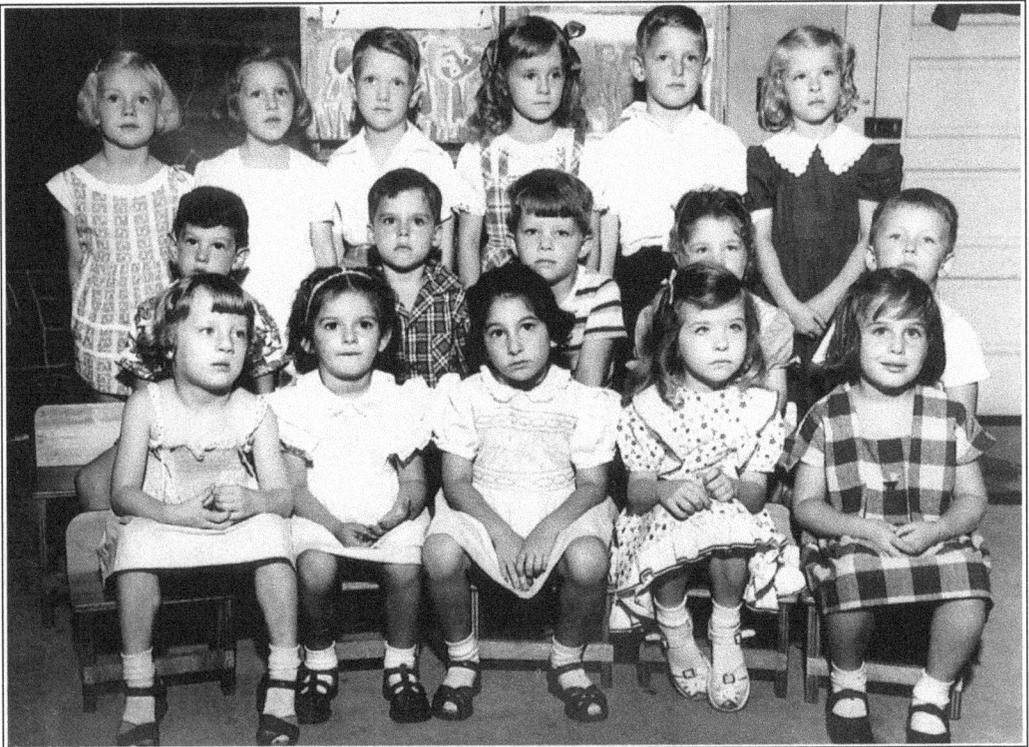

Here is Miss Lil Lindburg's 1949 kindergarten class picture. Each day, Miss Lil walked miles past Colony Gardens to school from her home at Woodlawn on Lady's Island. Emphasis was placed on teaching children how to print before they were allowed to advance to longhand, also called "real writing."

From left to right, Dan Upton, Tyrone "Shorty" McAlhaney, and Doug Cappelmann had just returned to Orange Grove Plantation on St. Helena Island from a camping trip on Distant Island.

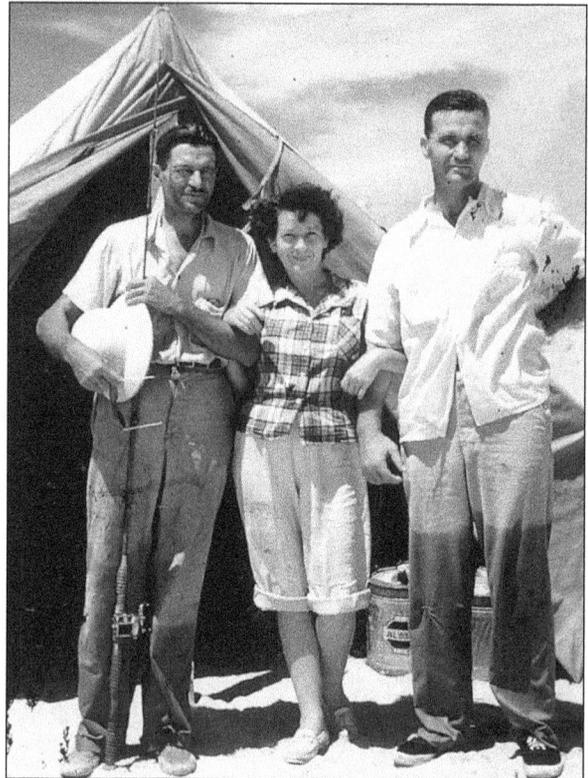

With soaking britches and rolled-up pants legs, first cousins George Ricker (left) and Marjorie McLeod (Fordham) and stand with her husband, Angus, after surf fishing on Fripp Island. Fishermen always hoped for a nice bass, but the bait was often snatched by a "stingeree" or a shark.

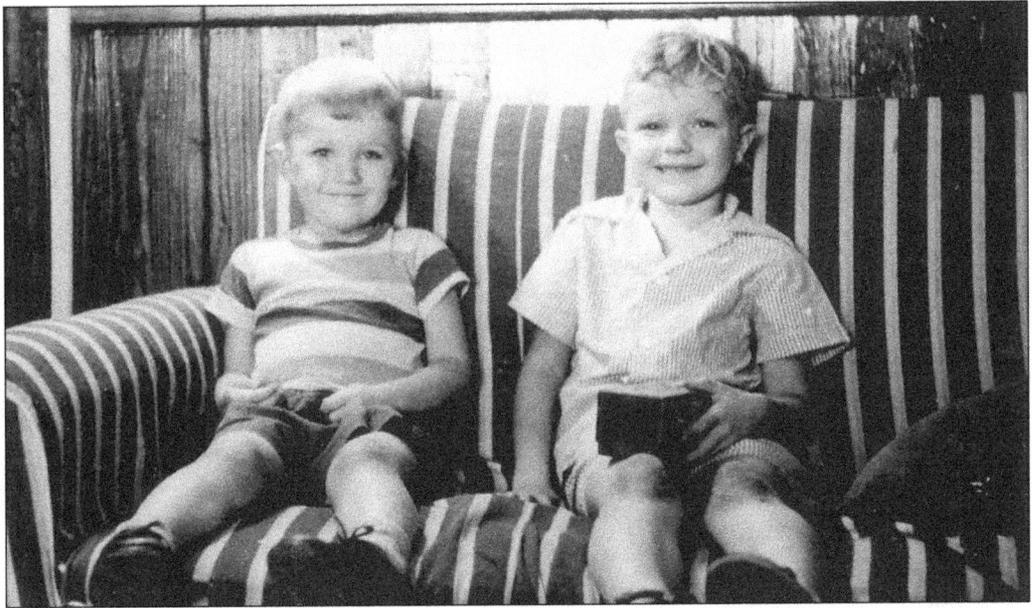

Two-year-old Martin Pinckney (left) and his brother, Roger, visit their grandmother, Fraser Dickenson "Sugar" Pinckney, on Pigeon Point Road. Martin is a civil engineer in Naples, Florida. Roger is the author of *Blue Roots, The African American Folk Magic of the Gullah People, The Right Side of the River*, and *The Beaufort Chronicles*. His new book is called *Little Glory*.

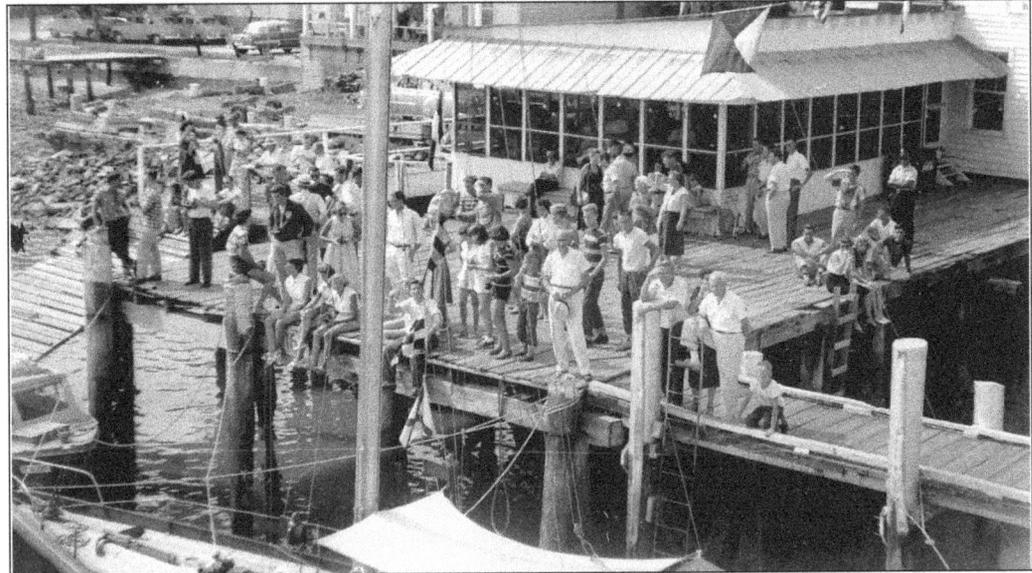

The Beaufort Yacht Club was and still is a private men's club, open to the town during the annual South Atlantic Yacht Racing Association Regatta. This was a special summer event in Savannah, Beaufort, Rockville, Charleston, Mt. Pleasant, and Wilmington, North Carolina. Teenagers and college students went from town to town for sailing and socializing. It was quite fine to relax on the cool screened porch of the BYC and watch the races. In this *c.* 1950 image, Somers Pringle stands with the hat and white shirt near the front. Paul Trask stands on the dock to the right of the mast with his hands in his pockets. Harriet Bowen is taking a picture. (Courtesy of Wyatt Pringle.)

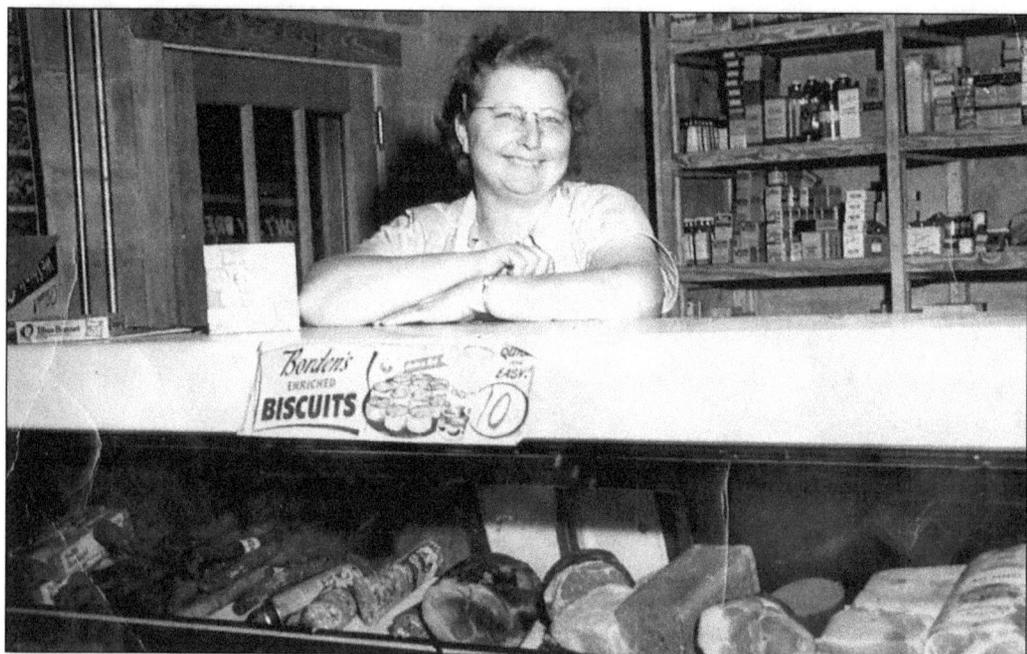

Addie Lee "Mom" Miller ran a general store on Boundary and Charles Streets for 38 years. Many children running away rethought their plans after "Mom" comforted them with a moon pie and R.C. Cola. The Boundary Street Country Club met here with regulars such as Clyde Padgett, Allen "Sonny" Lubkin, and Jerry Gowdy Sr. Mom had nine children and ran a boarding house and tree service. She had her 40-ton house moved to Lady's Island.

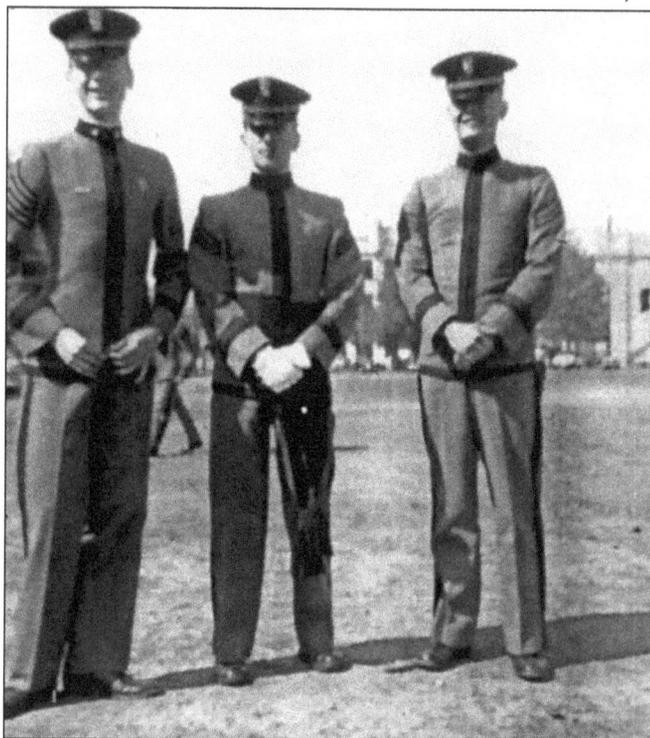

In 1829, the Citadel was built and occupied by state troops as protection for Charleston. In 1842, it was converted to an educational institution and students replaced state troopers. It had high academic standards and strict military discipline. During the War Between the States, mounting and manning heavy guns, guard duty, and escorting prisoners were some of the services provided by the cadets. From left to right are Brantley Harvey, Bob Hartzog, and Burns Jones in 1951.

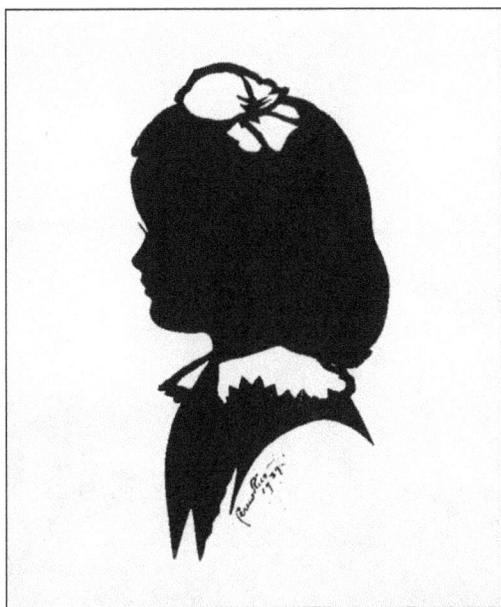

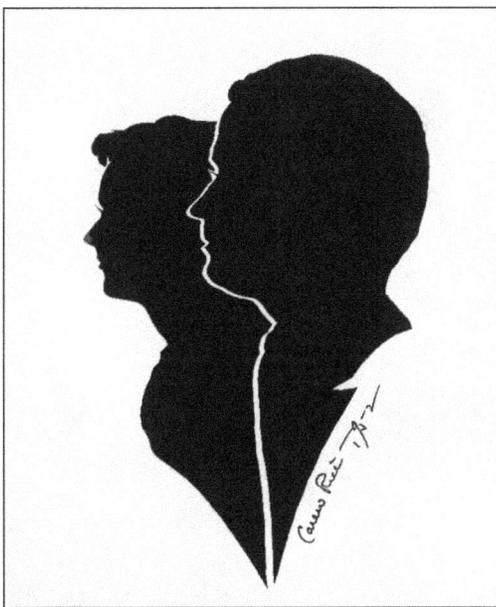

Carew Rice, son of James Henry Rice, was a talented scissor artist. With speed and dexterity, he cut detailed silhouettes and Low Country scenes. Mr. Rice grew up on Brickhouse Plantation in Colleton County; he passed away in 1972. Silhouettes of six-year-old Marjorie Fordham (Trask) and her parents Marjorie McLeod Fordham and Angus Duncan Fordham are examples of his extraordinary skill.

Three longtime friends celebrate the birthday of Thedie Keyserling in 1952. From left to right are Elizabeth Patricia Dobbi (Greene), Thedie Huegenin (Keyserling), and Douglas Grindley. Mink boas were popular before the days of animal activism.

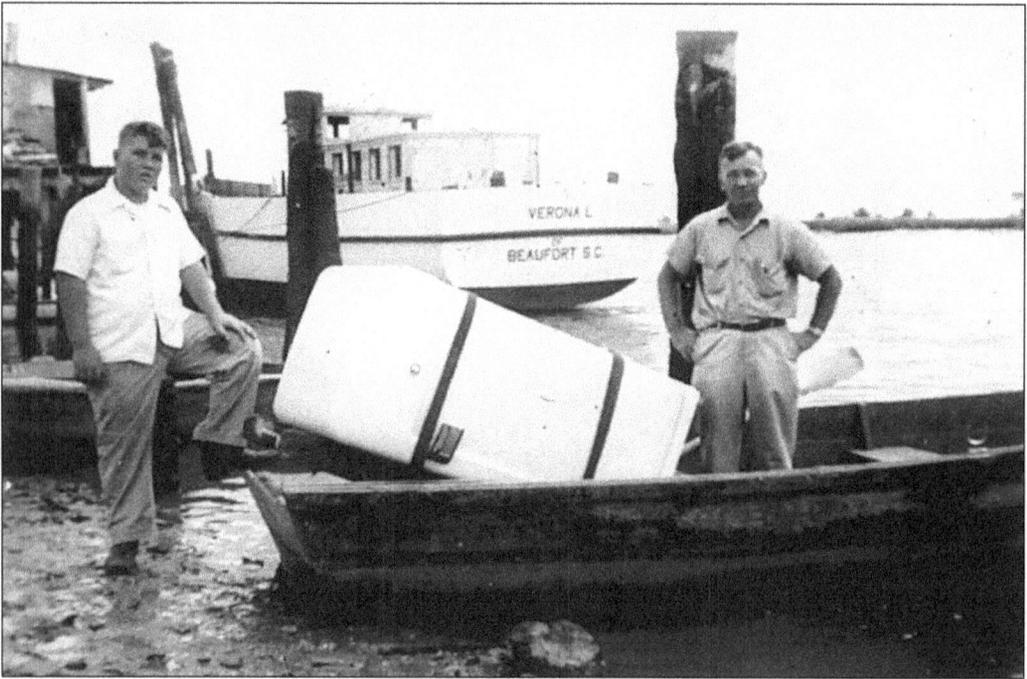

Patrick Dennis and his dad, John, were in the appliance business. Here they are delivering the first icebox by bateau to Coosaw Island. This was before the bridge to Coosaw was built in 1965. They were met by oxcart as transportation to the new owner. The *Verona L.*, later named the *Maria Fernanda*, was owned by Herman "Bubba" Von Harten.

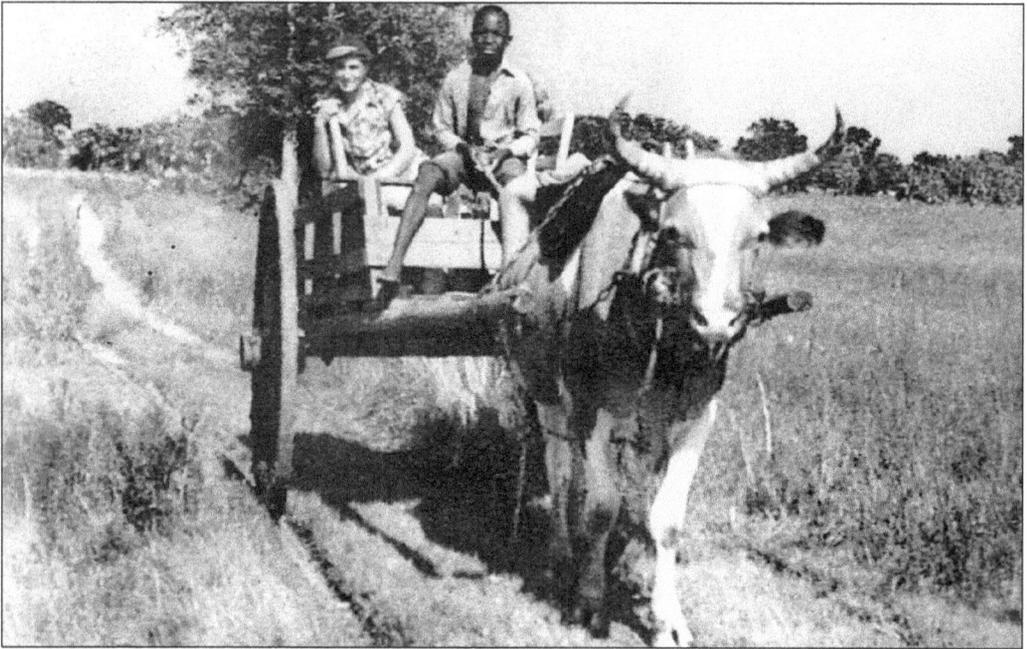

Oxen have been used since the days of rutted roads and muddy fields. Not exactly swift, they were as handy as a four-wheeled drive vehicle for pulling cars out of ditches and hauling loads. In the late 1950s, Leroy gives a ride to Vera Dansby who was visiting family on Coosaw.

70

As Edward Samuel Jr. left his Royal Drive-in Theatre and golf range on Ribaut Road, a whoosh of feathers landed at his feet. Scooping up the frightened fowl, he drove home with "Hootie" clamped onto his shoulder. Mother Marion, Buddy (four), Pat (twelve), and Kay (ten) were thrilled. "Hootie" favored Buddy, as shown in this charming photo taken by Frank Ramsey.

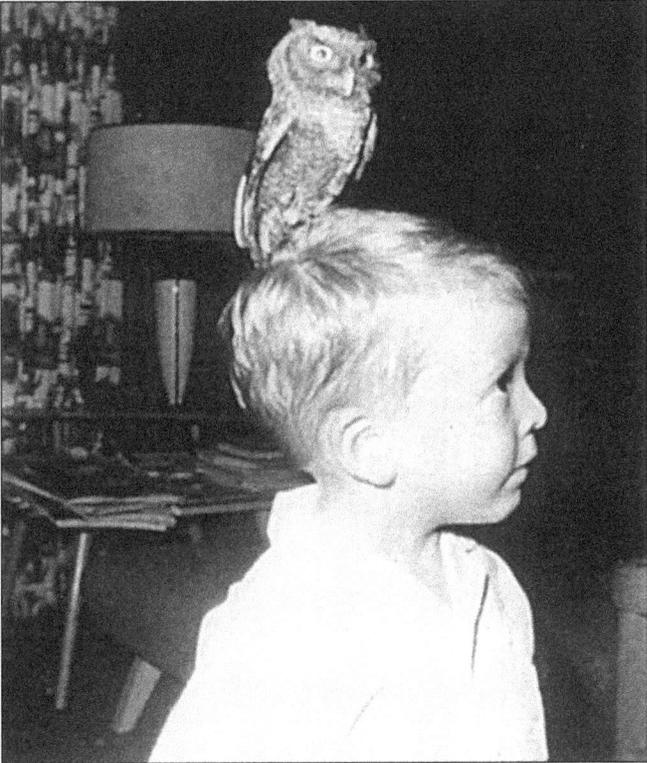

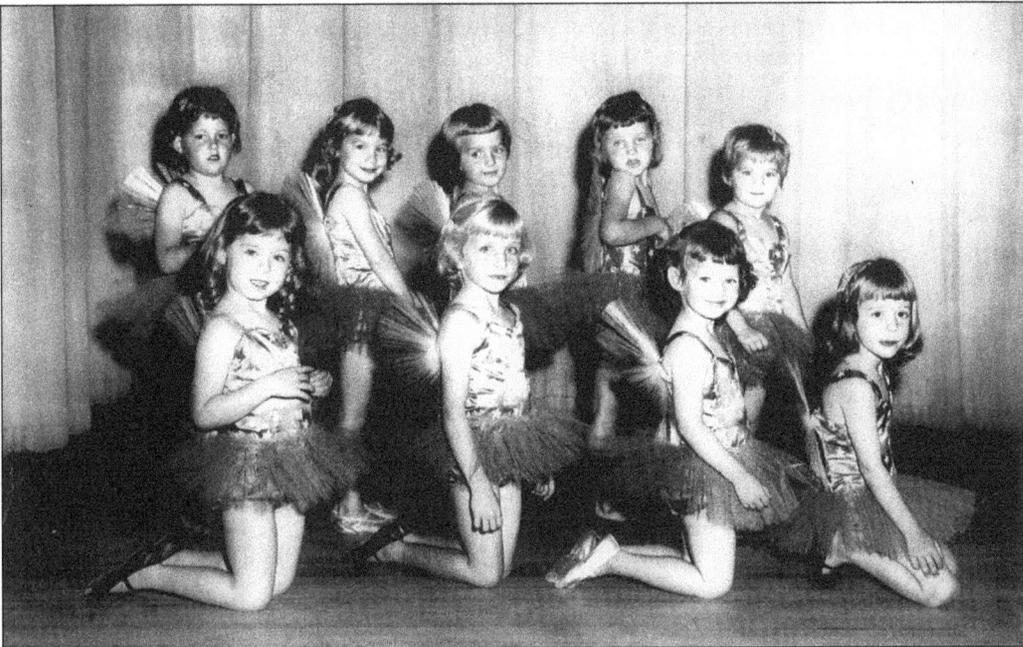

Kneeling, from left to right, are Pat Anderson, Cindy Brown (Tucker), unidentified, and Debbie Mitchell (Fielding). On the top row are Judy Chambers (Trask), Connie Kearns (Tootle), Terry Colquhoun (Reed), Pamela Aimar (Kinsey) and Anne Bazemore (Finke). These girls were pupils of Madeleine Pollitzer's dancing school.

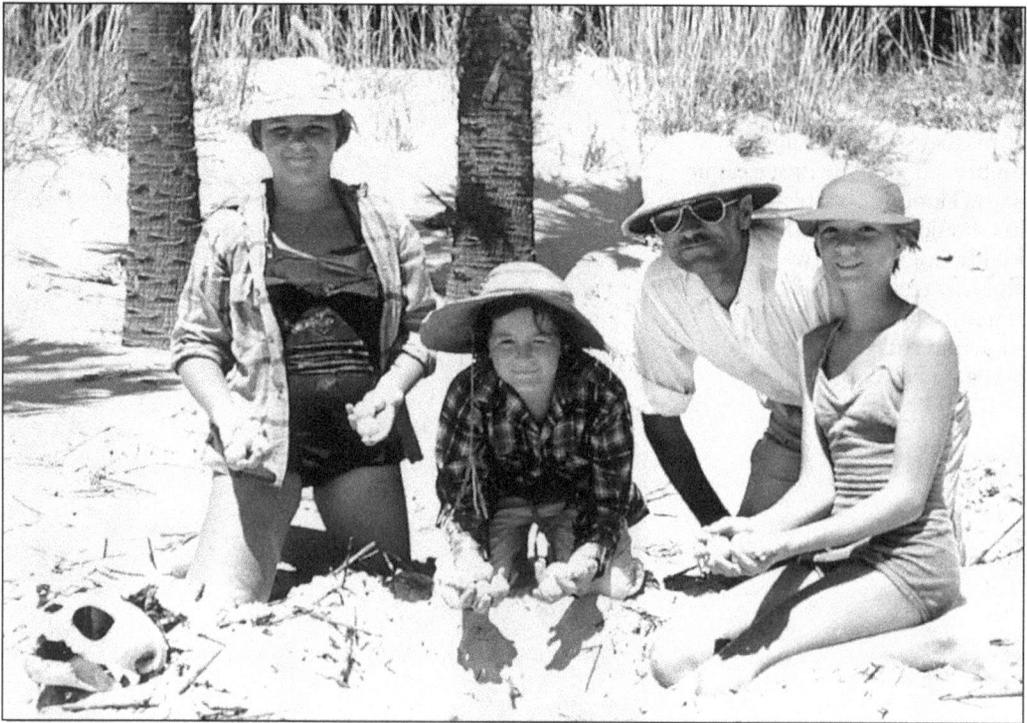

Before Loggerhead turtles became endangered, turtle eggs were a delicacy. In spite of a fishy taste and sandy texture, many people acquired a liking for them. Examining a nest are, from left to right, Jay McLeod (Kidder), Nancy Ricker (Rhett), George Ricker, and Caroline McLeod (Bowen). Note the turtle skull, bottom left.

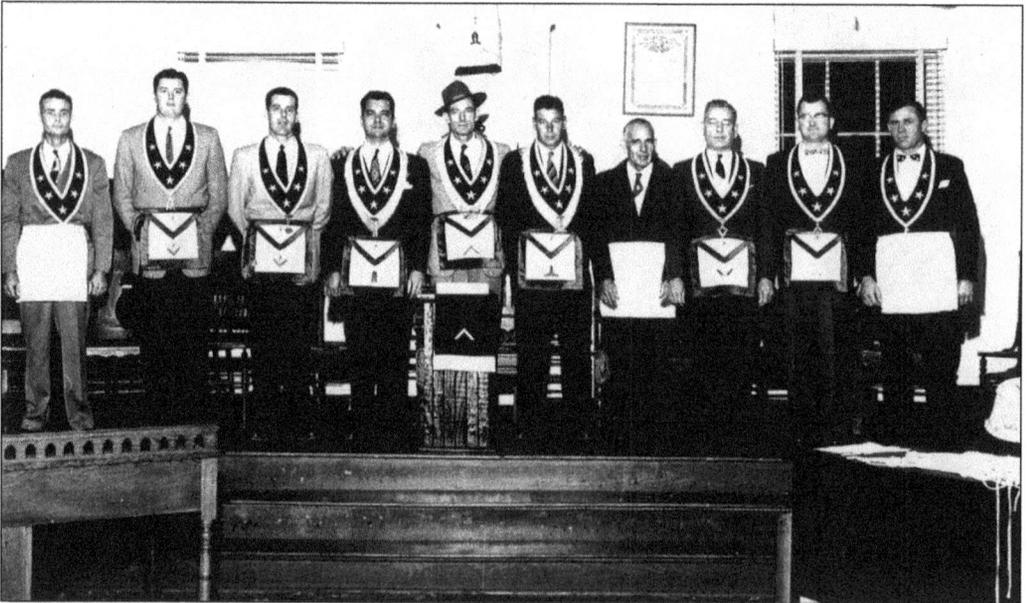

Here are the officers of Harmony Lodge #22 AFM, Ancient Free Masons. Pictured in 1955, from left to right, are Elmer Whitney, Henry Chambers, Bobby Black, Joe Vella, Kline Reid, Jim Darby, Hugh Rahn, Walter Jenkins, Kennie Koth, and Virgil Davis.

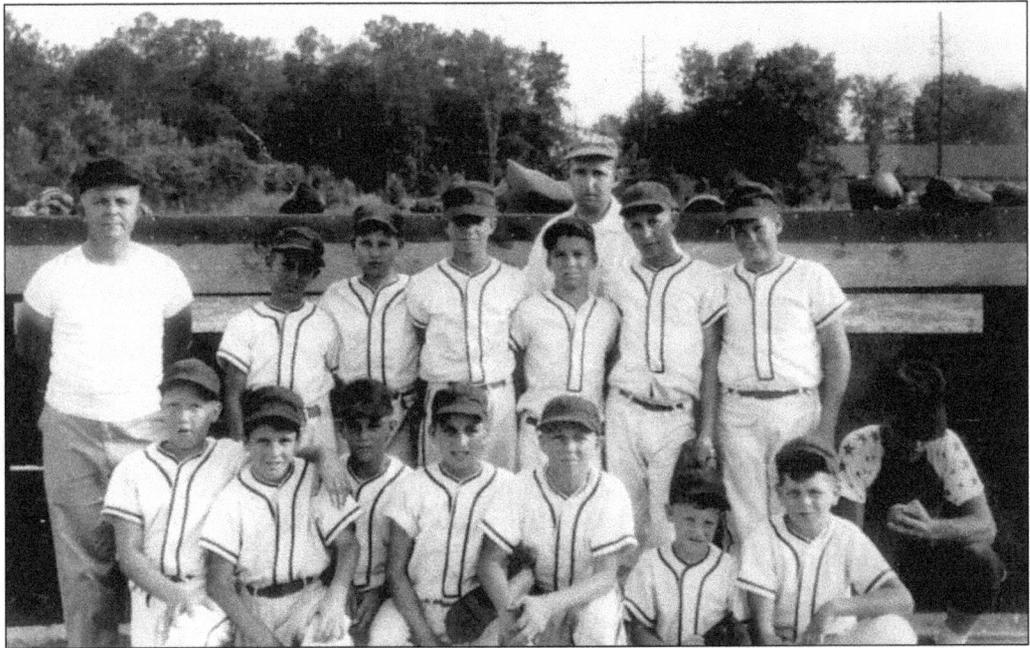

The Western Auto Baseball Champs in 1955 were, from left to right, (front row) Greg Calhoun, Gene Cox, Bill Kennedy, Eddie Owenby, Larry Brown, Bret Cooper, Carl Epps, and Kit Cook; (back row) Mr. Martin, David Jackson, Tommy McCracken, Paul Schwartz, Jerry Smoek, two unidentified players, and Billy Corbin.

In 1956, Nan Campbell (Kinsey) and her friend Dale Hryharrow (Friedman) dry off in the sun after a splash in the Pocataligo River at Oak Grove Plantation. Swimming at night was exciting, as the salt water was full of phosphorous. One could swim underwater with eyes wide open and the lights of the phosphorous made a magical scene like a starry galaxy.

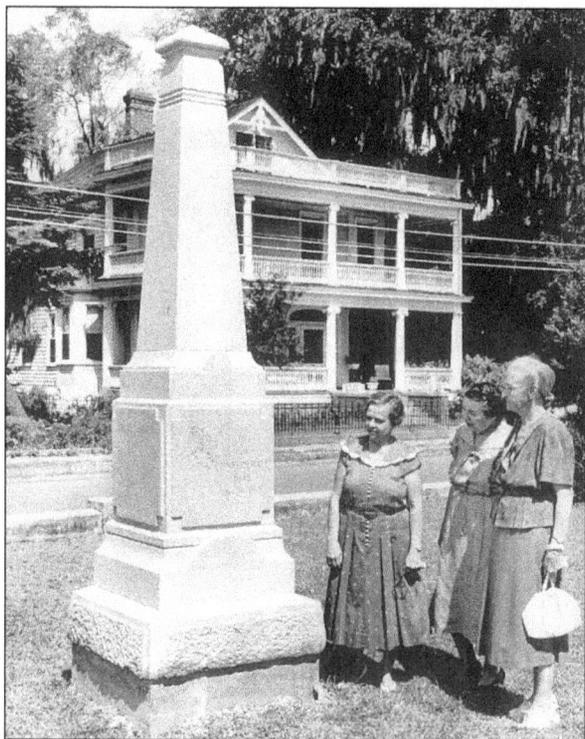

The Confederate Memorial in front of the U.S. District Courthouse on Bay Street was unveiled around 1911. It was erected by the Stephen Elliott Chapter of the United Daughters of the Confederacy. Pictured in 1957, from left to right, are Mrs. W.A. Black, Mrs. Gus Frank, and Mrs. Nellie Fripp. (Courtesy of Historic Beaufort Foundation.)

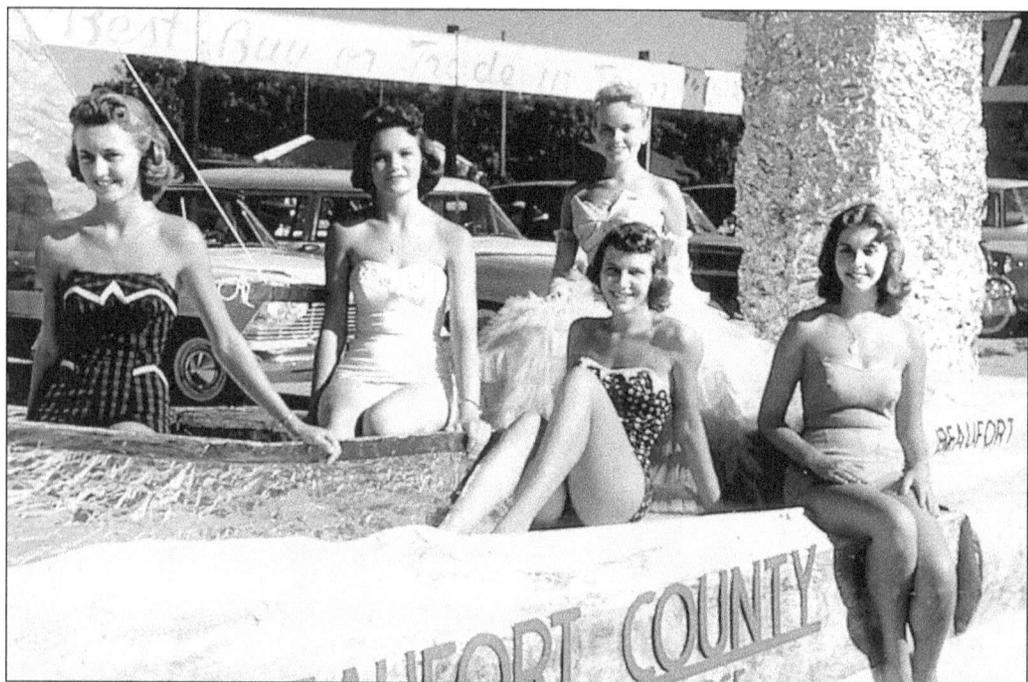

Ann Luckey (King), "Dodie" Wallace, Lily Easterling (Miss Beaufort), Ann Christensen (Pollitzer), and Virginia Gregg are the icing on the float in the 1957 Water Festival Parade. These strapless bathing suits were ideal for sun bathing but were a bit tricky when diving into a pool!

On January 24, 1907, Beaufort went up in flames. Brave and heroic work saved many business and residential sections; however, the inferno gobbled up stores and homes with terrifying fury. Today, Beaufort is protected by modern equipment and invaluable volunteers. Sitting on the old steam pumper in the late 1950s to promote the Junior Fire Marshall program are the Kinghorn Insurance staff. From left to right are Maj. James Payet, Jeane Massey, Katherine Rosenblat, Russell Harley, Wyatt Pringle, Linda Driftmyer, and Opal Davis.

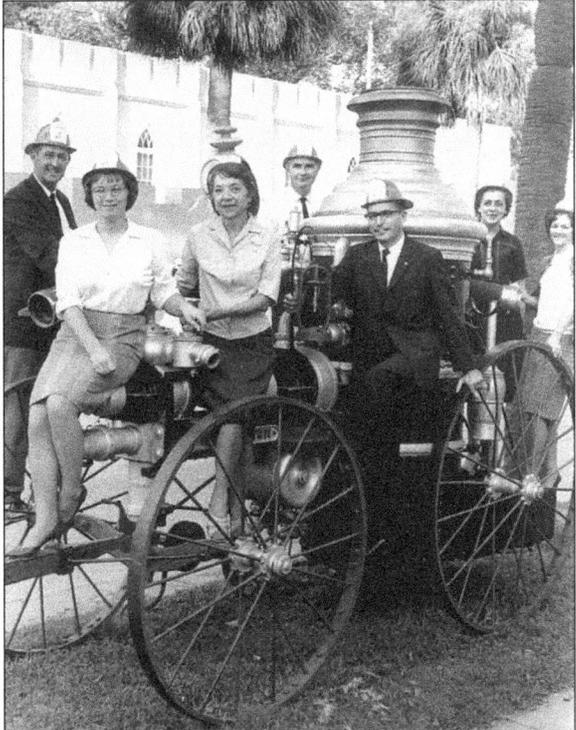

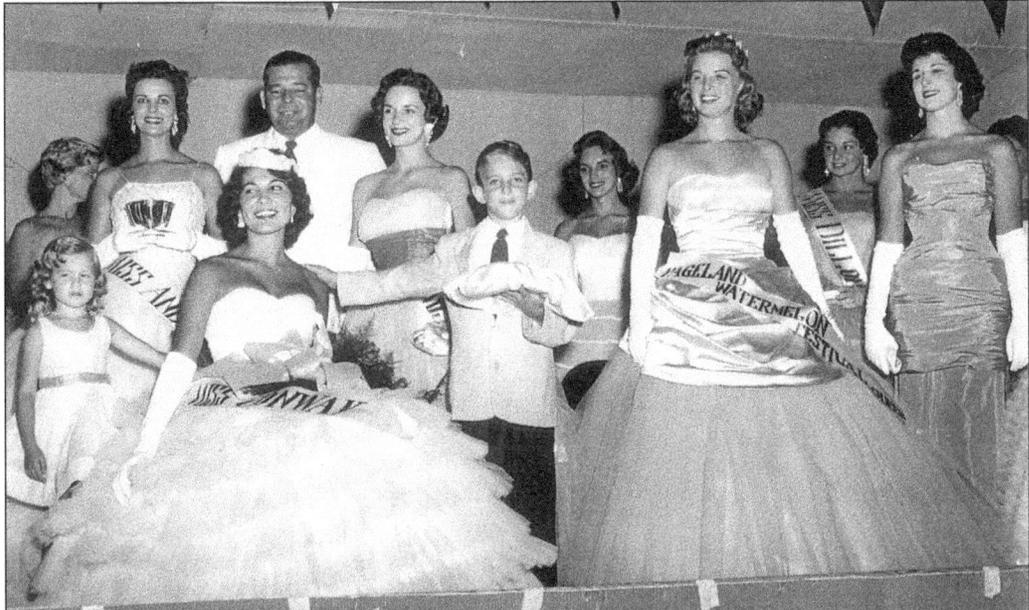

Barbara Mishoe, who already held the title of "Miss Conway," proudly wears the crown placed upon her head by Sen. James Waddell at the Water Festival in 1956. The flower girl is Connie Kearns (Tootle) and the crown-bearer is Lewis Greenly. The other beauties on stage are from various towns, each hoping to become Queen of the Carolinas Sea Islands. Senator Waddell was the keynote speaker at the Beaufort Memorial Hospital following its multi-million dollar improvements.

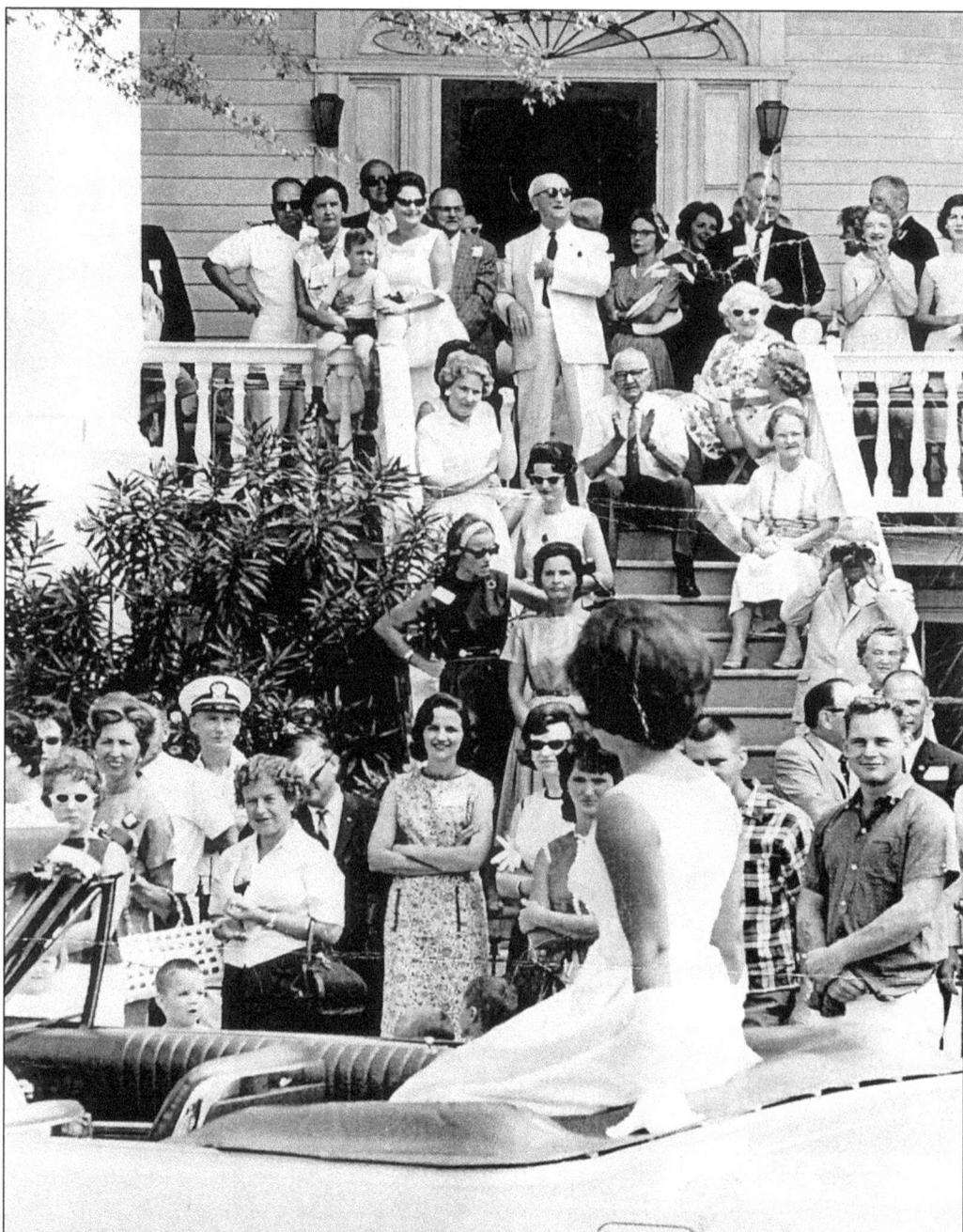

A large group watches the Water Festival parade on the steps of Hall House, now the George Elliott House, at 1001 Bay Street. Among those at street level, from left to right, are Jean Kearns, Gladys Thompson, and Dr. and Mrs. (Marcia) John Duffy. On the steps are Marjorie Fordham Trask, Marie Payette Peatross, Ed Rodgers, Billie Moody, Leamond Hall, and Mrs. James Byrnes. Standing on the porch are Dr. Dobyns, Mrs. Dobyns, Lee Bradbury, Posey Powell, Willie Scheper, Gov. James Byrnes, Helen Harvey, Bob Powell, and Becky McDowell.

Decoration Day Parade on May 30th is led by Freddie White (left) and Stanley Webb. Thousands of African Americans came to honor their war-dead; they prayed and decorated graves in the National Cemetery. Wreaths were set afloat in the Beaufort River on Memorial Sunday. Freddie was a navy man and Stanley served in the army. Stanley's daughter, Mae (Mendoza), graduated from Robert Smalls High School and has worked at the USCB Library since 1989.

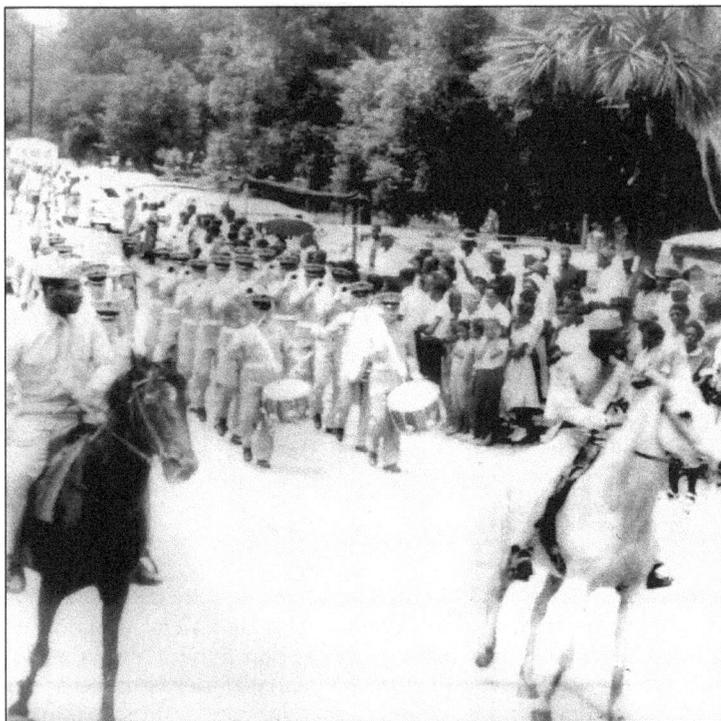

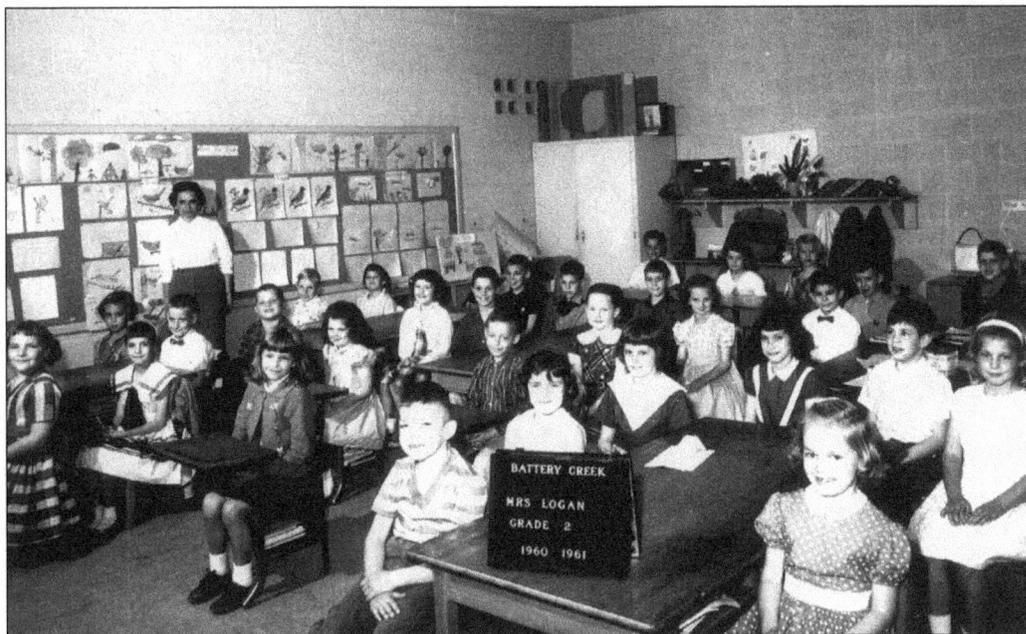

Here is Mrs. Hal (Mary Frances Polk) Logan's second-grade class of 1960–1961 at Battery Creek Elementary School on Burroughs Avenue. At recess, children played kickball, Red Rover, Last Tag, and other games in the schoolyard.

After playing barefooted all summer, Elizabeth (left) wouldn't wear shoes on the first day at Mossy Oaks Elementary School. Older sister Sandra always made sure she didn't get lost. The girls are the daughters of Russell and Kitty Harley. Elizabeth is married to Chris Willett and lives in Atlanta. Sandra and her husband, Scott Counts, live in Anderson, South Carolina.

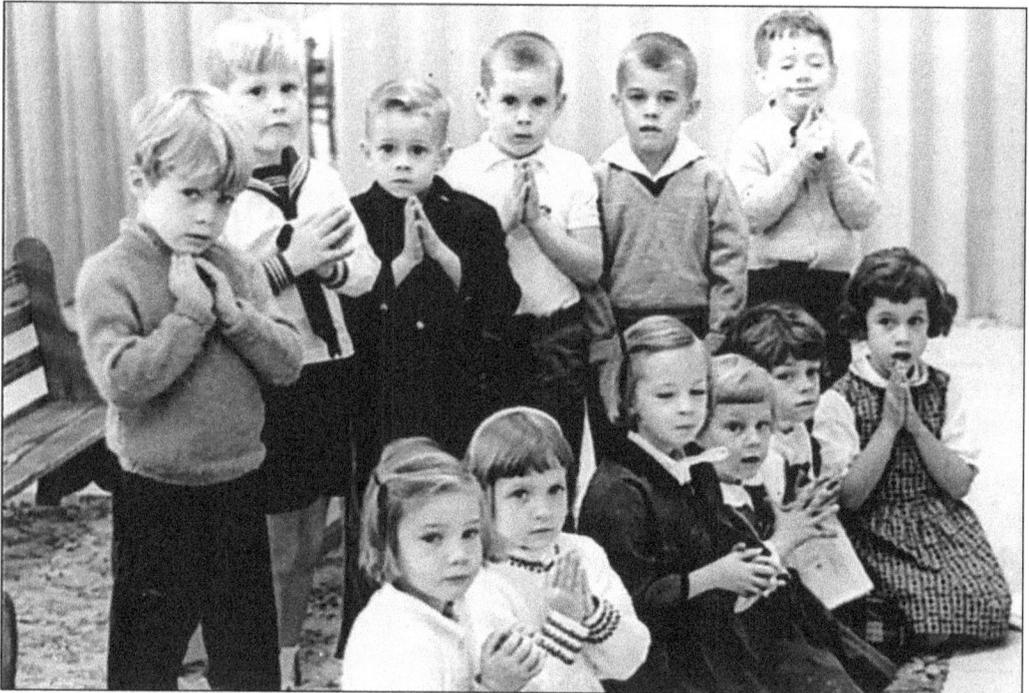

Young worshippers at Christ's Landing Sunday School at St. Helena's Church "steeple" their fingers for a blessing. Pictured from left to right are (front row) two unidentified children, Margaret Trask, Martha Ann Chauncey, and two more unidentified children; (back row) unidentified, Bruce Pratt, Porcher Pinckney, unidentified, William Scheper, and Andy Jones.

Toni Flowers (Shiver), daughter of Billy and Mary Flowers, attended Barrett School of Nursing in Augusta. She grew up on Old Salem Road in Burton. There was a special tree—half pecan and half walnut—on their property. Toni, her sisters Patsy and Geni, and brother Billy, played in a 300-year-old oak. Toni and her husband, C.B., have two children: Brinson, a doctor in Savannah, and Laura, a forest ranger in McBee, South Carolina.

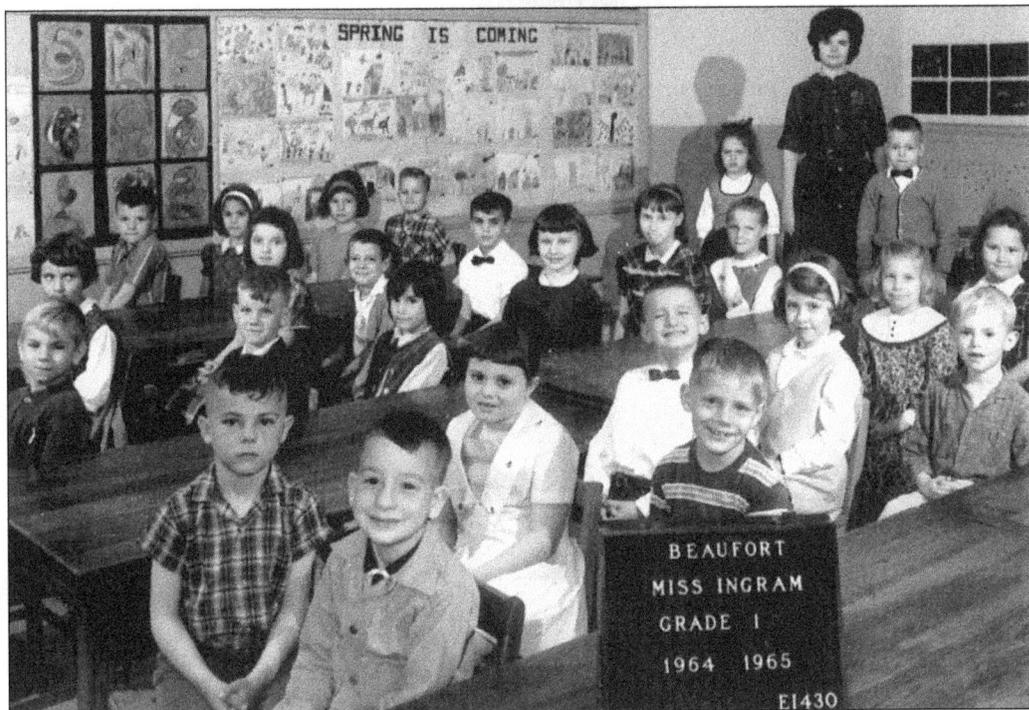

Mrs. Anne Ingram (Kennedy) taught first grade at Beaufort Elementary School where the Performing Arts Center is now located. The teased, back-combed lacquered beehive hairstyle was the rage back then. This photo was taken just before schools were integrated. Anne and her husband, Bill, live on Hancock Street on The Point.

Wyatt Pringle Jr. invited his chums to his sixth birthday party in 1965. Pictured from left to right are (front row) Angus F. Trask, Frances Pringle (Cherry), Marsha DeLoach, Frederick William Scheper IV, Craig Deloach, and the honoree; (second row) Tony Gile, Michelle Merritt, Henry Madlinger, and unidentified; (third row) Thomas Pratt, Reeve Sams, and King Merritt; (fourth row) Bruce Pratt Jr., Elizabeth Bond, and Darrell Smith.

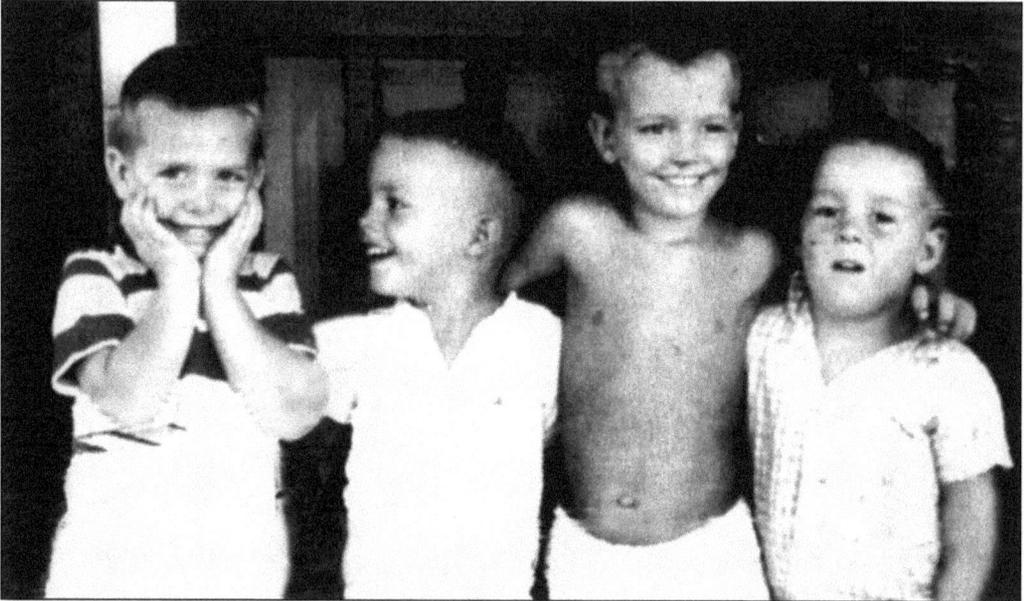

All professionals now, these little rascals had fun goofing off in the 1960s, "tumping over" in their sailboats and "chunking" rocks into puddles. Pictured from left to right, George Green now owns a florist shop in Columbia, Bill Chambers is an architect, Bill Harvey is an attorney, and Joe Chambers is a real estate appraiser.

80

The Beaufort Water Festival was dedicated to Mrs. Walter (Maisie) Terhune, fourth commodore of the festival and the only woman ever to serve in that capacity. Until her death in 1963, she was on the board of directors. On the foundation of her efforts and through the fulfillment of her vision, the festival continues to grow.

The Rotary Sweetheart Luncheon was held on Valentines Day 1968 at St. Helena's Parish house. Some of the special sweethearts are, from left to right, Mrs. Ira Smith, Mrs. A.E. Samuel Sr., Mrs. Earl Smith, Mrs. Fred Christensen, and Mrs. G.G. Dowling Sr. Ned Brown of the *Gazette* took the photo.

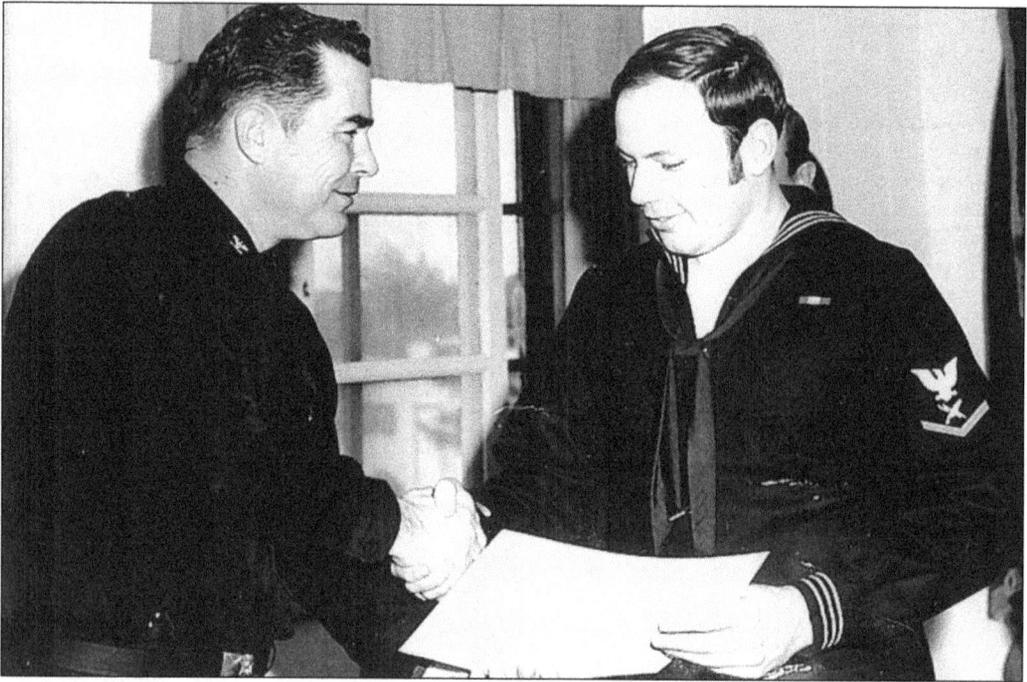

Richard Cappelmann was born on Friday the 13th, the 13th grandchild of a 13th grandchild. He was the son of Alma Stienmeyer and Claude Mitchell Cappelmann. Richard received the God and Country Award as an Eagle Scout and was professor of building technology at Beaufort Technical College. He is shown here (right) in 1968 with his naval recruiting officer.

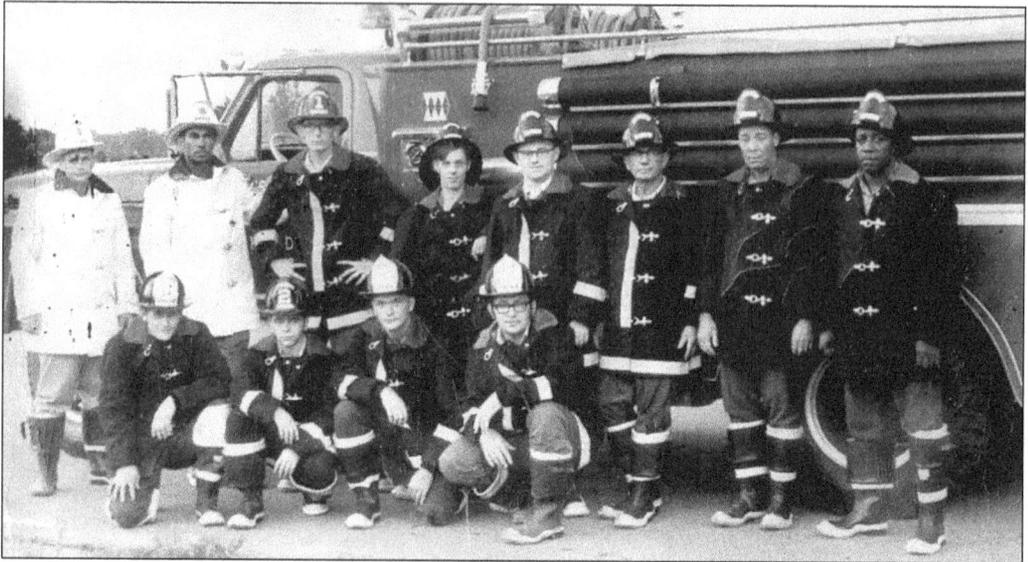

Here is the original crew of the Lady's Island/St Helena's Fire Department. Previously, island residents relied on firefighters from Beaufort and the Marine Corps Air Station—too far away. Standing, from left to right, are Chief Gus Blomquist, Assistant Chief Bubba Von Harten, Leland Smith, Bill Peters Jr., Donald Fanning, Harold Graves, Lawrence Broadus, and James Singleton. Kneeling, from left to right are, James Cooler, John Oram, Elmer Whitney, and Larry Poterfield. Thirty-three-year veteran Clayton Ellis is the fire chief today.

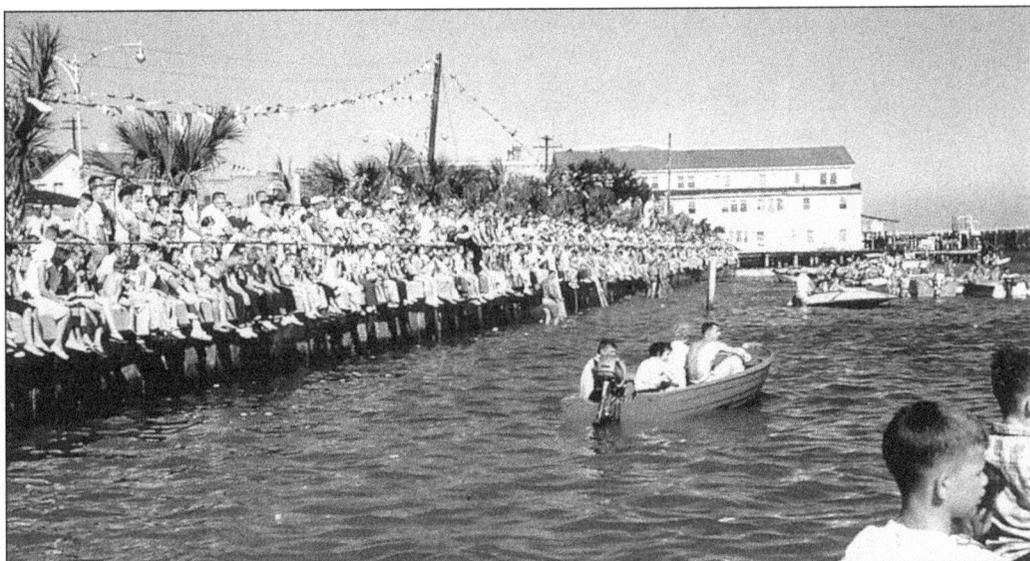

The crowd in the municipal parking lot watches the Water Festival. The building in the distance was the Waterhouse cotton gin west of the Breeze Theatre at the foot of Charles Street. The festival was incorporated in 1955 with a board of directors consisting of Edwin Pike, Marvin Dukes, R.G. McDowell, C.R. Powell, Ray Kearns, Henry Boyce, Jr., and James Gray. In 1958, golf was added to the events under the leadership of Sammy Gray, one of the originators.

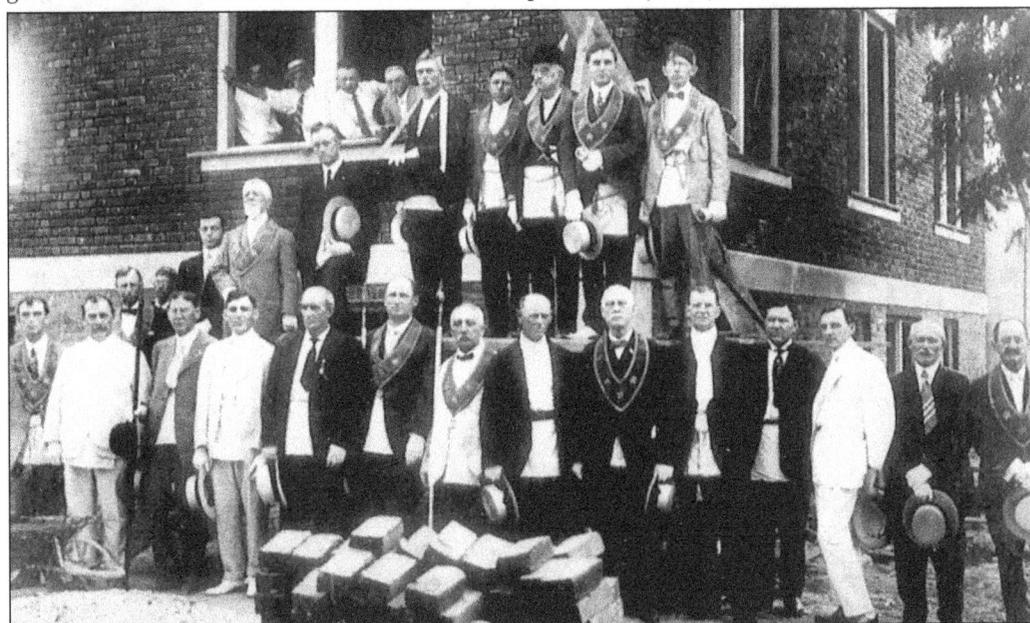

Copied off this photo of the Masonic Men at Carnegie Library are, from left to right, (front row) "E.B. Rodgers, Chas Danner, P.M. Epstein, Alex Levin, L.H. Edmonds, Wm. Ohhandt, Joe Keyserling, A.L. Gage, T.H. Harms, W.R. Bristol, Mr. Williams, L.A. Hall, Morris Levin, and Chas Cohen; (second row) W.M. Steinmeyer, P.H. Hay, Max Lipsitz, Benj. Burr, Rev. Turner, Nat. Cemetery Keeper, D. Mittle, S.H. Rodgers, Sam Levin, W.E. Richardson; in window H.C. Pollitzer, E.E. Lengnick." The building was later a courthouse and today houses the offices of city planning and codes.

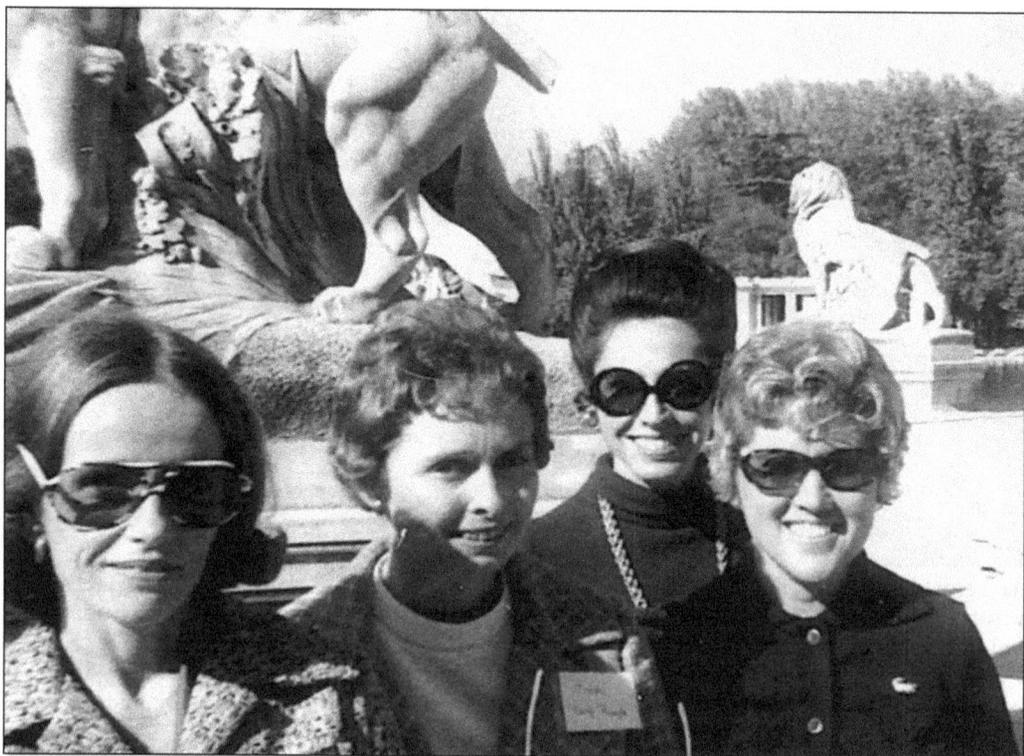

In 1971, Citadel grads and guests chartered a plane and left the gnats and humidity for an adventure to Spain. The pilot announced to the jolly travelers, "Sit down! Stabilize this plane or there'll be no more cocktails!" This photo was taken in Madrid. From left to right are Beaufortonians Marjorie Fordham (Trask), Sally Gray (Pringle), Cilla Jones (Dukes), and Jean Varn (Scheper).

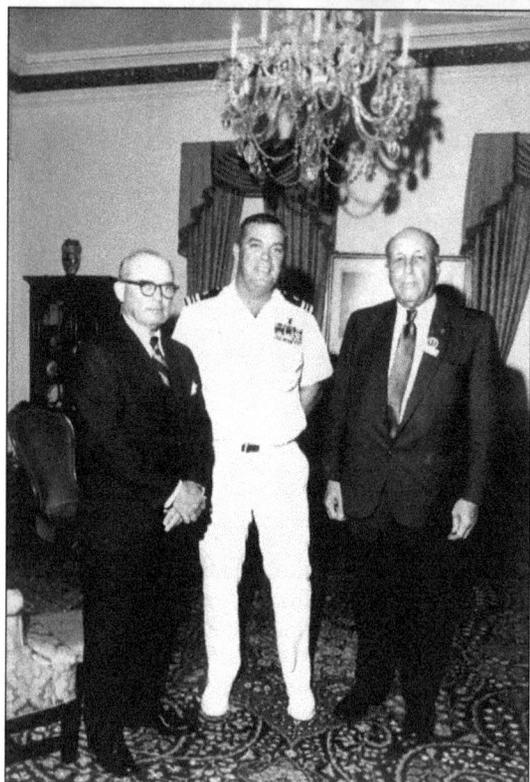

Retired Admiral Bob Hare (left) and Leroy Keyserling welcome the captain of the USS *Beaufort*, Arthur Erwin. A reception was held at Elliott House to hail the arrival of the ship in 1972.

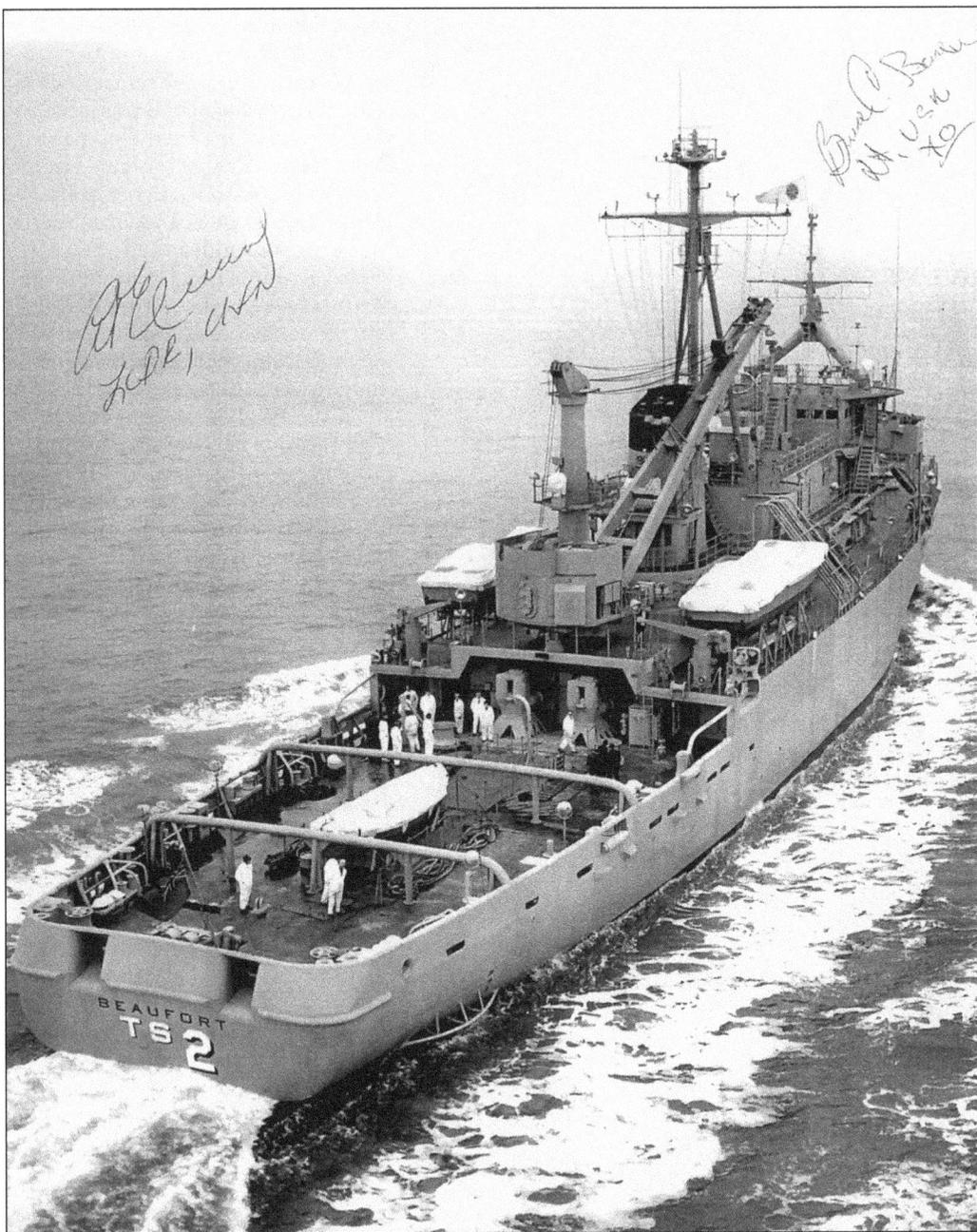

Beaufort's mayor, Henry Chambers, and Mayor Rogers Hunt of Beaufort, North Carolina, (pronounced "Bo fort") commissioned the USS *Beaufort* at the Norfork Naval Shipyard. They and others flew to Norfork with Port Royal Harbor pilot Ed Rodgers to bring her to Beaufort. The crew was hailed with shrimp boils and beer busts at the Armory and crabs, oysters, and fried catfish in backyards. The Anchor Inn at the Naval Hospital and the entire city welcomed the ship bearing its name before it left for the Panama Canal.

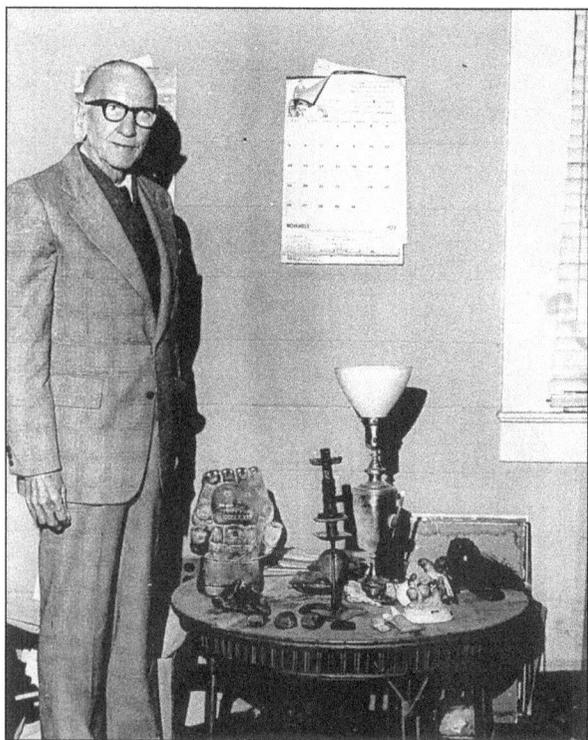

James Edwin McTeer (1903–1979) was sheriff of Beaufort County for 37 years, filling the remaining term of his father at the young age of 22. His grandmother, Florence Percy Heyward, was descended from Thomas Heyward Jr., signer of the Declaration of Independence. Sheriff McTeer commanded the U.S. Coast Guard mounted beach patrol for the Sixth Naval District during WWII. Over time, he became skilled at the practice of root medicine. The sheriff was the author of four books about the Beaufort area, including *High Sheriff of the Low Country* and *Beaufort Now and Then*. In 1979, he was honored by having the new bridge connecting Port Royal to Lady's Island named for him. In this photo, he is seen with some of his tools of "white" magic.

From left to right Dot Hand Chambers, Martin and Isabel Hoogenboom, and Owen Chambers gather at Oak Grove Plantation for Nan Campbell (Kinsey's) debutante party in the 1970s. Each year, daughters of prominent families were introduced to society with a round of oyster roasts, teas, swimming parties, and balls.

Gerhard Spieler was born in Ballenstedt, Germany and came to Beaufort in 1967. He is a well-known Low Country historian and journalist and married to Ruth deTreville. This photo was taken on Hunting Island in the 1980s. The beach under trees becomes eroded from water and wind and many trees are uprooted during storms.

Madeleine Pollitzer prepared the meal for the grand opening of Royal Pines Country Club in 1972. She received a letter from Walter Rodgers, chairman of the board of the club, congratulating her for such a good job. Madeleine started the first catering business in Beaufort, then began a dancing school, and later helped start the children's Pony Club.

In 1975, Boy Scouts from all over the United States went to Idaho for the National Jamboree. This photo shows Beaufort boys, uniformed and packed, leaving to join the fun. From left to right are Henry Chambers, Steven Demosthenes, Joe Chambers, Jonathon Keyserling, Tommy Keyserling, Charles Demosthenes, and Stratton Demosthenes. Kneeling from left to right are Bill Chambers and Bill Harvey.

The Hon. T. Legare Rodgers (seated) was Clerk of the Court of General Sessions for 20 years. He succeeded his mother, Elma Gay Rodgers (seated), who was clerk for four years. She succeeded Edward Burton "Burt" Rodgers, her husband, who succeeded his father, Hon. Samuel Henry Rodgers. This family gave 72 years of fine service to this office. From left to right (standing) are Edward, Henry, Burt, and Walter. Brother John is not pictured.

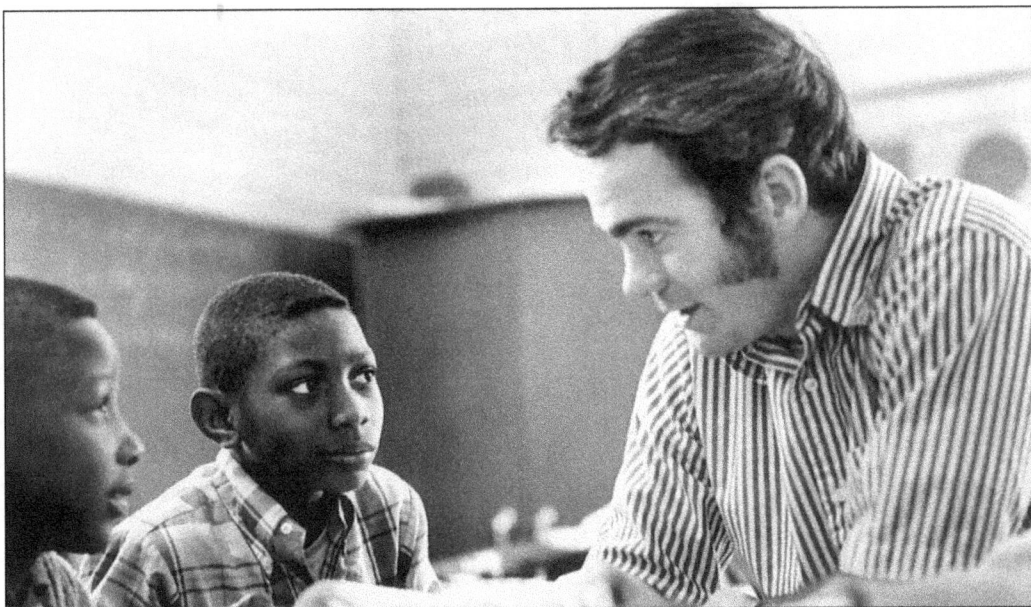

Pat Conroy taught in a one-room school house on Daufuskie Island. He wrote about this experience in *The Water is Wide*, later made into the movie *Conrack*. Willie Scheper, president of the Peoples Bank, helped him self-publish *The Boo* about Citadel life. Subsequent books were *The Great Santini*, *The Lords of Discipline*, *The Prince of Tides*, and *My Losing Season*. Here he mesmerizes two boys with a riveting tale in the classroom on Daufuskie. (Courtesy of the University of South Carolina Beaufort Library.)

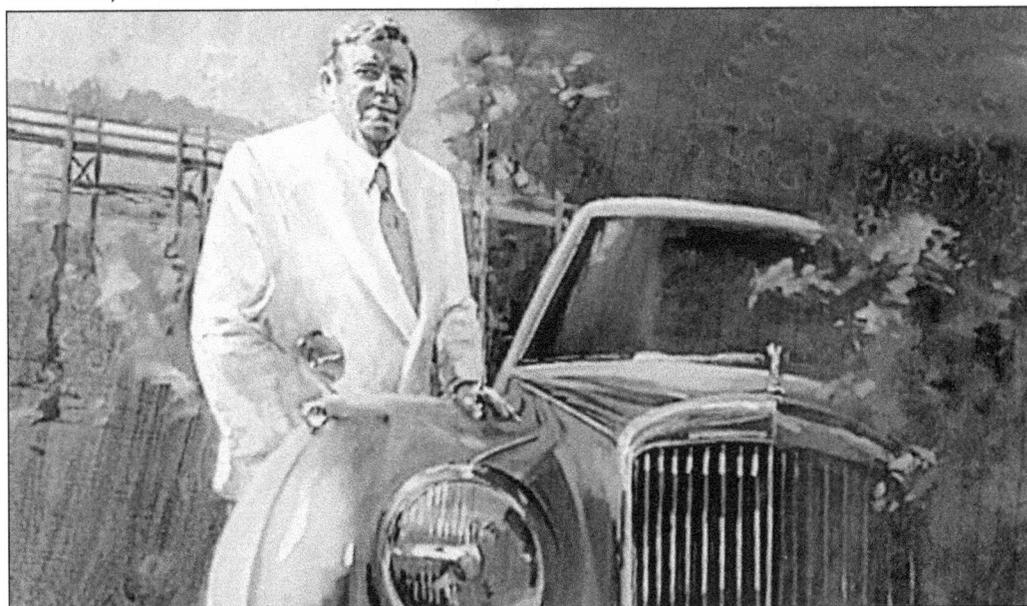

Roger Pinckney X served as coroner of Beaufort County for 35 years and was a builder of docks, including this one as barter for this classic Bentley. Coby Whitmore, who painted covers for *Ladies Home Journal*, *Good Housekeeping*, and others, was the artist of this portrait. Roger and wis wife, Chloe Martin, were married 58 years. He died at age 91 and his tombstone reads "Beaufort's Raconteur Extraordinaire."

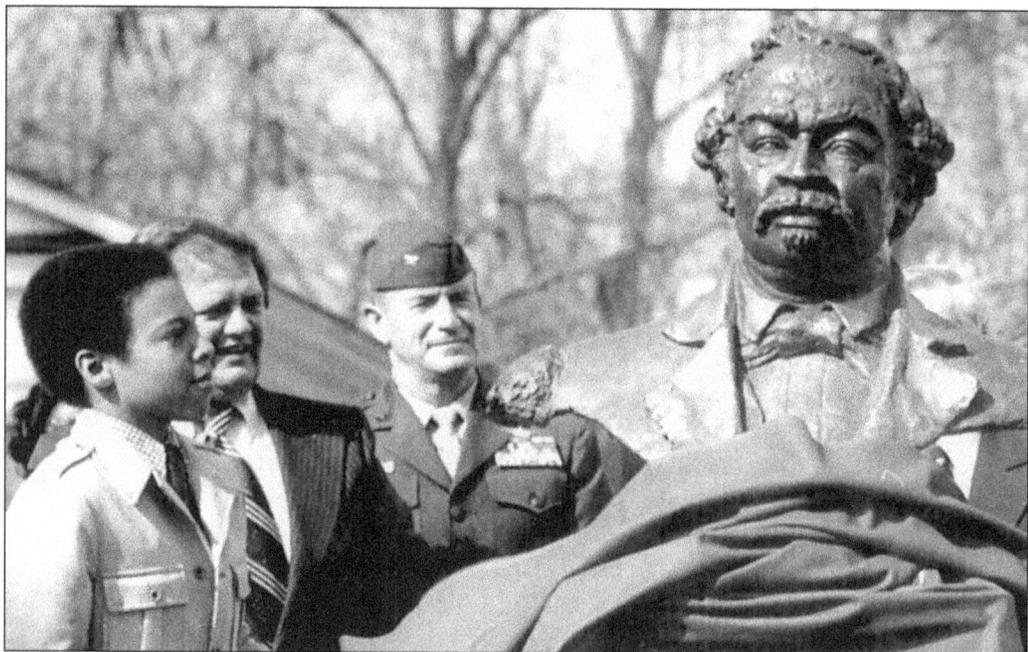

The unveiling of the bronze bust of Robert Smalls in 1976 took place at the Tabernacle Baptist Church on Craven Street. Robert Smalls (1839–1916) turned his dream of freedom into reality by commandeering the Confederate ship *Planter* and handing it over to Union forces and freedom. He later became a state legislator and U.S. Congressman. Pictured from left to right are the great-great grandson of Robert Smalls, Michael Moore; U.S. Congressman of Beaufort Congressional district, Wendell Davis; and Col. Paul Siegmund of the U.S. Marine Corps Air Station. The sculpture was by Marion Ethredge. (Courtesy of the University of South Carolina Beaufort Library.)

Gwyneth and Jake Paltrow came with their mother, Blythe Danner, for the premier of *The Great Santini* at the Plaza Theater in 1977. They arrived by train into Yemassee, South Carolina. Blythe had broken a toe on a hide-a-bed and was on crutches. She played the part of Lila Wingo in the movie. From left to right are Gwyneth, Hugh Patrick, and Jake.

Returning for the premier of *The Great Santini*, here are Robert Duvall (left) and Blythe Danner being escorted about the town by Mayor Henry Chambers. Film crews love this picturesque town with its angel oaks, old mansions, vibrant waterfront, and friendly residents.

Eighty-seven-year-old Scipio Stuart lived near the Broad River and regularly sailed 40 miles to Savannah in a 16-foot bateau loaded with vegetables to sell in the old City Market. For 25¢, he bought bananas and an armful of soda crackers. His biggest thrill was riding the mule-drawn trolley car. For 52 years, he was a deacon in the Macedonia Baptist Church near Burton.

Here are the Community Gospel Singers in 1979 at Port Royal. From left to right are Nathaniel Roberts, Henry Robinson, Edward "Tex" Washington, Ella Parker, Walter Mac, Willielee Fyall, John Parker, Dola Mae Williams, and Deacon Joseph Simmons, who died one day before his 100th birthday. He is buried in the National Cemetery with the Buffalo Soldiers, two cavalry and four infantry regiments established by Congress in 1866. Most of the black recruits had served in the Union Army during the Civil War.

Old friends and longtime Beaufortonians wouldn't live anywhere else! Pictured from left to right are John and Caroline Trask, Marvin and Cilla Dukes, Paul and Marjorie Trask, and Wyatt and Sally Pringle. Orange Grove Plantation on St. Helena Island, owned by John and Caroline Trask, is in the background.

The first grade at school is always somewhat daunting as attested to by Paige Lewis, Ashley Williams, and Caroline Fordham. This photo was taken at Mossy Oaks School in 1981.

The Gettys family values "togetherness" at sunset at 315 Federal Street. Pictured from left to right are Jim, Bruce ("Mom"), Riley, and Harriet (Coleman). "Dad" owned a chemical company in Hartsville and later taught physical science and chemistry at University of South Carolina Beaufort. Both he and Bruce were active in Historic Beaufort Foundation. Bruce often laughed over her name, saying she had been drafted many times! Their daughter Mary Patrick (not pictured) is an active member of Clover Club, a music and literary organization, and a popular personality about town.

The Clover Club was founded in 1891 as a music and literary society by Mary Waterhouse (founder and secretary), Mabel Danner (treasurer), Julia Pollitzer (president), and Grace Bristol (vice president.) Their motto is "For the best that thou canst be, is the service asked of thee." It is a privilege to hold a membership in this time-honored organization. In this charming 1966 photo, members of the club, from left to right, are (front row) Mrs. Charles Webb, Mrs. Rivers Varn, Mrs. Thomas Cheatham, Mrs. Edward Sanders, Mrs. Edwin McTeer, Mrs. F.W. Scheper Jr., and Mrs. Lloyd Brown; (middle row) Mrs. John Hollins, Mrs. Riley Gettys, Mrs. G.G. Dowling, Mrs. Maurice Matteson, Mrs. J.W. Gray, Mrs. Burns Jones, Mrs. Richard Bateson, Mrs. W.J. Montgomery, Mrs. Reese Lindsay, Mrs. Morris Cooke, and Mrs. Hugh Pearson; (back row) Mrs. Ross M. Saunders, Mrs. John Broz, Mrs. Brantley Harvey Jr., Mrs. Paul Trask, Mrs. Wyatt Pringle, Mrs. John Hryharrow, and Mrs. F.W. Scheper III.

Jim Williams (center) was the main character in John Berendt's best-seller *Midnight in the Garden of Good and Evil* about Savannah's eccentric characters. Jim restored homes in Beaufort and Savannah. Every Christmas he gave a elegant black-tie cocktail party in his home, Mercer House, on Monterey Square in Savannah. Jim's guests from Beaufort were, from left to right, John and Mary Murphy and Caroline and John Trask Jr.

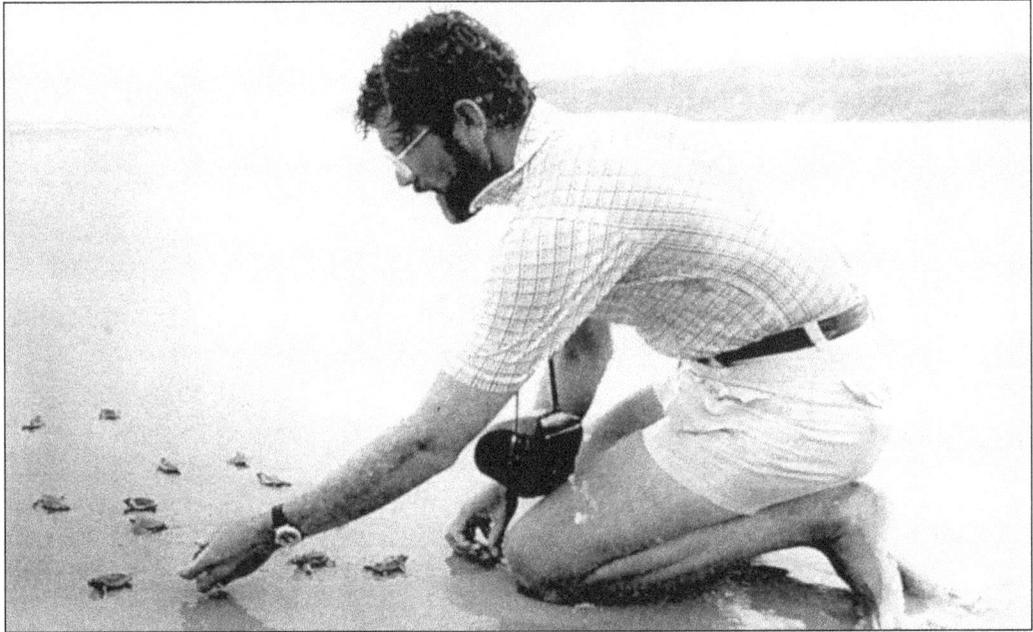

David McCollum, associate biology professor at University of South Carolina Beaufort, escorts baby Loggerhead turtles on Pritchards Island to the ocean before the conservation program began in 1982. Phil Rhodes, who owned the island, was worried about turtle survival. When David McCollum, Dr. Ed Caine, David Gorynski, and Elly Levin volunteered to help, Joe Mix and Gibbs McDowell offered the use of their fishing camp and a vast number of turtles were saved. Mr. Rhodes donated the island to the University of South Carolina. The project is managed by Bo and Amber Von Harten today.

The Loggerhead Hilton was built by David McCollum, Buck Morris, and an older man called "Mother." The Egyptian method of construction was used with levers, pulleys, and ropes to muscle the pilings into the ground. The "Hilton" ultimately washed away. The project has been in four different buildings since then. On the roof is Drew Cain and and another volunteer.

For four years in a row, the commodore of the Water Festival was a Citadel graduate: Bill Robinson (1982), Skeet Von Harten (1983), Duncan Fordham (1984), and George Brown (1985). The Pirettes, 12 local high school girls, were official hostesses. Commodore Robinson chose the theme of "Getting to Know Our Neighbors" and invited Charleston mayor Joseph Riley and Savannah mayor John Rousakis as guests in the parade in 1982. From left to right are Brown, Fordham, Von Harten, and Robinson.

Helen Harvey and Brantley Harvey are shown at a party at Oak Grove Plantation. Helen was a founder and owner of Lowcountry Real Estate and mother of the year in 1999. Brantley was lieutenant governor of South Carolina from 1974 to 1978 and a founding member of the Beaufort orchestra. As a boy, he took violin lessons from Rita Crofut, a highly accomplished musician.

In the late 1980s, Bay Point Island, owned by the McLeod family, was sold to Prince Faisal of Saudi Arabia. Walter Greer, artist and resident of Hilton Head, dressed as the prince for a take-off on the Arabs buying up large properties in South Carolina. He is in front of Henry Chamber's family home. Henry, mayor of Beaufort from 1969 to 1990, was born in 1928 in the room at top left.

This is an original painting of Beaufort by Parks Duffey III, from the collection of Mr. and Mrs. John Trask Jr.

As the sun sets and friends gather on the dock, Frogmore Stew, made with sausage, corn, crabs, shrimp, and potatoes, is served. Newspaper is spread out and the stew is "tumped" onto the table for guests to scoop and enjoy. On the Kennedys' dock are, from left to right, Caroline Corey (Coslick), Connie McGraw, Frank Coslick, and Janet Martin (Deaton). "Frogmore" was the name of Queen Victoria's hunting lodge in Scotland.

On her 80th birthday, Chlotilde Rowell (Martin) serves the cake. She was a feature journalist for *The News and Courier* and wrote the popular column, "Low Country Gossip." She was also the first woman reporter in South Carolina on *The State* newspaper. Margaret (Pinckney) (Savage) is shown looking over the shoulder of Elizabeth Parker (Goldsborough). When Eddie Rickenbacker started a flying school in Columbia, South Carolina he asked for volunteers to fly with him. Chlotilde's hand shot up eagerly. She flew with him and covered the story.

In 1852, Berners Barnwell Sams built this residence for his wife and 15 children. He died before the house was completed. In the rear remain the tabby servant's quarters, which housed a blacksmith, cookhouse, and laundry. The home faces the "Front Green," used as a drilling ground while the country was at war. The building was a hospital during the war and later an Episcopal rectory. John Broz, owner of an export shipping business, stands next to the Doric columns of his wife's family home.

Margaret Raney (Scheper) and her husband, F.W. Scheper, president of the Peoples Bank, bought this house at 303 Federal Street in 1931 for $5,000. Today it is owned by Sharon and Dick Stewart. Mrs. Scheper, a gracious Southern lady born in Bamburg, South Carolina, invited tourists up on her porch for minted iced tea. She was a member of the Clover Club, the Garden Club, and St. Helena's Church. She died in 1996 at age 94.

In 1923, Rev. R. Maynard Marshall and Mrs. B. Ellis deTreville developed a plan to clean the over-growth from the ruins of the Sheldon Church. Under the direction of young Roger Pinckney, the junior choir and parents worked many weekends. This enthusiasm led to the memorable worship service at the ruins, which is held annually on the second Sunday after Easter with picnics and old friends. Names to be remembered in connection with this fine event are Billy and Helen Campbell, Eleanor and Rivers Varn, Roy and Claire Attaway, Margaret and Bill Scheper, Mrs. Arthur Sams, and Mrs. Marshall, assistant choir director. In 1945, Bill and Biz Campbell took charge of maintaining the grounds and arranging the many weddings conducted here. Bill is a highly decorated soldier for work behind German lines in World War II. Pictured with the Campbells is Rev. Frank F. Limehouse III, senior rector of St. Helena's Church.

Julia Seay (Kinghorn) from Anderson, South Carolina, daughter of the minister at First Baptist Church, met her future husband at the parsonage. With shaven head, the tall freshman from Clemson received "nary" a glance from Julia. When the red hair grew back, Julia's eyebrows danced. They have been married 63 years and have 3 children: Louise (Smithwick), Andy Jr., and Dorothy (Huggins). The happy pair listens to evening crickets at Fripp Island with their great-granddaughter, Marie Smithwick.

A familiar person around town is Dr. Lawrence Rowland, Professor Emeritus at University of South Carolina Beaufort and a scholarly historian. His wife, Margo Hunter, is on the left with Grace White, the first female lawyer in Beaufort County. The Zonta Club, a female service club, honored Grace White, Frieda Mitchell (a teacher known for her work in child advocacy), and others in its Female Focus program in 2001.

Many on Port Royal recall Miss Annie Mae Ingram. She arrived with her husband in 1926 and worked as a domestic, earning an hourly wage of 10¢. She took the ferryboat to Parris Island for her employment. Working as a midwife, she ushered many babies into the world. She was a member of the Union Baptist Church on Port Royal and belonged to The Order of Eastern Star.

The television show *Gullah Gullah Island* kept youngsters smiling. Ron and Natalie Daise sang and acted skits of a family on a fictitious island off the east coast. The stories focus on the Gullah dialect and culture, a heritage from West Africa and indigenous to the Sea Islands off South Carolina and Georgia. Sara and Simeon, Shaina Freeman, James Coleman II, and Vanessa Baden are pictured.

Matilda Middleton grew up on St. Helena Island. As children, she and her brother cut marsh grass for the horse at low tide with a scythe. The cow munched Spanish moss. Matilda rowed her bateau in the creeks and caught bushels of crabs with hand-lines baited with chicken necks. Her mother grew sweet potatoes, peas, and made grits from corn. And sugar cane . . . "Ummmmmm, good!" At 96, she attends Ebenezer Church with Rev. Leonard Ritter Sr. officiating. Her most inspiring hymn is "There's Power in the Blood."

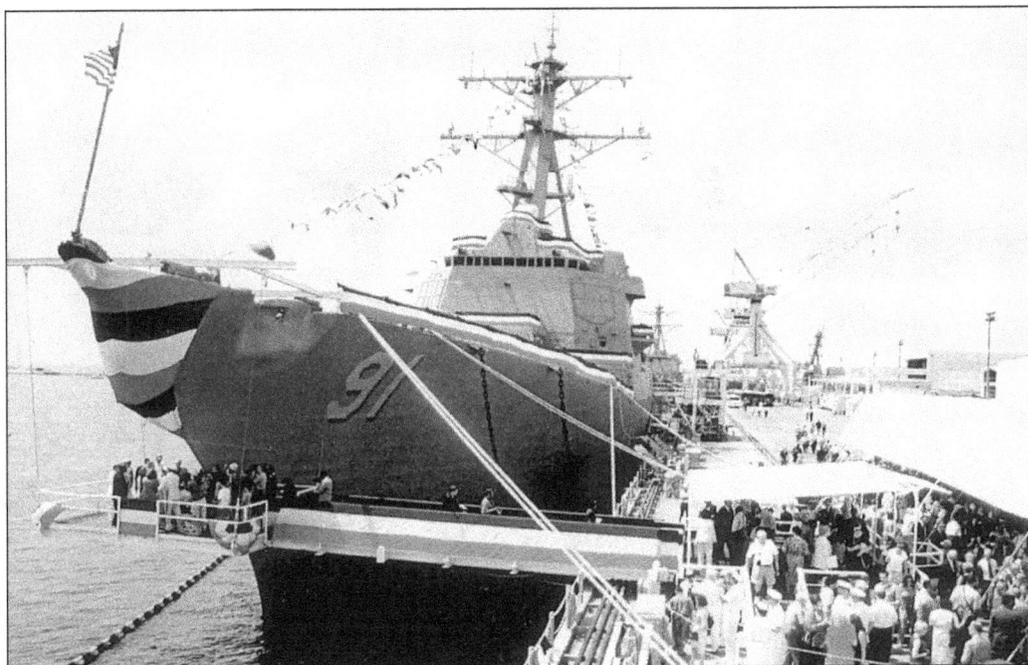

William Pinckney (1915–1975) was a navy cook aboard the USS *Enterprise* during the Battle of Santa Cruz in 1942. An explosion killed four of the six men in the ammunition room. Temporarily blinded, he carried a wounded survivor to safety through smoke and fumes, a deed that earned him the Navy Cross. The destroyer DDG-91 was named *Pinckney* in his honor.

In June 2002, his widow, Henrietta Pinckney from Lady's Island, and family from New York were flown to Pascagoula, Mississippi, for the launching of the *Pinckney*. Navy secretary Richard Danzig remarked, "William Pinckney embodied the Navy's value of selfless service."

In 2000, a unique art project came to town. The Arts Council of Beaufort County rounded up these delightful creations. Chicago's *Cows on Parade*, 300 life-sized decorated cows, cut two dozen from their herd and shipped them to Beaufort. *Cows on Vacation* were placed in parks, on sidewalks, on porches, etc. This one was at the Visitors' Center, sponsored by Howell, Gibson and Hughes, P.A. Tom McCaffrey painted the cow.

"Miss Dottie" McDaniel of Craven Street is a colorful character sauntering around town and riding her bike. She was married to two different Cecils at different times: Cecil Clark and Cecil McDaniel, both from Beaufort. She attends St. Helena's Church and for exercise swims in "Chloe's Creek," officially Pinckney Creek on the map, at Pigeon Point.

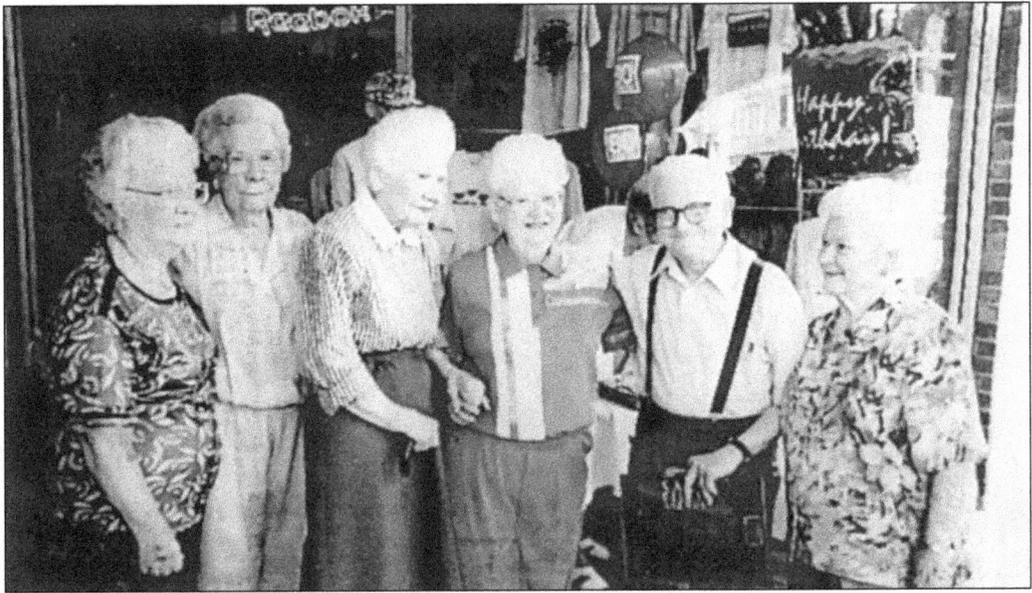

Max and Bertha Lipsitz, Lithuanian immigrants, opened their department store on Bay Street in 1902. Their son, Joe, was honored at a party given by the city for his 80th birthday in May 2000. The photo shows the Lipsitzs and employees who have worked at the store between 10 and 59 years. From left to right are Effie Martin, Aline Moore, Margaret Priester, Lucille and Joe Lipsitz, and Pauline Smith.

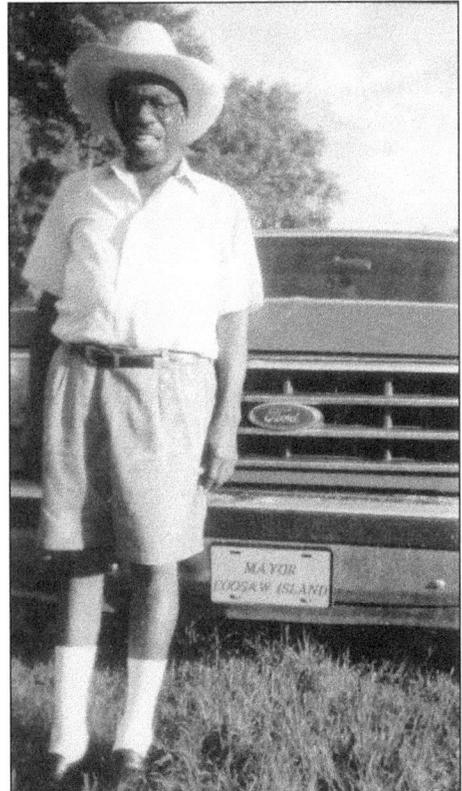

Eighty-year-old Peter Brown, the unofficial mayor of Coosaw, was born in 1923 on the island. In his youth, he often "swam the cows," hanging onto a tail, across Lucy Creek to market. As boys on Decoration Day, also called Emancipation Day, he and friends walked barefooted over the bridge to Bay Street. Arriving into town, they put on shoes to participate in the parade festivities.

A Fantasy

Oh! When the sun's a-rising
 It seems to send a ray
Of special, glorious beauty
 Out across our Bay;
The waking river shimmers
 Like a woman's silken gown
While morning breaks in glory
 Over Beaufort Town.

The marshes, stretching seaward
 (A shawl, with fringes deep,)
Would will the flowing waters
 In closer folds to keep; —
But, swelling o'er its confines,
 In current strong and free,
It hears its Ocean Mother, and hurries
 To the sea; — Then, like an ardent
Lover who fears his lady's frown
 It turns, to hold in winding arms
The shores of Beaufort Town.

When the sun's a-sinking
 The sky's a golden glow
With all its flaming color
 Reflected down below,
(For in the shining river, each ray falls
 glistening down)
Thus evening brings the sunset
 To homes in Beaufort Town.

When moonlight floods the harbor
 And high tide sweeps the shore,
One sees a path, beyond the stars
 Straight up to Heaven's door.
Its portals seem to open
 While rays of light come down,
And like a benediction
 They rest on Beaufort Town.

Ah! — When I am a-dying,
 And close the shadows creep
To this place I'd ask to come,
 To sleep my last long sleep —
For in its soft warm mantle
 They'd gently lay me down,
So, — I would be as I would wish
 A part of Beaufort Town.

— Mary Fuller Hull

Nancy Ricker (Rhett) is a well-known artist in the Low Country with a gallery on Bay Street and one at Frogmore. She painted this waterfront scene with the little boy feeding the hungry gulls and the shrimper shaking out his castnet.

Mary Fuller Hull (1870–1955) wrote the sensitive poem to the left. She is now a part of her beloved Beaufort town as she desired and is buried at St. Helena's Church.

Three

WEEKEND MERRIMENT

These bathers have an uplifting feeling as they frolic on a barrier island in the 1920s. These islands are long, narrow landforms of unconsolidated, shifting sands that block winds and protect the mainland. They are vulnerable to the assaults of man, bridges, and development. Left alone as nature intended, they can handle battering winds and rain. They migrate in response to changing currents and rising tides.

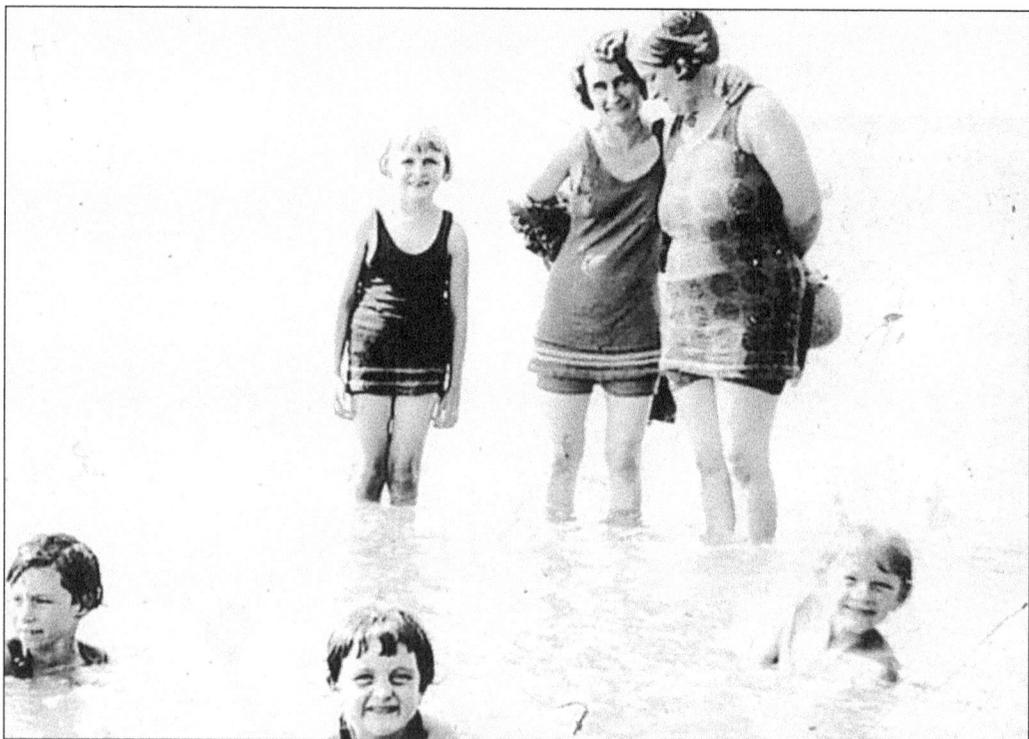

This happy photo in the 1920s shows bathers in swimming costumes at Burckmyer Beach on Lady's Island. The Boy Scouts had a camp here in the 1930s and 1940s. There were bathhouses, a pavilion, and a jukebox. Entrepreneurs Julian Levin, Harry Smith, and John Maddox bought a bowling alley in Vidalia, Georgia for $300 and trucked it here. After leveling the ground, they operated perhaps the only outdoor bowling alley in America. Alas! The high tides caused by the 1940 hurricane floated their investment away!

In 1928, best friends Marjorie Hope McLeod (Fordham) (left) and Virginia Burckmyer (Froneberger) hang onto the stern of a barnacled bateau in the Beaufort River.

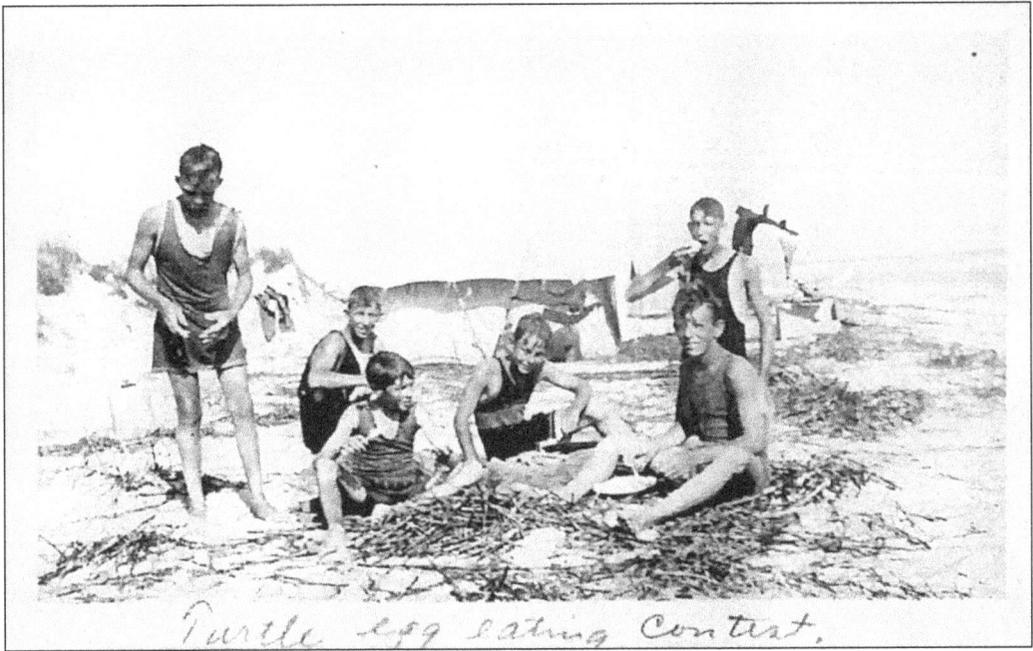

Turtle egg eating contest.

Notation on this old photo taken in 1929 says "Turtle egg eating contest." This was in the days when turtles were not endangered. The eggs are the size of ping pong balls and the leathery shells can easily be torn, squeezed, and the contents slurped for a delightful raw delicacy.

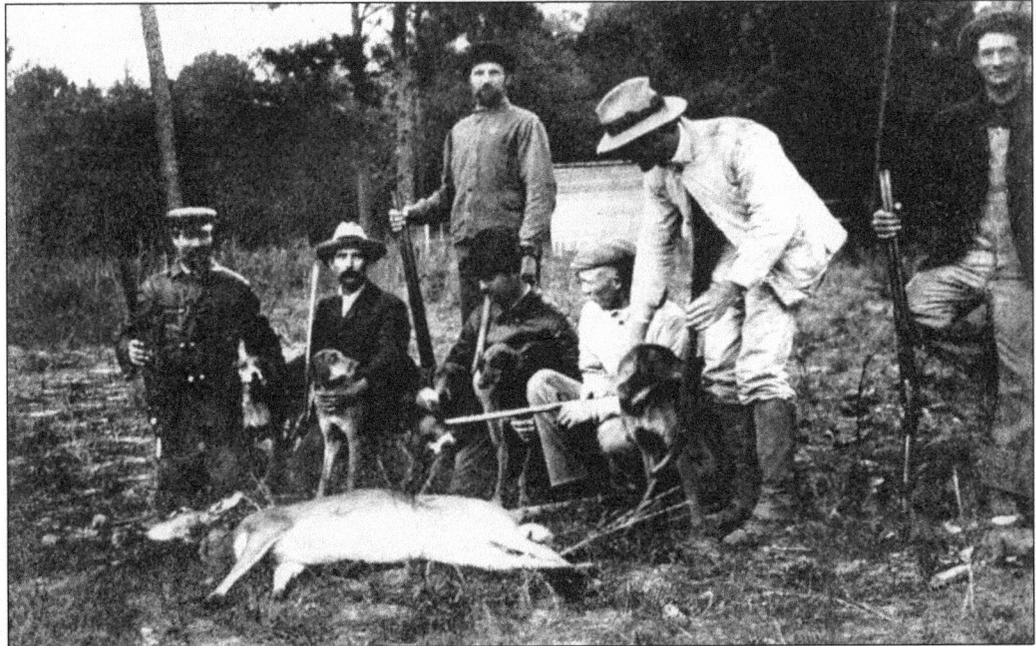

In 1930, seven of the Pinckney brothers hunted deer on Halls Island. Hunters drove the swamps and thickets with deer hounds and finished the day with a pot of deer "burgoo," a savory stew with rice or a wild pig roasted over the fire while the venison is divided up. From left to right are (front row) Coatesworth, James Porcher Sr., Dessy, and Eustace; (standing) Willie, Joe, and Tom.

Wearing her bathing cap, Elizabeth "Zip" Ricker, left, is off to the races aboard the barnacled back of this giant Loggerhead. Part of swimming attire was a bathing cap to keep her Marcel wave dry. (A wet Marcel had the tendency to straighten out and looked dreadful for a cute date that night.) An earlier photo, right, shows Florence Tucker (Physioc) hitching a ride as the turtle returns to the ocean after laying 150 eggs.

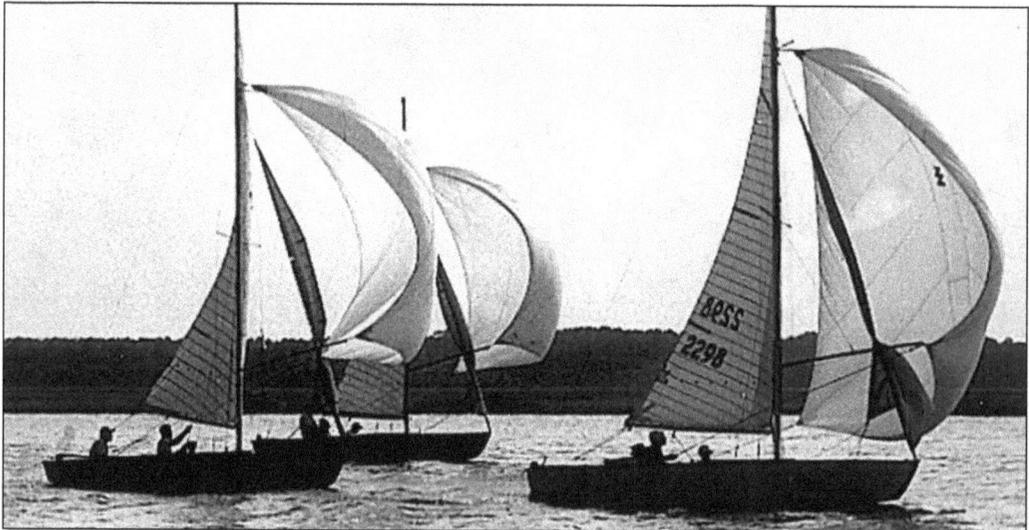

The Lightening classes were large and confusing as many boats jostled for position at the starting line. Henry Edmunds, commodore of the Charleston Yacht Club and chairman of the races, was petitioned to widen the space between the buoys marking the start. Adhering to the rulebook, he responded, "We've denied the request because the starting line is crystallized to the spot."

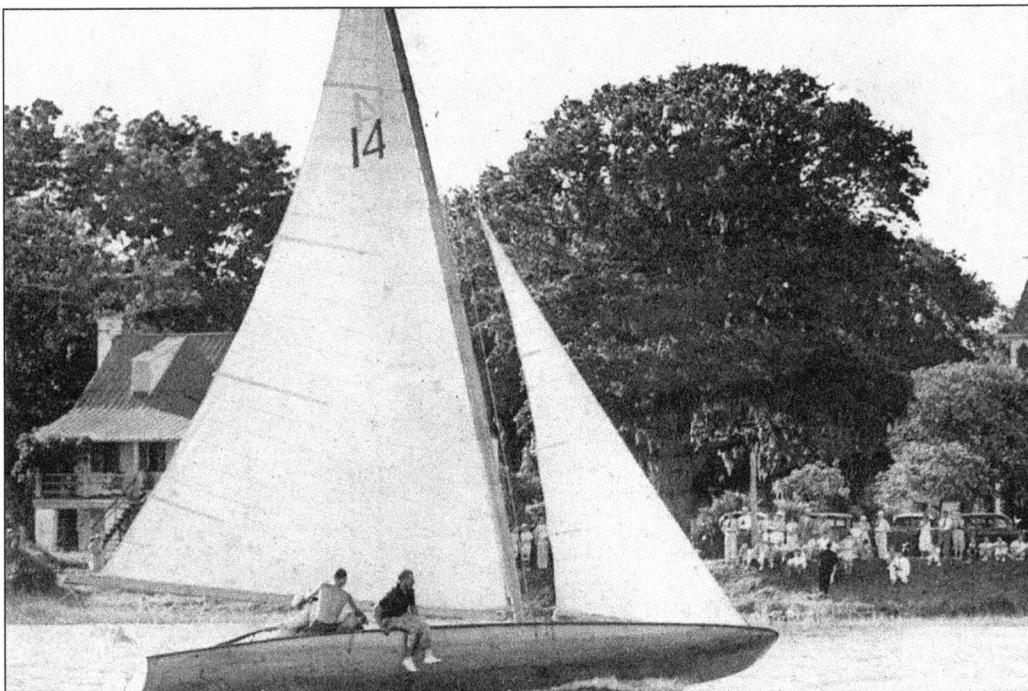

This photo shows the *Syndicate* racing at Rockville with spectators on the banks. Dick Bray is on the left with Mr. Willie Scheper dangling over the side.

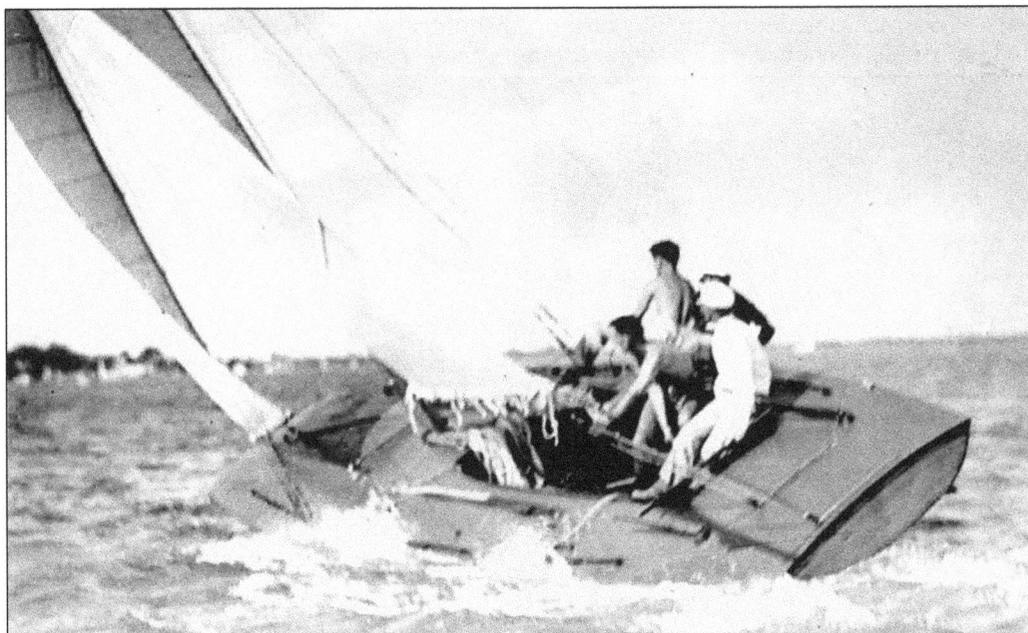

The *Syndicate*, a 30-foot Class A Scow, owned by "Mr. Willie" Scheper Jr., was champion of the South Atlantic Racing Association, 1936–1937. This photo was taken by M.B. Paine in 1937. Often crewing were Burt Rodgers, Legare Rodgers, Dick Bray, Swede Nilson, and Willie Scheper III. More crew were Walter Rodgers, Kinghorn brothers, McLeod brothers, Charles Luther, James Thomas, and other lucky ones.

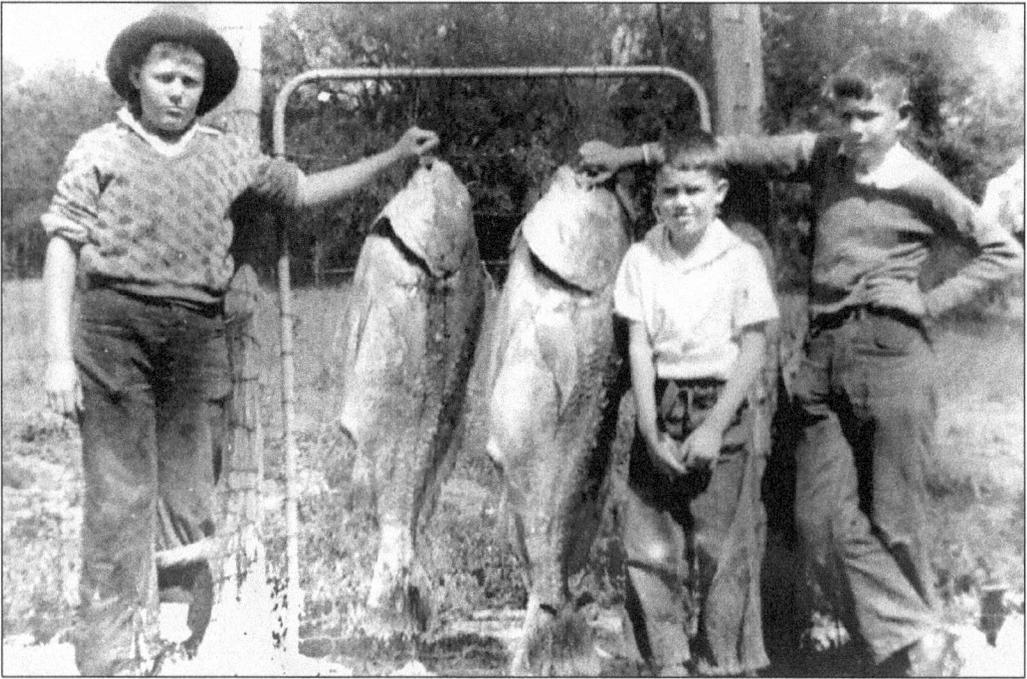

The McGowan brothers will have drumfish for months! From left to right are Beau Sam, Ed, and Pierre. These 60-pound giants could be caught, using a whole blue crab as bait, in Port Royal or St. Helena Sound. Another favorite fishing drop was the wreck of the *Savannah*, a potato boat that sank during the hurricane of 1893. Julian Levin, Harry Smith, John Maddox, and J.C. Bishop spent many happy hours fishing at these drops.

Jim and Sue Collier and Roger Pinckney X went to Bradenton, Florida in 1940 for " the big ones." Sore muscles and tired backs needed rubbing with industrial strength Absorbine Sr. after hauling in these large tarpon.

With Bass Weejun loafers anchoring down the corners of her blanket, Miss Beaufort of 1939, Margaret Tedder (Rodgers), works on her tan. These were the carefree days of slathering on baby oil and iodine to promote tanning before sunscreen came on the market. In 1947, she and Legare Rodgers were married and in 1957, she became deputy clerk of court until 1976.

Ned Brown sits on the boom of *Ranger*, a 60-foot mackerel fishing schooner, owned by Willie Scheper. Knowing all the rivers, sandbars, and anatomy of the inland waterways, Ned and his brother, Charlie, were invited to accompany the new owner on his journey to Florida.

"Heels down! Look between the ears! Post to the trot!" were commands that Pat Von Sutka gave her riding students at Sams Point Stable on Lucy Creek in the late 1940s. From left to right are Stanley Fox, Claude McLeod, Dick Horne, and Leslie Graham. An unidentified grandfather is inspecting the line-up.

Saxby "Jack" Chaplin and Grandma Vaigneur wonder how to cook this monster drumfish. Cleaning a fish this size was hard work. The tail was nailed to the dock and scales raked off with a garden hoe. This photo was taken in Port Royal in April 1949.

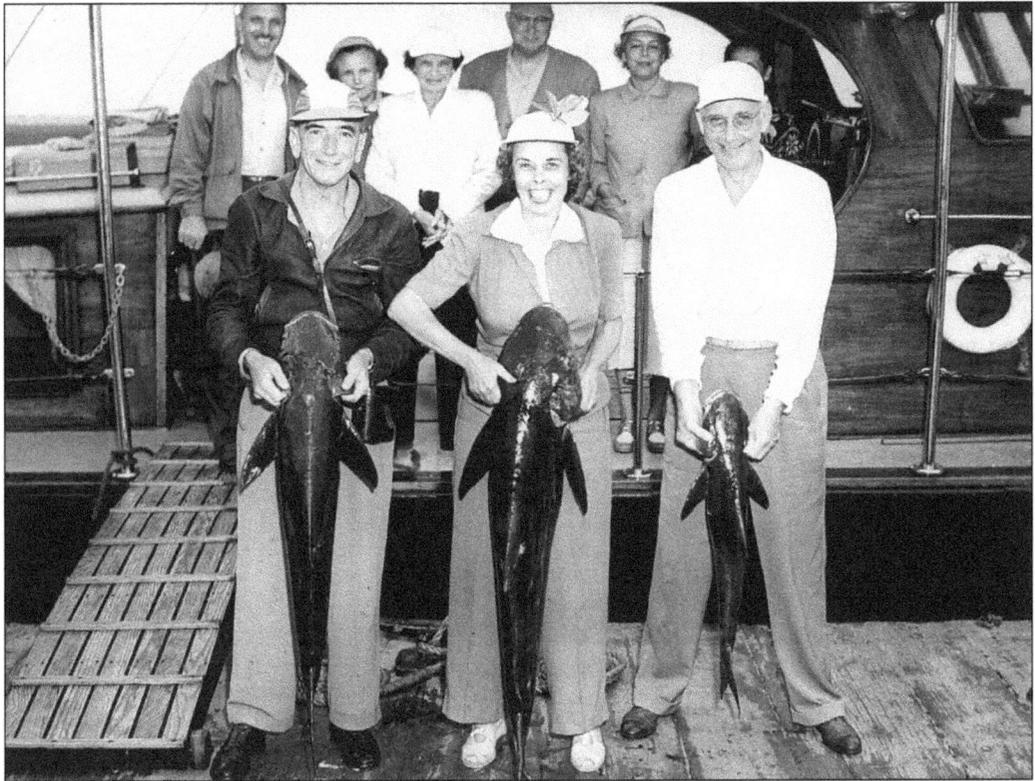

In 1948, this group went cobia fishing in Port Royal Sound on board a boat owned by the Marine Corps. From left to right are Gen. A.H. Noble, commanding general at Parris Island; Margaret Scheper; and Bill Pate. The back row is unidentified. In 1980, a world record cobia of 125 pounds was caught in the Beaufort waters. It was 25 percent larger than the standing U.S. record.

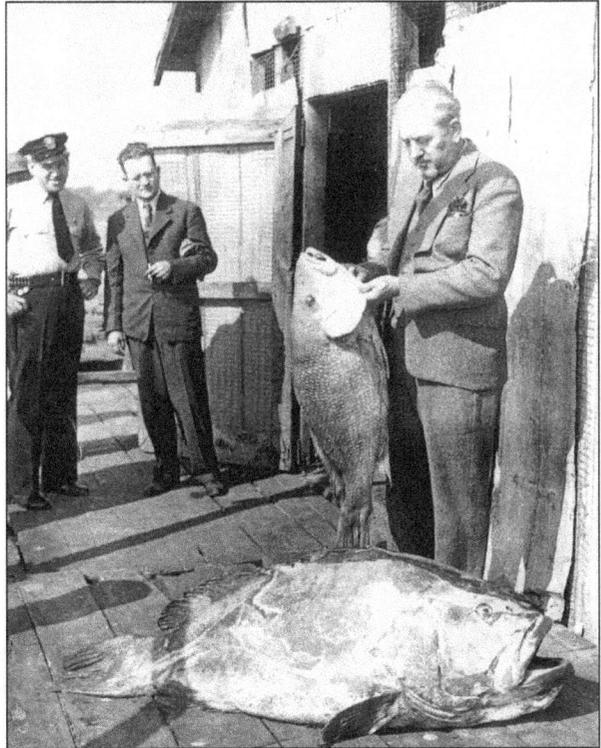

From left to right, Tony Beatrice, L.W. Reeves, and Earl Chadwick admire a prehistoric-looking Warsaw grouper on an old wharf prior to the present Henry Chambers Waterfront park. Earl is holding by the gills a 50-pound snapper.

"Last one in is a rotten egg!!" was the whoop as everyone raced towards the "drop off." Shrieking with glee, the game continued until exhaustion with belly busters, cannon balls, and swan dives. While "marooned" on the island, nobody gave a thought to the summer reading assignments handed out on the last day of school.

George McLeod (left) and Billy Keyserling chuckle over their pan-sized fish caught on Pritchards Island. Fried fish, tails and all, with grits was a hearty breakfast that "hit the spot" and "stuck to your ribs" all morning.

Off to the Masters Golf Tournament in 1955 were, from left to right, Duncan Fordham, Emily Lengnick, Susan Youmans (Rushton), and Claude McLeod. Plaid Bermuda shorts, matching caps over hair slicked with Brill Cream, and penny loafers were all the rage.

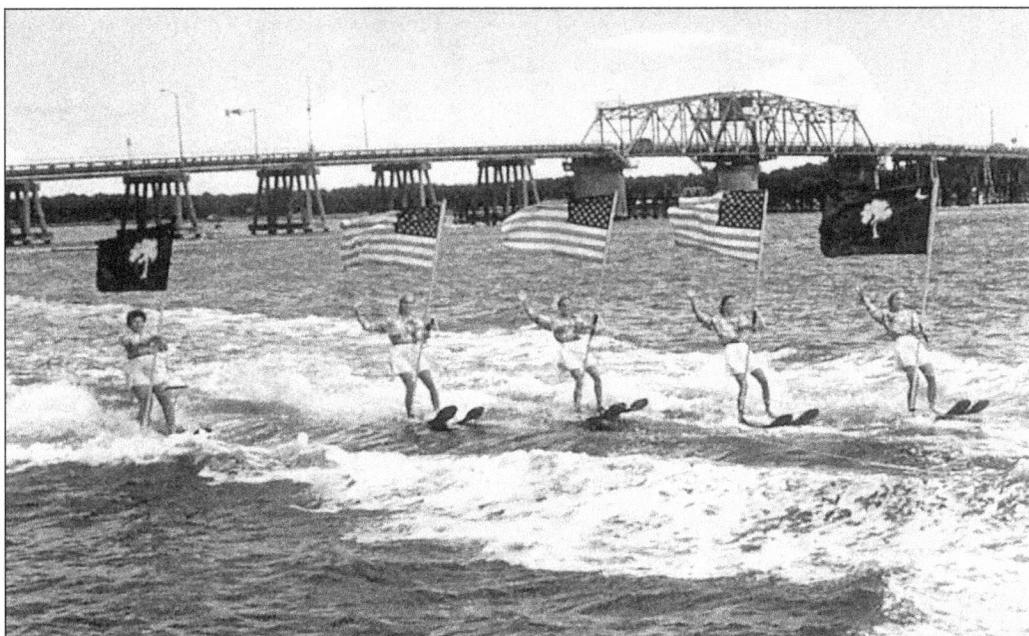

Since its inception in 1955, the Water Festival has celebrated local history and the county's bond with the sea. Over time, many events have been added, including cycling, croquet, tennis, bingo, skiing, scuba treasure hunt, three-legged races, street dancing, whipped cream pie fights, bluegrass music, and performances by the Parris Island Marine Band. Jean Kearns took this photo of the water skiers carrying the Palmetto flags. The Woods Memorial bridge is in the background.

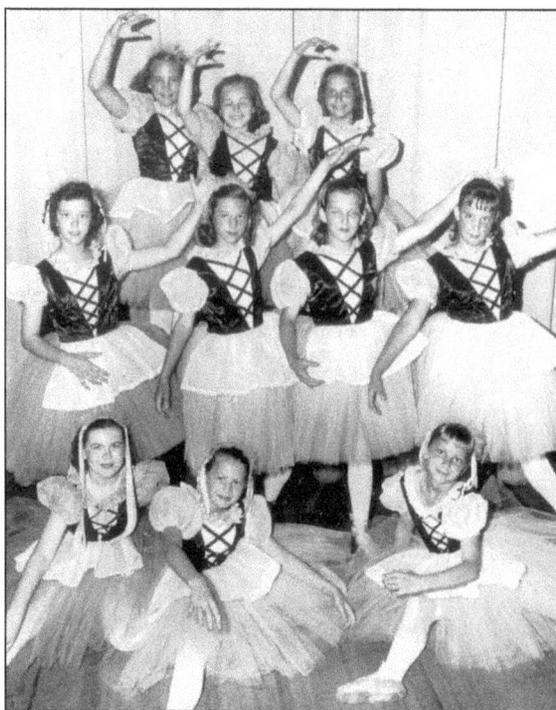

Madeleine Pollitzer's dance class was in Pandora's Friends at Beaufort Elementary School in 1961. From left to right are (front row) Mary Ann Martin, Bitty Green (Brant), and Carol Black (Kelly); (middle row) Marcia Kennedy (Parker), Anita Sandel (Henson), Kay Bracey, and Jane Mitchell (Hincher); (back row) Nan Campbell (Kinsey), Susan Jones, and Kathy Chakides (Gaffos).

Julian Levin and sons enjoy a day of bass fishing at Bull Point. The boat was a wooden Wolverine purchased before living room furniture was acquired—first things first! He learned about sailing while operating the bailing can aboard the catboat, *Sandfly*, owned by the McLeods. From left to right are Julian, a physician at Scott Airforce Base in Illinois; Arthur, with A.G. Edwards in Beaufort; and Julian Sr., who has practiced law in Beaufort for 54 years. He is married to Renee Steinberg from Savannah.

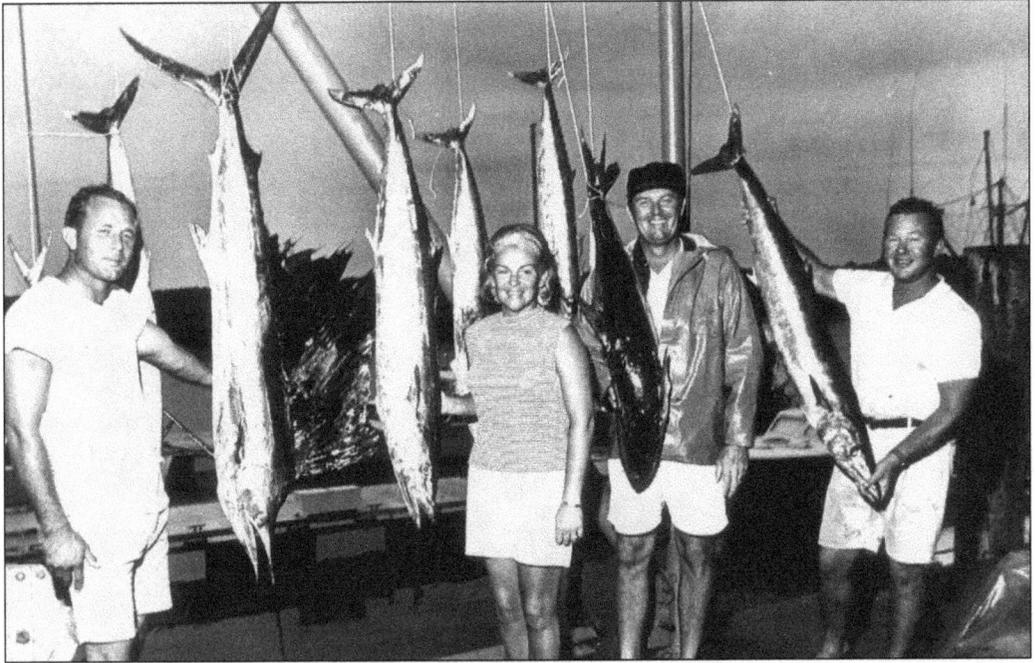

After an exciting fishing trip aboard the Pingree's boat *Roulette*, this happy group displays some spectacular sailfish at the Lady's Island Marina dock. From left to right are Bobby Cooler, Virginia "Ginga" Pingree, Henry Chambers, and Sumner Pingree.

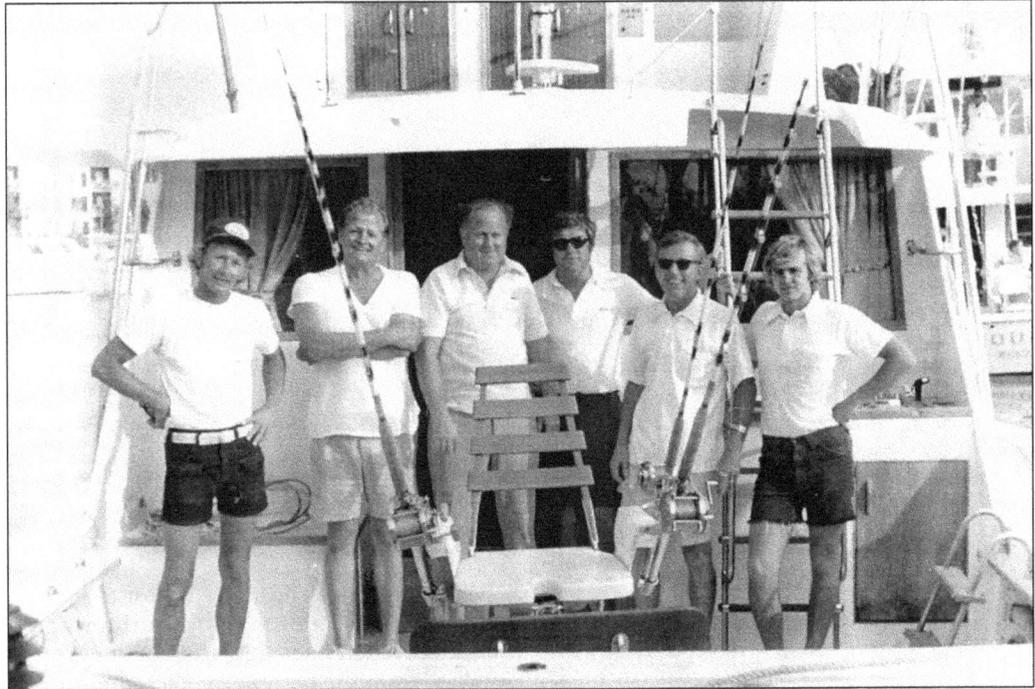

Standing on the stern of the *Ciljoy* at Harbor Town at a blue marlin tournament in Hilton Head, from left to right, are unidentified, Skeet Patterson (from Florida), Marvin Dukes, Richard Gray, Sammy Gray, and Merritt Patterson.

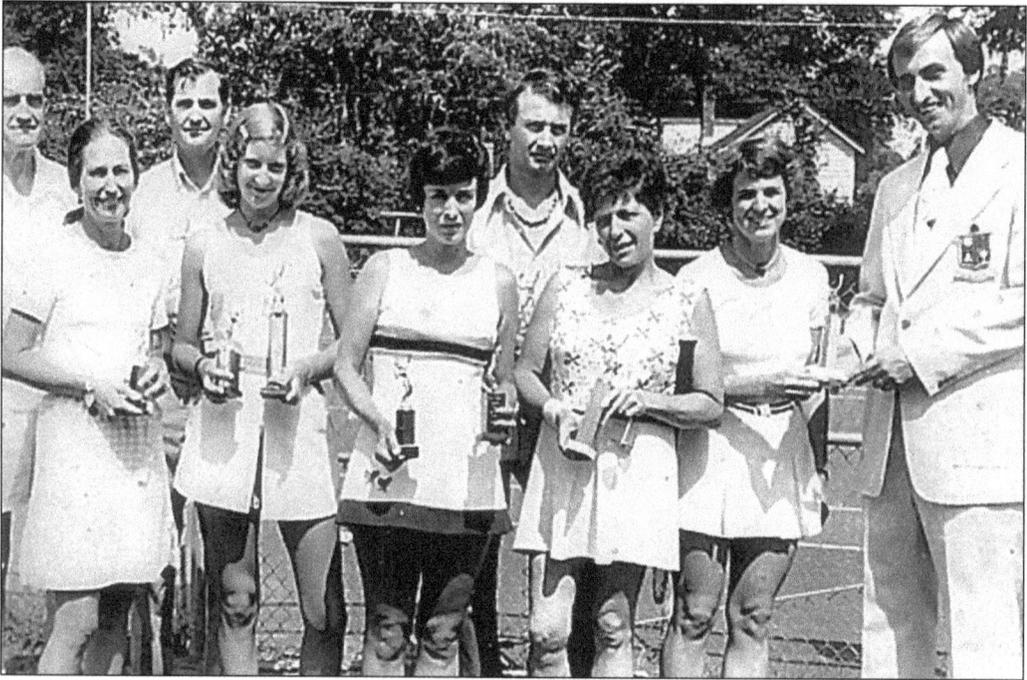

Here are the winners and runners-up at the tennis tournament during the 1975 Water Festival. From left to right are Lee Bradbury, Peggy Sanford (Peyton), Lou Roempke, Shelley Hanna, Alice Klatt, Dan Huff, Harriett Keyserling, Susan Graber, and coach Kurt Copeland.

William Kennedy noses his boat into a creek mouth so his son, Bill, can throw the castnet. When hauled in, the net draws inward from the bottom trapping the shrimp. Mullet are often caught in the net and sometimes called "sea rabbits" because of their big black eyes and ability to jump.

Shall we go to the dance? Hugh Patrick (left) and Justin Tupper might have a hard time getting dates for the prom after mud-boggin' in the pond on The Point.

Reporter Janie Jarvis interviews world heavy-weight boxing champion, Joe Frazier. "Smokin' Joe" was born in Beaufort in 1944; he was the first man to beat Muhammed Ali. In 1964, he was the Olympic heavyweight champion and from 1970 to 1973 was the world heavyweight champion. Janie is the daughter of Beaufortonian Mary Patrick.

In 1993, The South Atlantic Yacht Racing Association presented its sportsmanship award to veteran sailor Mills Kinghorn, still racing at age 86. In 1993, the Beaufort Yacht and Sailing Club founded the A. Mills Kinghorn Award for sailing excellence to honor this beloved son of Beaufort. Here, Mills skillfully holds a starboard tack aboard a Force 5 dingy in 1994.

At low tide, the "sandbar" has always been a safe place for parents to take children to play in the puddles and make drip castles. It is located in the Beaufort river opposite the hospital. Shaina and Sean Kearns, grandchildren of Jean and Ray Kearns, are getting the feel of the mud between their toes.

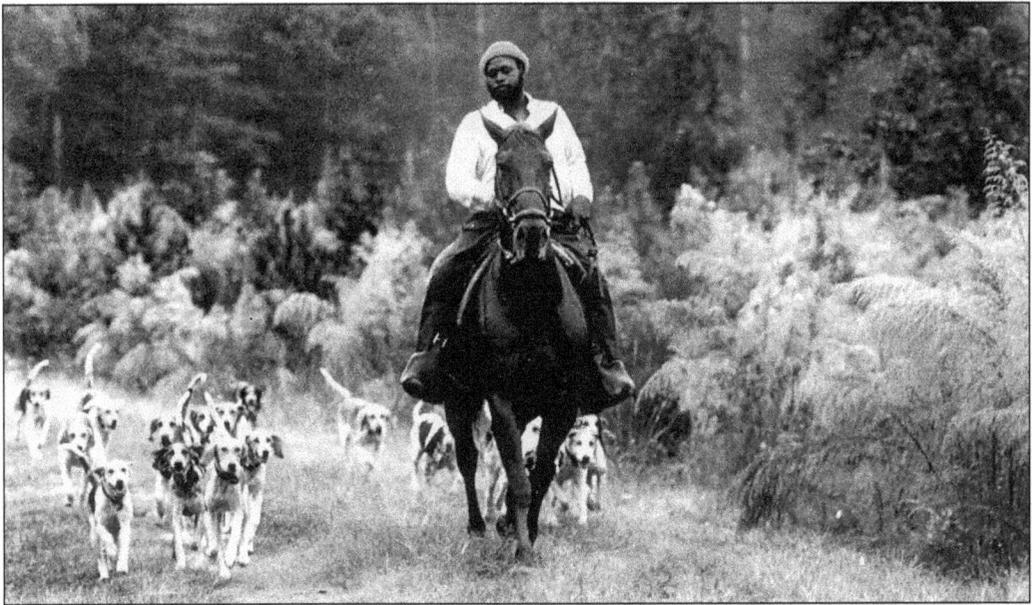

Bill Green, the last remaining Gullah deer-driver, works at Middleton Hunting Club in Charleston where he cares for the horses and trains the hounds to flush deer out of the woods towards the hunters. The hunters or "standers" are stationed about 100 yeards apart over several hundred acres. Blowing a cow horn, Bill can command the hounds, call for help, signal a wounded buck, or end the hunt. He owns Low Country Cooking and Catering in Frogmore, five miles from Beaufort, and was a guest on the Martha Stewart show, where he demonstrated steaming oysters in a wet croaker sack.

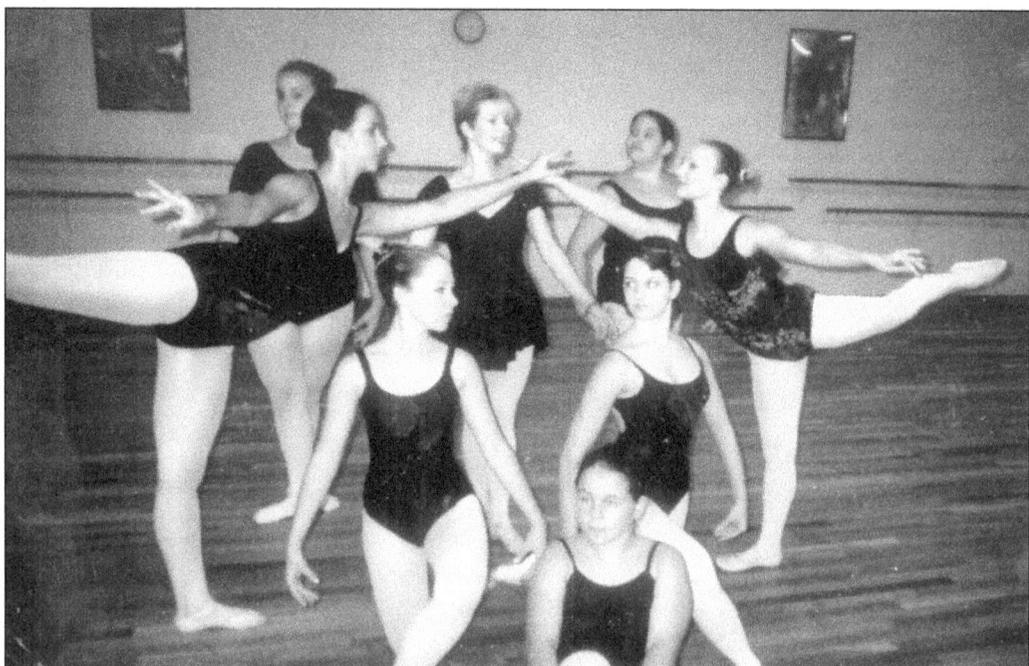

Gaye Baxley (Hattoway) drives from Isle of Hope in Savannah to teach ballet at Beaufort Academy of Dance on Toppins Road. Pictured from left to right are (front row) Mindy McIlwain, Krystal Radnoff, and Sarah Midyette; (middle row) Erin Demers and Sarah Dykeman; (back row) Christina Larsson, Gaye (Hattoway), and Allyson Dykeman.

Anna Pinckney soars over a jump on "Hootie," a chestnut Thoroughbred. Anna teaches at Shalimar Horse Center owned by Kay Neil on Broad River Road. Anna's sister and brother-in-law, Alicia and Bob Story, own Storybook Farm in Charleston. Bob coaches the College of Charleston's equestrian team.

After a day on the water with his chum Ralph Bailey, Steve Mitchell tied up his boat, *Waterworks*, and climbs the gangplank from the floating dock. The two friends had participated in the Beaufort Yacht and Sailing Club fishing tournament. He is probably going for help to lift his really heavy fish out of the cooler!

A familiar sight to people on Coosaw Island is this little yellow Maule airplane piloted by Jim Knight, soaring overhead and dipping its wing to say "hey y'all." Retirees Jim and Terri Knight of Coosaw Island have been recognized throughout the community for their untiring volunteer service with the Boy Scouts and the First Presbyterian Church. Jim's dog is called Churchill.

127

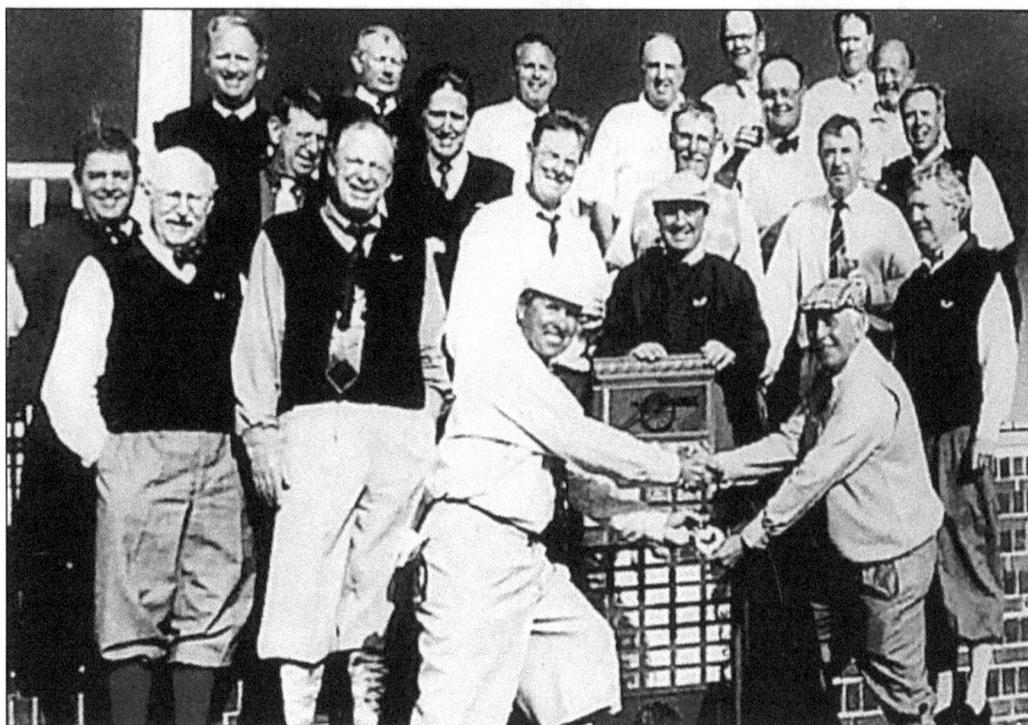

Secession Golf Club was opened on Gibbes Island in 1992 and is owned by its members. Membership is by personal invitation only. Pictured from left to right are (first row) Tom Wojnas and Dick Deal; (second row) Mike Myers, Lamar Kilgore, Bud Hunter, H. Ray Finney, North Goodwin, Stan Andrie, John Cantrell, and John Waddy; (third row) Drew Kinder, Horst Schroeder, Bill Sheehan, Gary Shimmin, Tom Smith, Bob DePiro, Jim Cooley, Bob Sinatra, and Dick Goldburg; (fourth row) Jim Hynes and Tom Paskins.

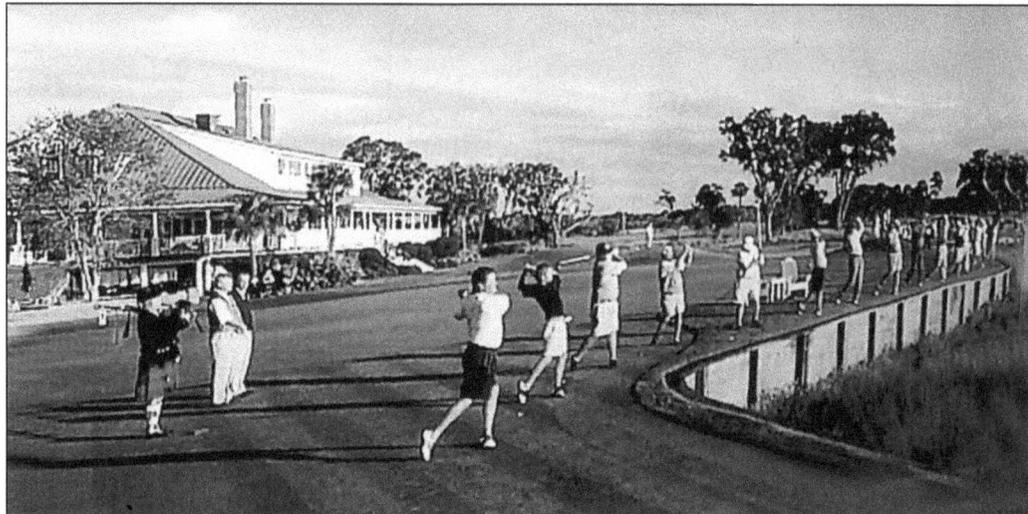

Golfers line up in front of Secession Golf Club in a golfing tribute to the one-year anniversary of the destruction of the World Trade Towers. Playing golf here is much like playing "Scottish style"—walking, not driving, the links-style course in unpredictable conditions caused by changing winds, tides, and weather.

Visit us at
arcadiapublishing.com

www.ingramcontent.com/pod-product-compliance
Lightning Source LLC
Chambersburg PA
CBHW080558110426
42813CB00006B/1336